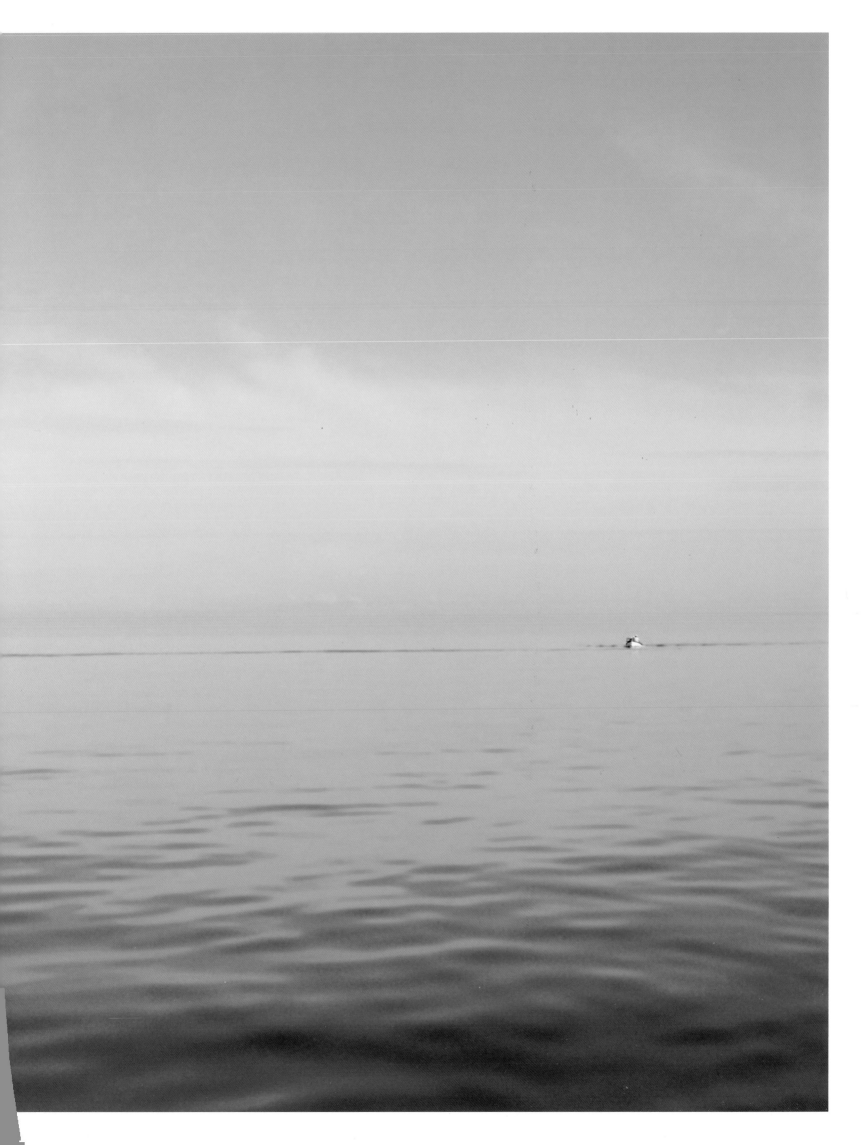

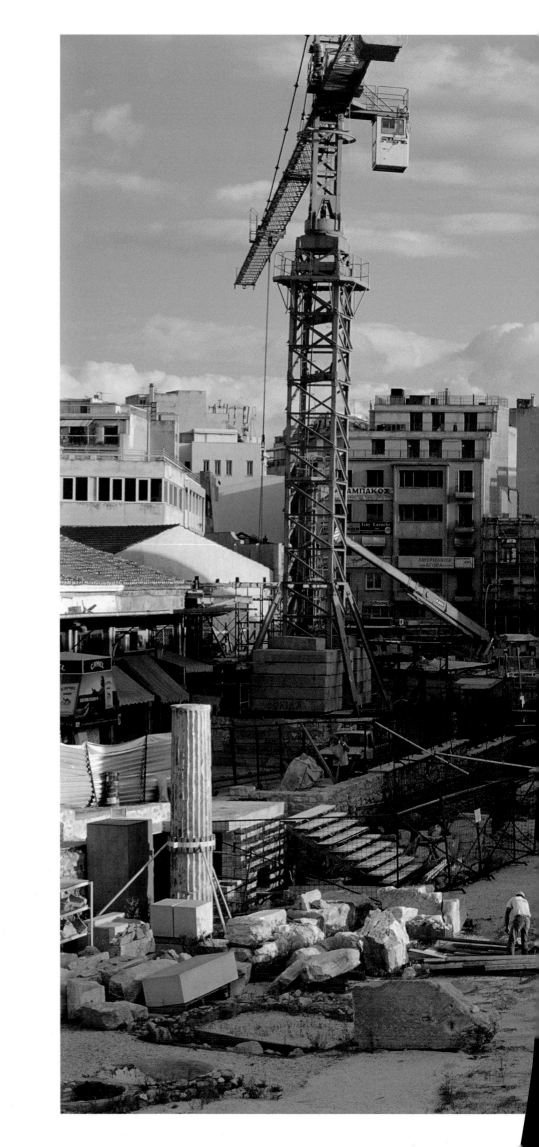

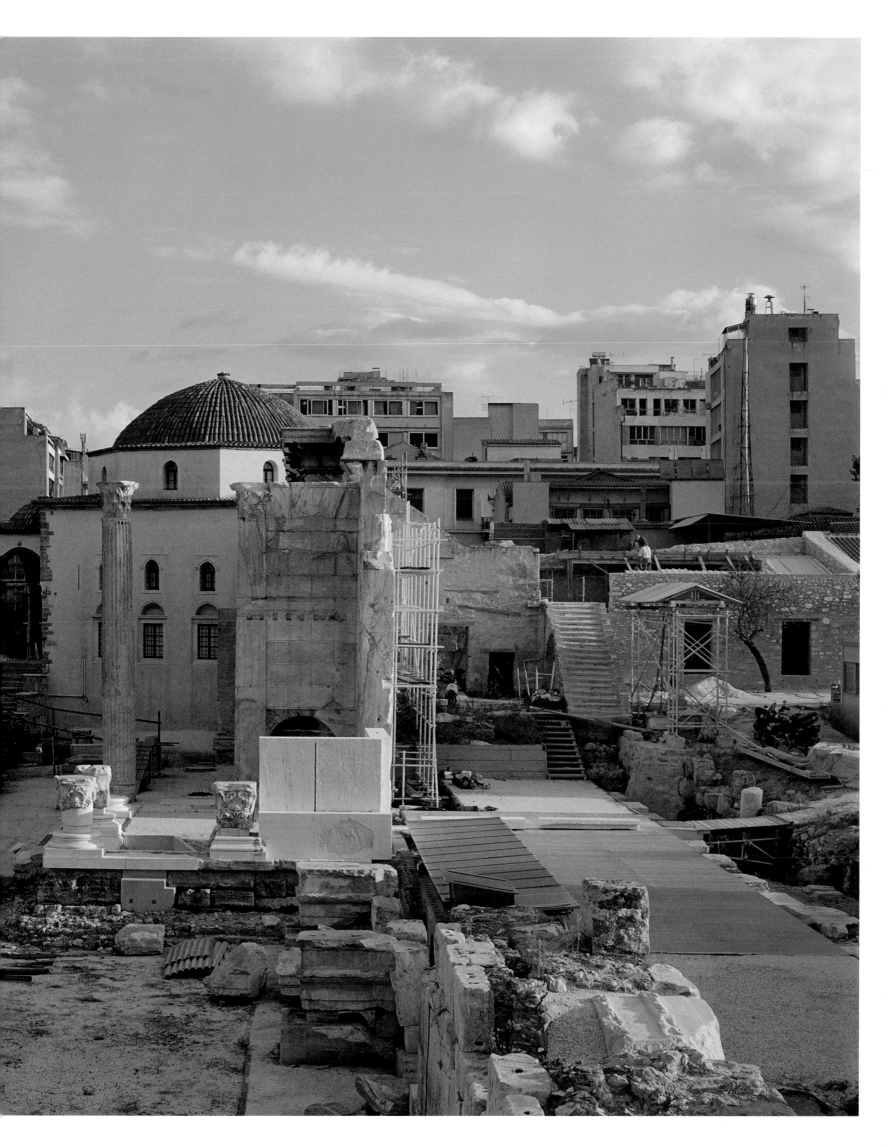

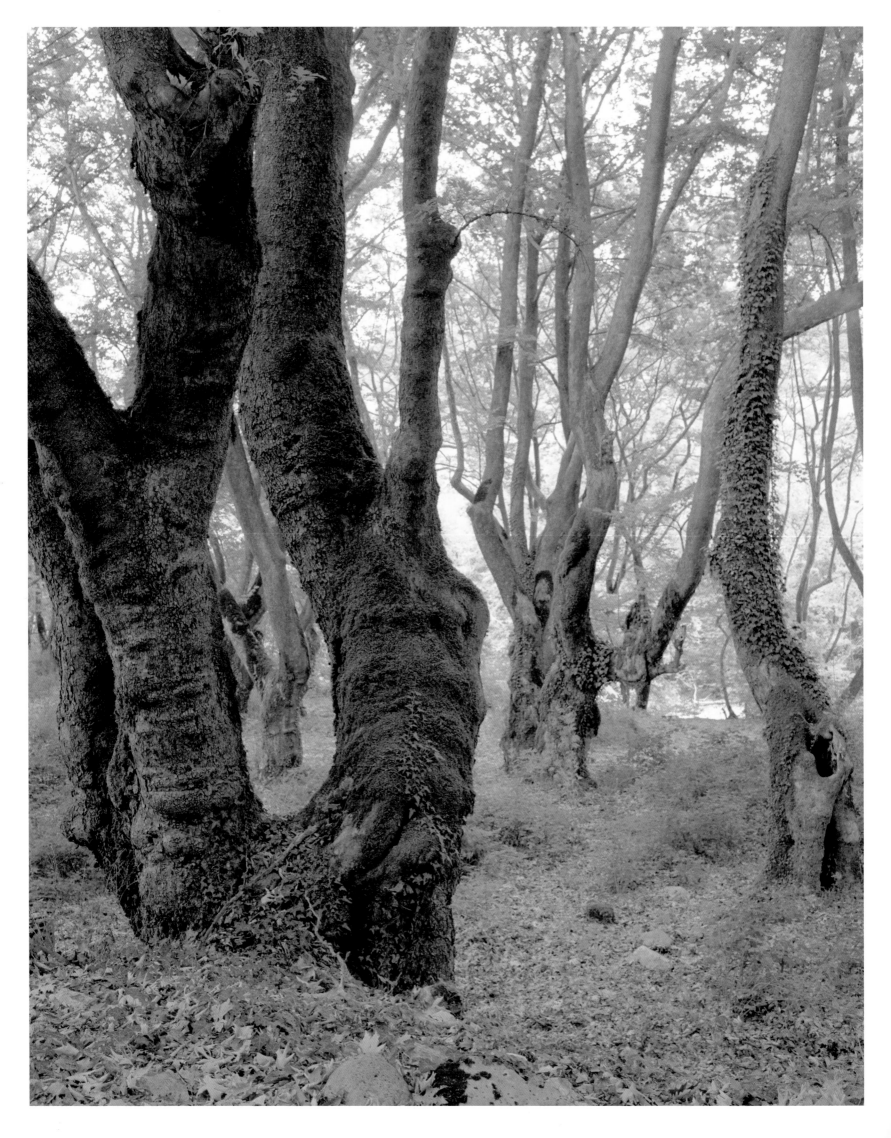

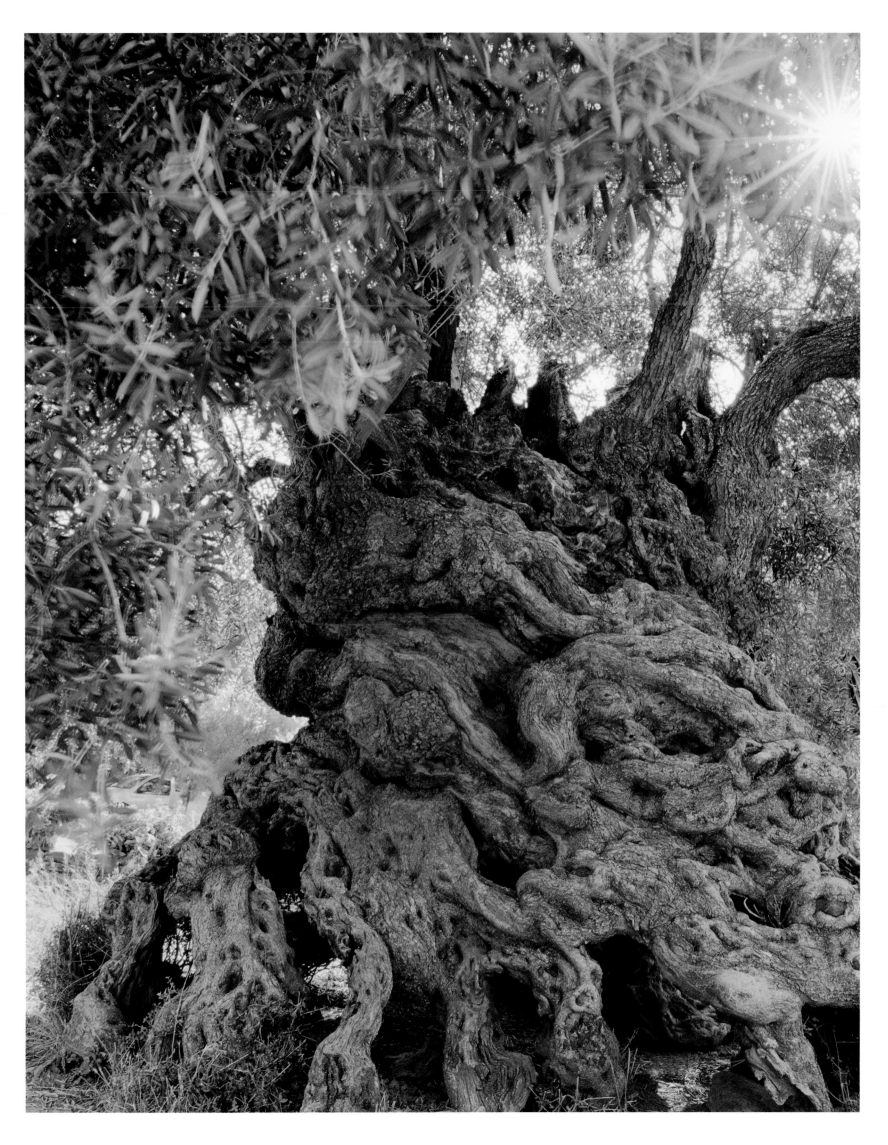

HELLAS
PHOTOGRAPHS OF MODERN GREECE

WILLIAM ABRANOWICZ

INTRODUCTION BY LOUIS DE BERNIÈRES

HUDSON HILLS PRESS

MANCHESTER AND NEW YORK

To my wife, Andrea; my mother, Midge; and my grandmother, Margaret.

CONTENTS

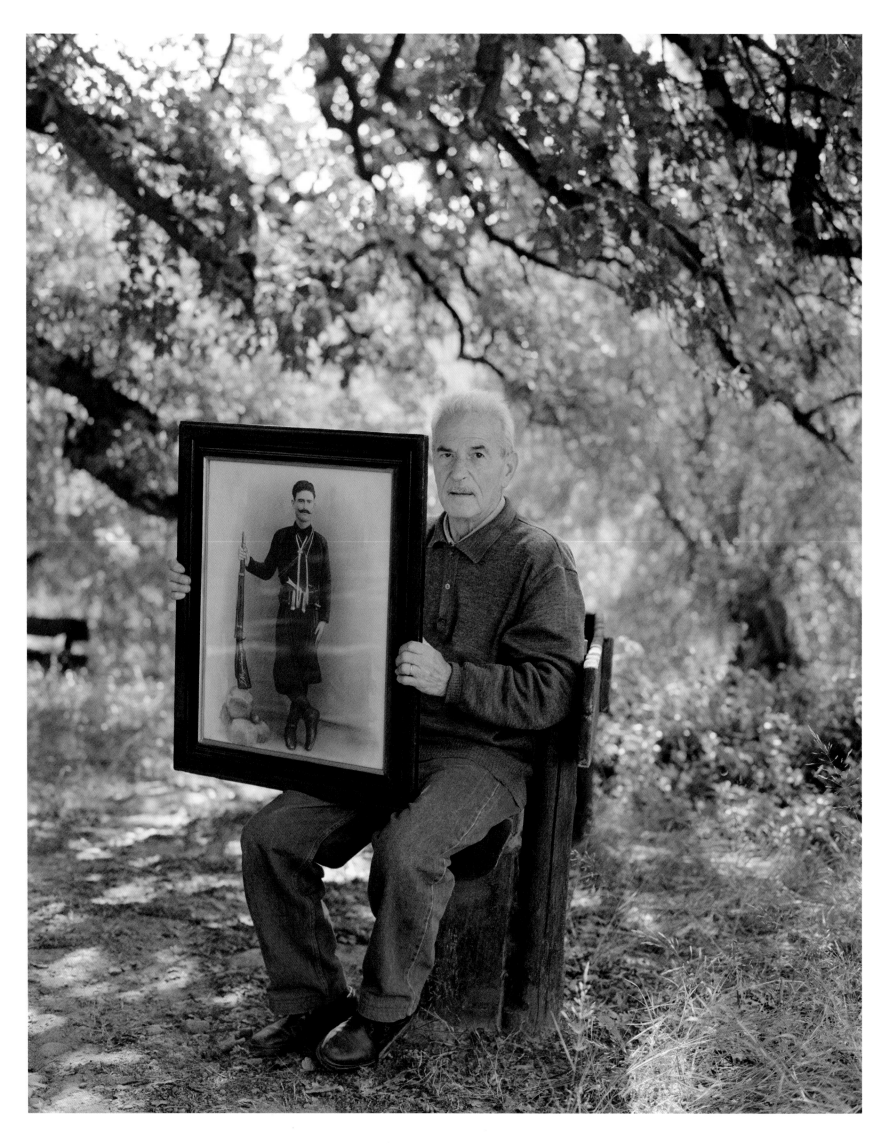

HELLAS

PHOTOGRAPHS BY WILLIAM ABRANOWICZ
LOUIS DE BERNIÈRES

YOU HOLD IN YOUR HANDS A BOOK THAT SAYS A GREAT DEAL ABOUT GREECE, possibly with greater subtlety than any number of words. This is because almost everything one can say about Greece is only partially true, or is contradicted by its equally valid (and equally partial) opposite. Until recently, Greece looked as though it was evolving rapidly as it adjusted itself to the standards and regulations of the European Union, and was going through a period of economic reform. Governments seemed to be collecting taxes successfully for the first time, with considerable consequences for the infrastructure. Greece used to look like a poor country, even though everyone would say with a knowing smile "There's no such thing as a poor Greek."

At the time of writing, however, it appears that this leap into the future was a delusion foisted on the world by a mendacious government. Even so, Greece has changed enormously since I first went there, and economic crises do always pass. Athens now has a superb underground railway system, and one hardly sees anymore those little black-garbed old widows trudging along the side of the road accompanied by a donkey loaded with sticks. Greece feels less like a Balkan country these days, and it is most likely that anyone reading this introduction in ten years time will scarcely remember the current crisis.

Most foreigners experience Greece firstly as holidaymakers. They remember the joyous "bouzouki nights" put on for tourists in the tavernas, which always end with Zorba's Dance played at extraordinary volume and speed. They remember the first time that they tried retsina, the time they got sunstroke at Knossos, or the time that they first ate aubergine cooked in pints of olive oil. They remember seas even bluer than the skies, and the brilliant whiteness of houses stacked up on hillsides, set off by woodwork in various cheerful shades of turquoise and blue. The bearded Orthodox priests in their flapping black robes, and the difficult alphabet, add an intriguing touch of the exotic. The tourist goes home without realising that in winter the weather can be utterly foul, and that the islands empty out as everyone returns to Athens or Thessaloniki.

Of course there are plenty who go to Greece without noticing anything at all. I once met a skinny father and flabby son from Glasgow, both butchers, who had calculated that if they flew to Corfu and boozed for two weeks, it would work out much cheaper than boozing for two weeks at home. It was August, and they were as pale as vampires. They were boozing in a disco that played nothing but British and American pop music, and living off French fries.

After one or two visits, one notices a little more; that the cafes only have men in them; that kitchen windows are often adorned with a pot of basil; that Greeks have a puzzlingly high esteem for instant coffee; that they don't like their food as hot as the rest of us do, and let meals cool down on purpose. One assumes that the pot of basil is for culinary purposes, and only after many visits does someone tell you that no one eats it, because it is considered sacred.

However, there never comes a time when one can realistically say that one has been to Greece, or that one knows it. The mainland is impossibly mountainous, and the rest of Greece consists of hundreds of islands, each with its own customs, dress, dance, musical style, dialect, and cuisine. There is no point asking for *sofrito* anywhere except in Corfu, and you will only find cod *a la speziota* in Spetses. You will probably only eat snails in Crete. You will hear *kantades* sung in the Ionian Islands, but certainly not in the Sporades. If you ask for red wine in Kythera, you will get rosé from a tin jug. Everyone thinks that Cephallonians are mad, except for Cephallonians, who think that they are easily the cleverest Greeks.

Greece was a puzzle to me went I first went there. I had had a classical education, and despite having often seen news items about "The Colonels," I still had it in my mind that Greeks carried scrolls and talked about philosophy. You may find streets named after philosophers, but in reality Hellenism and the Hellenes are long gone, and what Greeks are really nostalgic for is Byzantium, the Eastern Roman Empire that fell to the Ottomans in 1453. They still refer to Istanbul as "the City," and they want it back even though they know they can never have it. Greece was part of the Ottoman Empire for about four hundred years, a period when Christians and Muslims were mixed together in every part of Greece. Christians were often Turkish speaking, and Muslims were often Greek-speakers.

Although all the Muslims and the mosques vanished in the War of Independence in the 1820s, the legacy of that occupation is everywhere to see, most obviously in the cuisine, but also for example in the folk tales, the superstitions, the touchy sense of personal honour, and the love of giving hospitality. It is well-known that Greek and Turkish

folk musicians have no trouble whatsoever in improvising with each other. Most irritatingly to those who love both countries equally, the Greeks and the Turks also have a mutual love of blaming each other for just about everything, provoking each other into fits of bad temper, and only remembering atrocities committed by the other side. It makes me smile when I hear that once again the Turks have managed to scramble the entire Greek airforce, and then gone home before the Greeks arrive. It infuriates Greeks, of course.

Ancient Greece was the origin of much that we value in western culture, and we credit it with the first experiments in democracy, theatre, science, and secular philosophy. Greece is the motherland of us all. It is also, of course, a Balkan country, but a Balkan country with a long and affectionate relationship with both Russia and Serbia, firmly cemented by the shared Orthodox faith. One is forced to resort to the cliché that Greece is at the crossroads of everything. Modern Greeks are increasingly aware of this, and look forward gleefully to a very prosperous and interesting future as the pipelines converge.

This is a happy prospect after the long series of misfortunes that Greece suffered in the 20th century. First there were the Balkan wars (1912 and 1913), in which it won territory from the Ottomans and then lost it again. At the end of the Great War, the allies agreed that Greece should occupy western Anatolia, but then Greek armies pushed towards Ankara, only to be defeated and humiliated by the forces of Mustafa Kemal Ataturk (1922). "Infidel" Smyrna was burned, and then, according to the terms of the treaty of Lausanne, Greece's Muslims were sent to Turkey, and Turkey's Christians were sent to Greece, even if they did not speak the relevant languages.

It was the end of Hellenism in Asia Minor, where the best ruins of ancient Greece are still to be found. Greece filled up with unmanageable numbers of well-educated but penniless refugees, and to this has sometimes been attributed the rise of the communism and militant socialism, with their attendant disorder, that eventually led the King to ask General Metaxas to assume dictatorial powers in 1936, which, of course, he abused.

Metaxas redeemed himself in 1940 by proudly rejecting Mussolini's demands to allow the incursion of Italian troops, and so Greece's finest young men were sent away to fight an impossible battle in the mountains of Albania, which they won. Then the Germans invaded. There was starvation caused by a British blockade, and the Nazis were particularly cruel and oppressive. When the British liberated Greece in 1944, the leftists did not think that being occupied by the capitalist, imperialist British was the kind of liberty that they had hoped for. The Greek communists were Stalinist, but they had no

idea that Stalin had agreed with Winston Churchill that Greece should be in the British sphere of influence, in exchange for influence over Yugoslavia. The communists lost the civil war that ensued in 1946, and many were forced into exile in countries like Czechoslovakia. In those days, if you were a Greek intellectual, you were leftist, and so Greece lost its artists and intellectuals. Those that remained were in perpetual trouble with the authorities. You sometimes hear people referring to the "Black Terror" (of the Nazis), the "Red Terror" (of the communists), and the "White Terror" (the revenge of the rightists and royalists). Then there was the coup by "The Colonels" (1967), which the King failed to resist, and the fiasco brought about by the 1974 declaration of union with Cyprus, which provoked the intervention of Turkey, leaving behind an intractable problem that still has not been resolved. At the restoration of democracy, with the left in the driver's seat this time, the monarchy was abolished and the King went into exile.

The wounds left behind by all these events have still not healed. People try not to talk about the civil war, but Greece is still very badly divided politically, the arguments and recriminations between left and right are still horribly vehement, and there are still many royalists quietly hoping for the return of the King.

Why should one attend to a potted history such as this, at the beginning of a beautiful book of photographs? Because otherwise there is danger of reading these photographs with the eye of a tourist. There are old people depicted in them who might have starved as children, endured the German occupation, and fought, and lost friends and relatives in the civil war. Some would tell you that General Metaxas was a deliverer, and others that he was the Devil himself. The middle-aged people might remember grandparents who spoke Turkish. A young man's mother might have been in prison or in exile, and he himself has certainly done military service. The children, however, are growing up in a new, confident Greece that will be more outward-looking, and, it is to be hoped, less obsessed by old grievances. At the same time they will start to lose much of their Greek identity as they put on baseball caps and start playing electric guitar instead of bouzouki and mandolin.

The photographs in this collection show Greece through the eyes of an artist who loves Greece and knows its history. In other words, he is not just taking pretty pictures of picturesque things. Ancient Greece is present in the fantastically complex trunk of a very old olive tree. Here is Byzantium in the form of icons and candles, and the skulls of monks in an ossuary. These hark back further too, because ossuaries were a pre-Christian institution. Here is something from Ottoman times—a grandfather holds up a picture of a soldier, perhaps a *klepht*, perhaps his own grandfather, perhaps one who died in the Balkan wars. Here is modern middle-class Greece, with its collections of

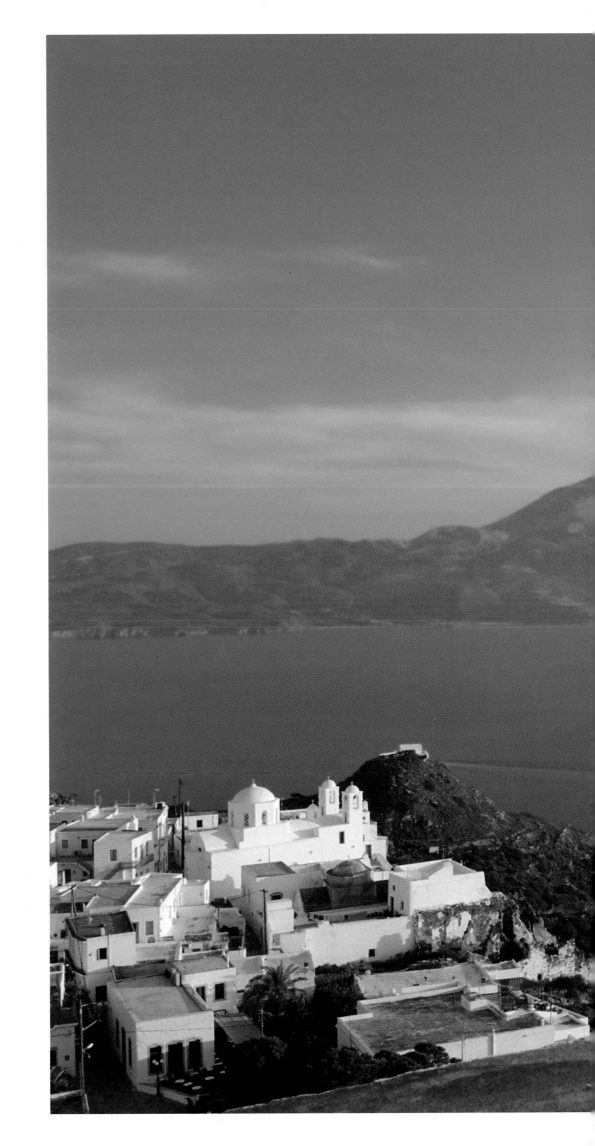

gewgaws and trinkets, and its photographs of ancestors in their best clothes, who were probably expelled from Turkey after the Asia Minor catastrophe. Here is the Greece of the holidaymakers, with their sarongs, camper vans and mountain bikes.

There are some photographs that capture Greece as it has always been: sheep on a hillside; the soulful profile of a man in a tee-shirt who would otherwise look like everybody's exact idea of an Orthodox priest from any era; four generations of a family that has stayed together; people at a large table talking amid the detritus of a long meal; a belled goat with oddly philosophical eyes. My favourite shows something that one only seems to see in Mediterranean countries, two boys in an attitude of innocent affection.

People learn to love Greece for many different reasons. In my own case I was first drawn in by the work of composers such as Hadjidakis and Theodorakis, and that led me naturally to a love of the poets whose words they had set to music. A whole new aesthetic and intellectual universe opened up to me, and now I cannot imagine life without the poetry of Cavafy, or *pentozali* dance tunes from Crete. I enjoy eating *kleftiko* in the Plaka as much as anyone could, I like to shop in Monastiraki market, I like to go up mountains with two of us on a tiny moped, Greek style, and I like the wholehearted enthusiasm of my Greek friends.

These are some of my reasons for loving Greece. In this fine collection of photographs you will discern some of William Abranowicz' reasons, and no doubt you will be reminded of your own. Each picture is two and a half thousand years deep.

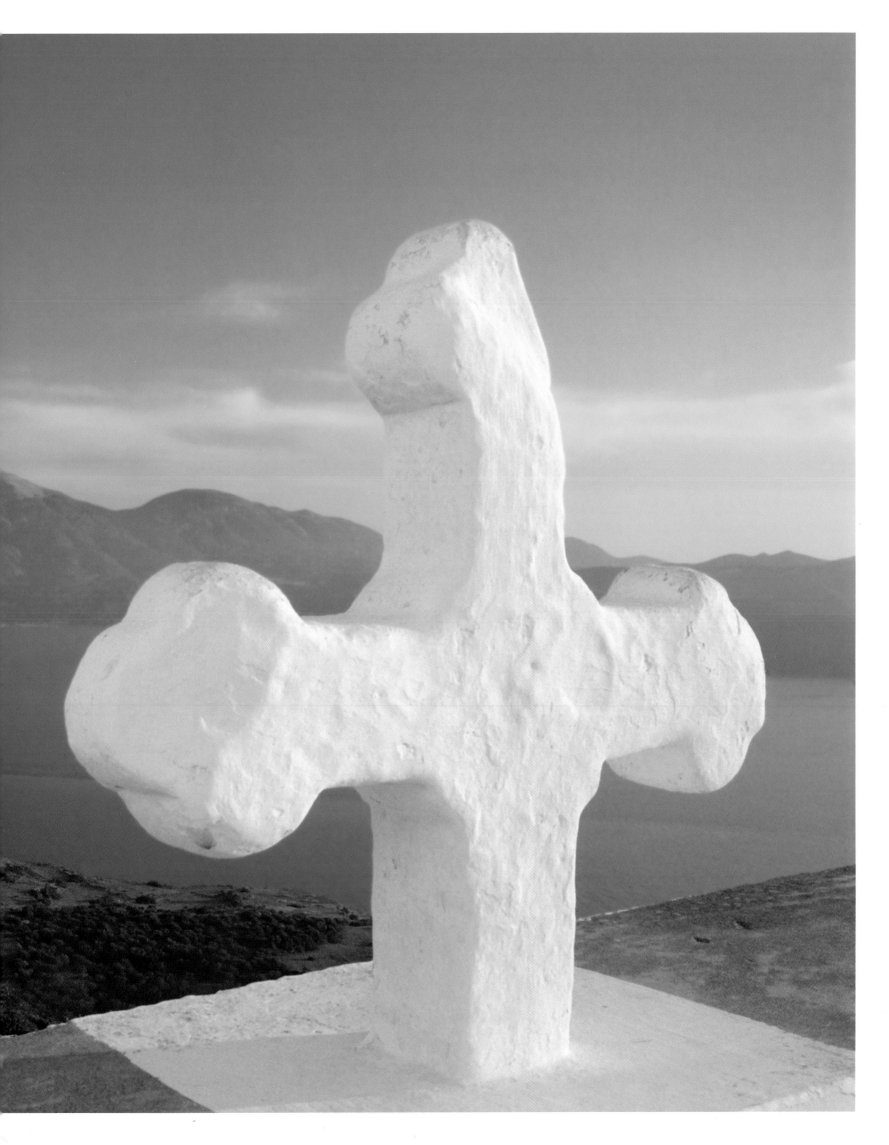

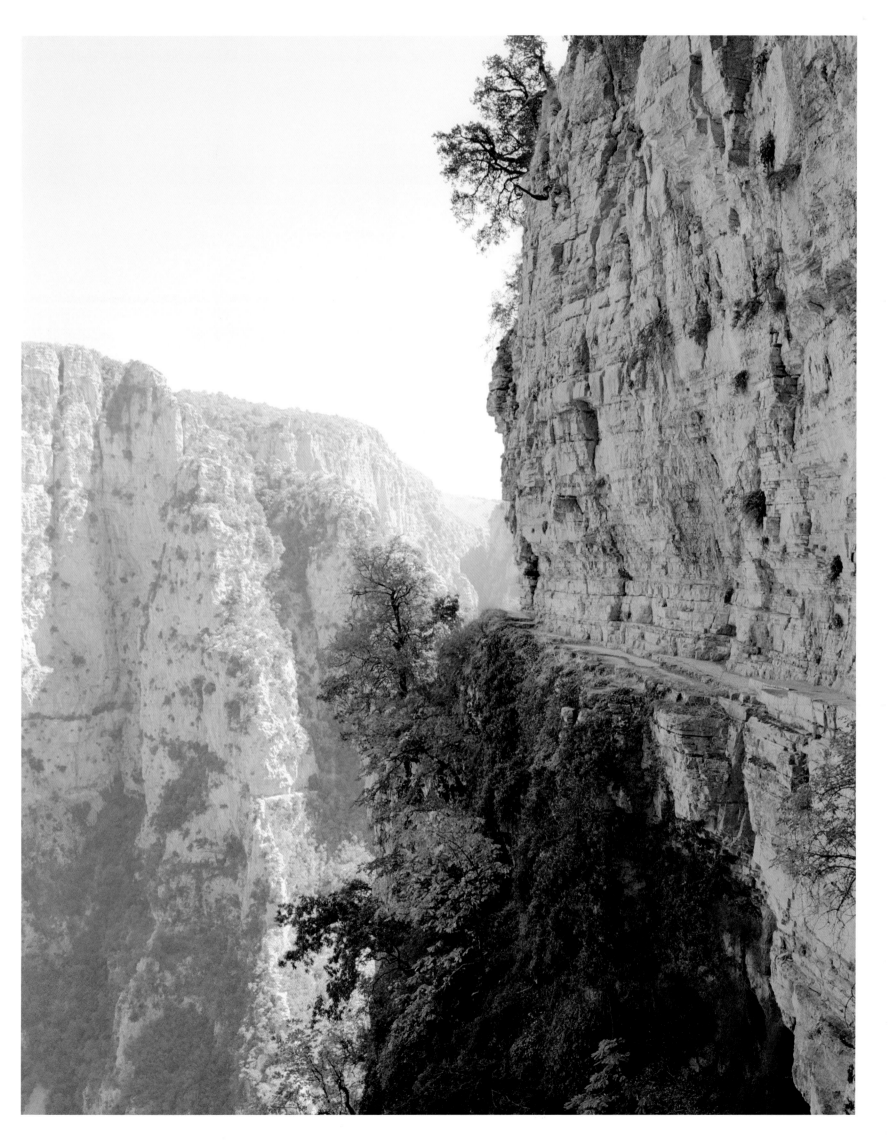

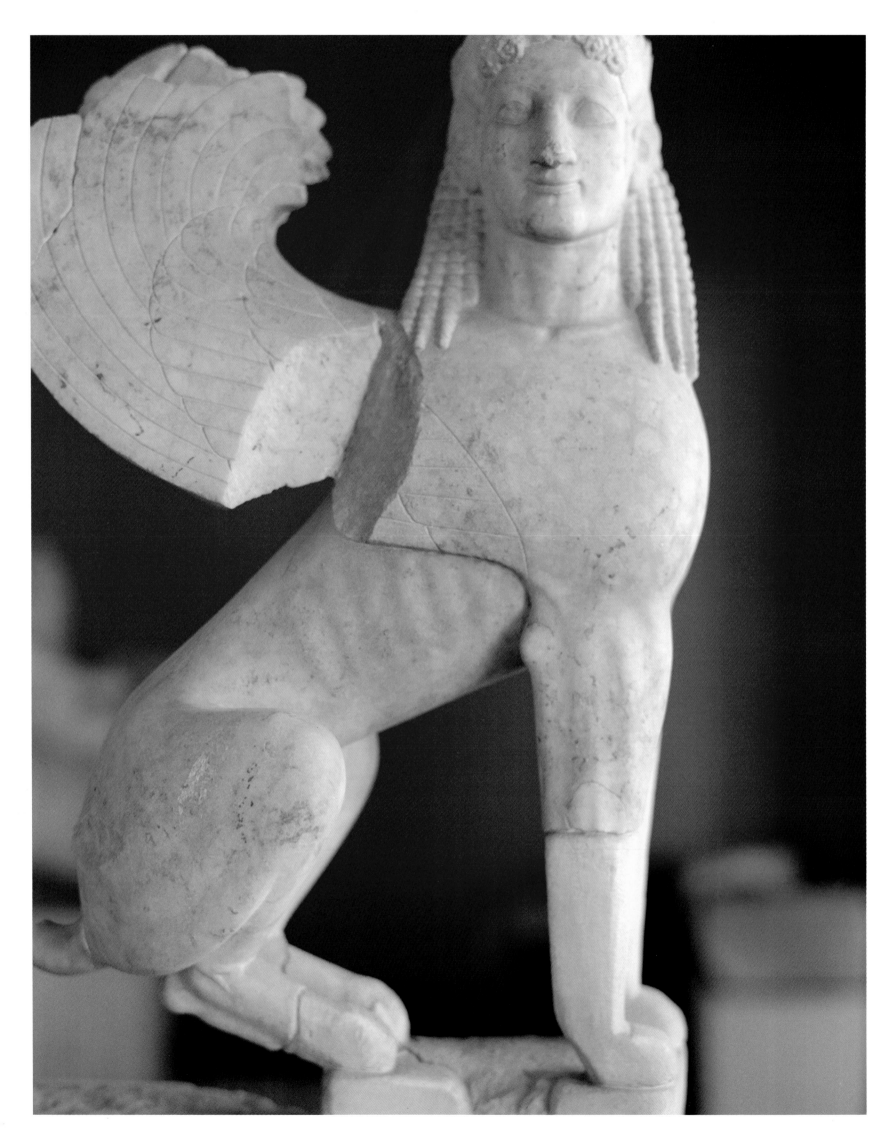

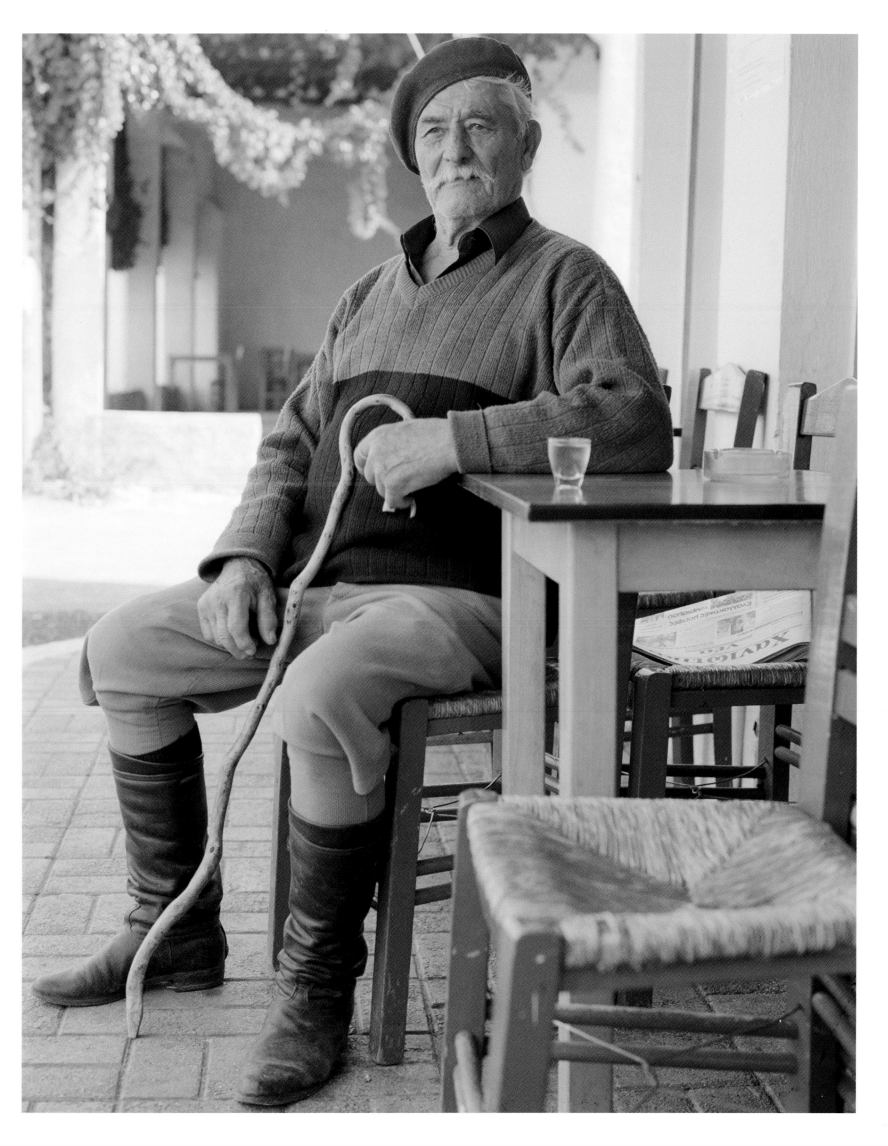

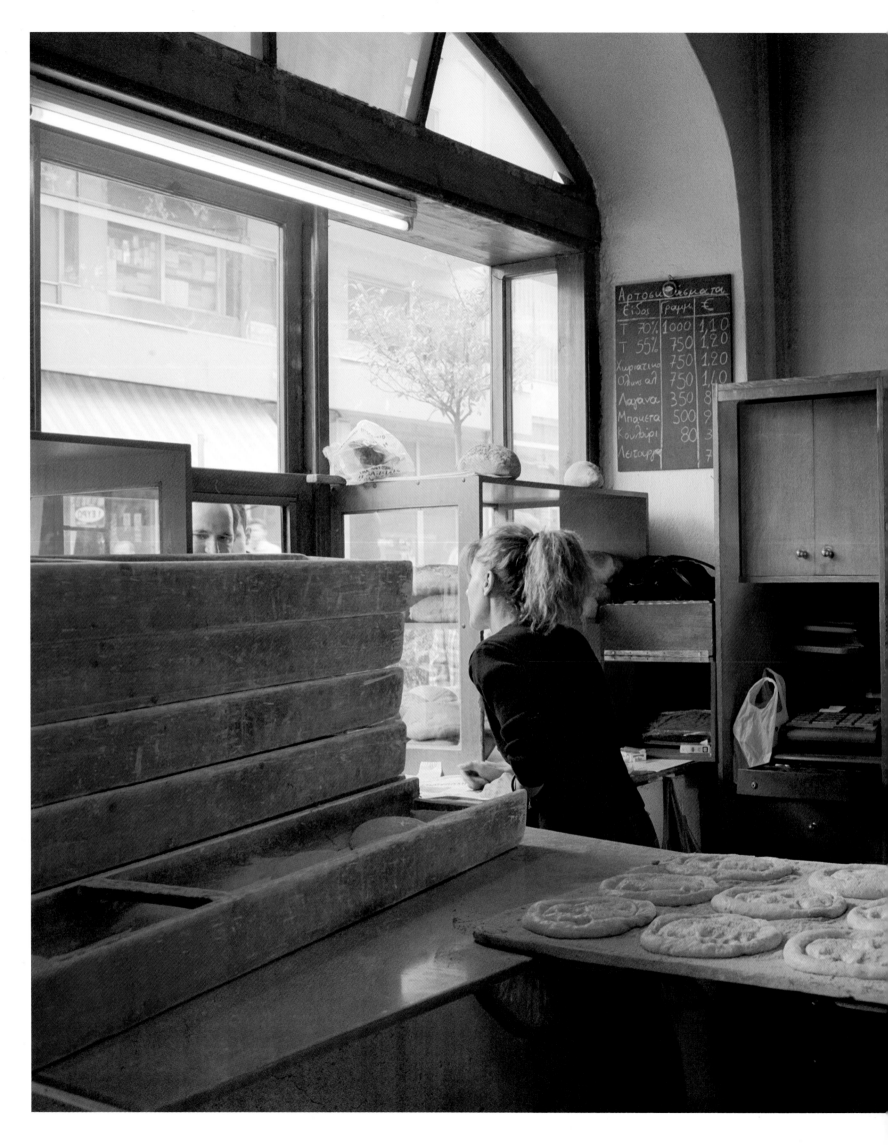

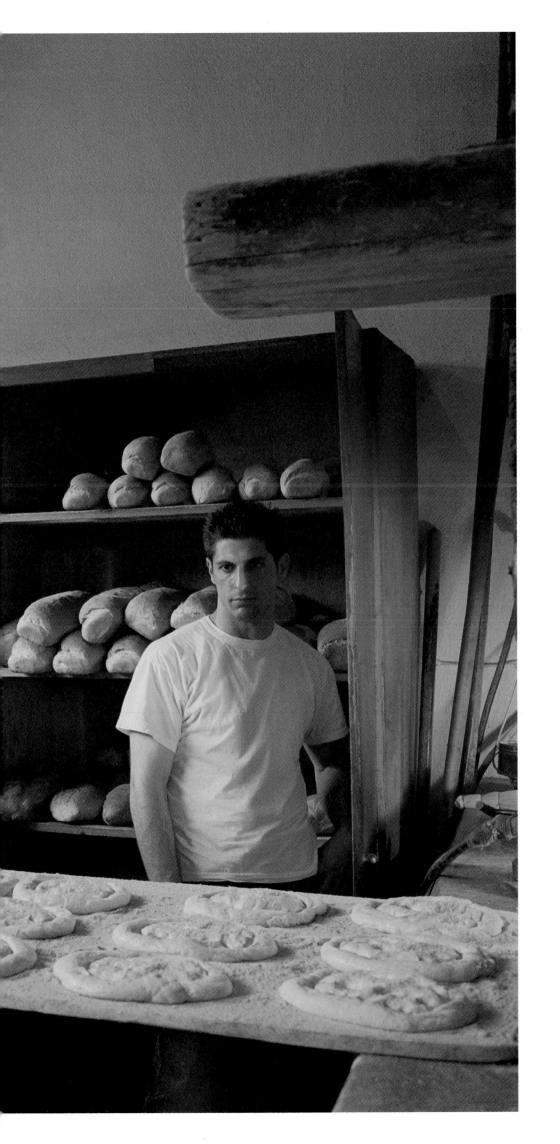

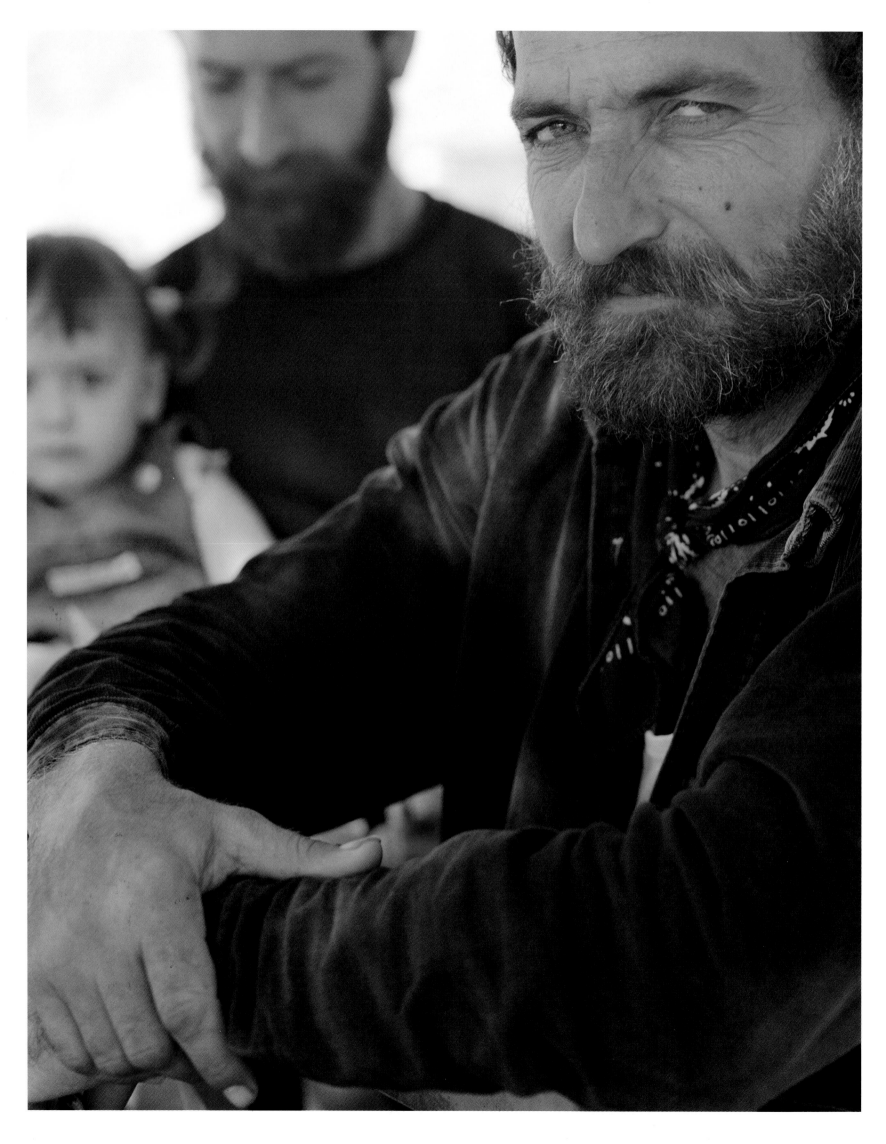

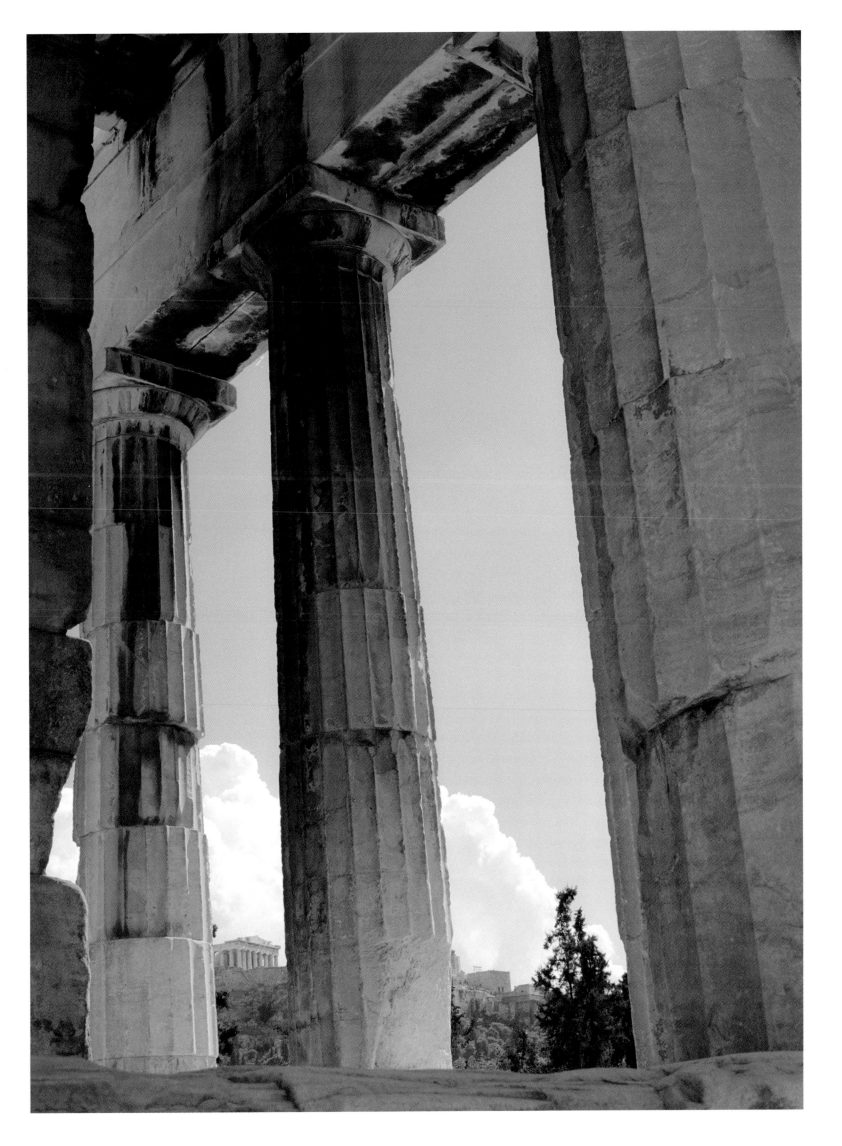

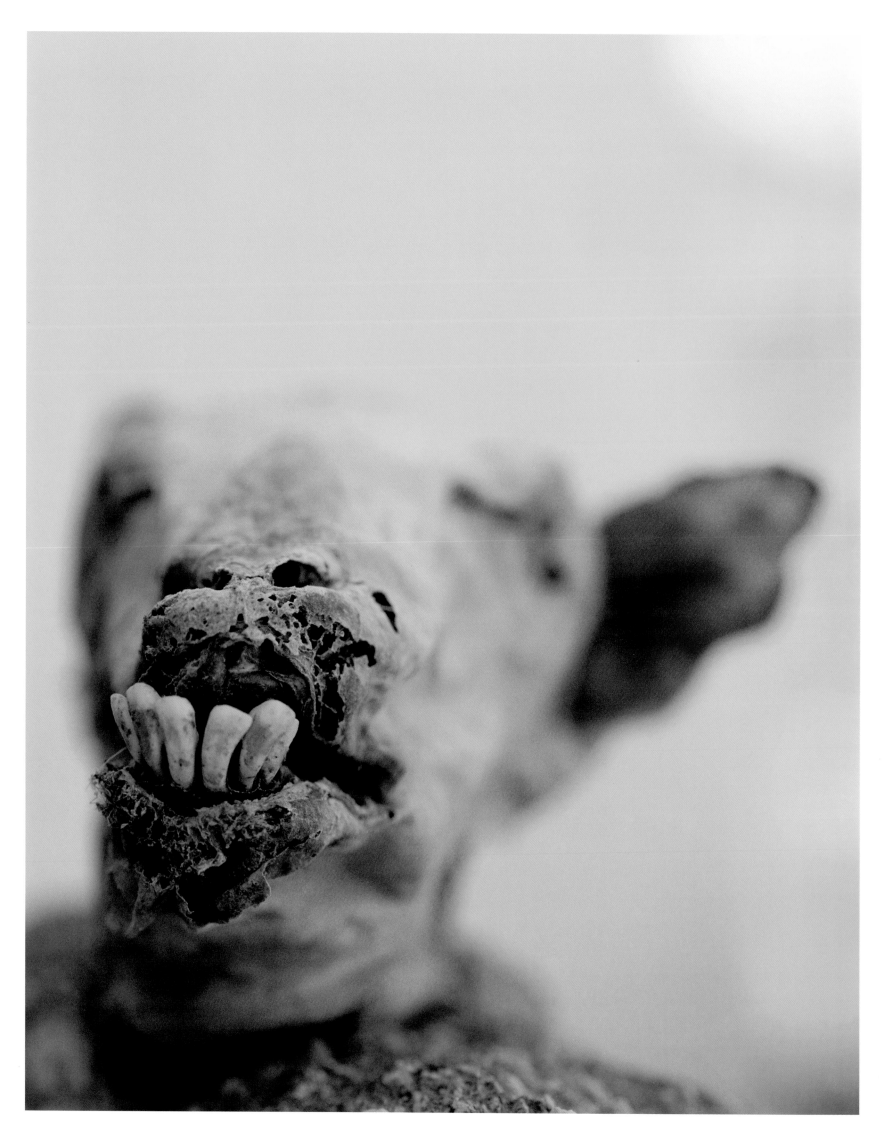

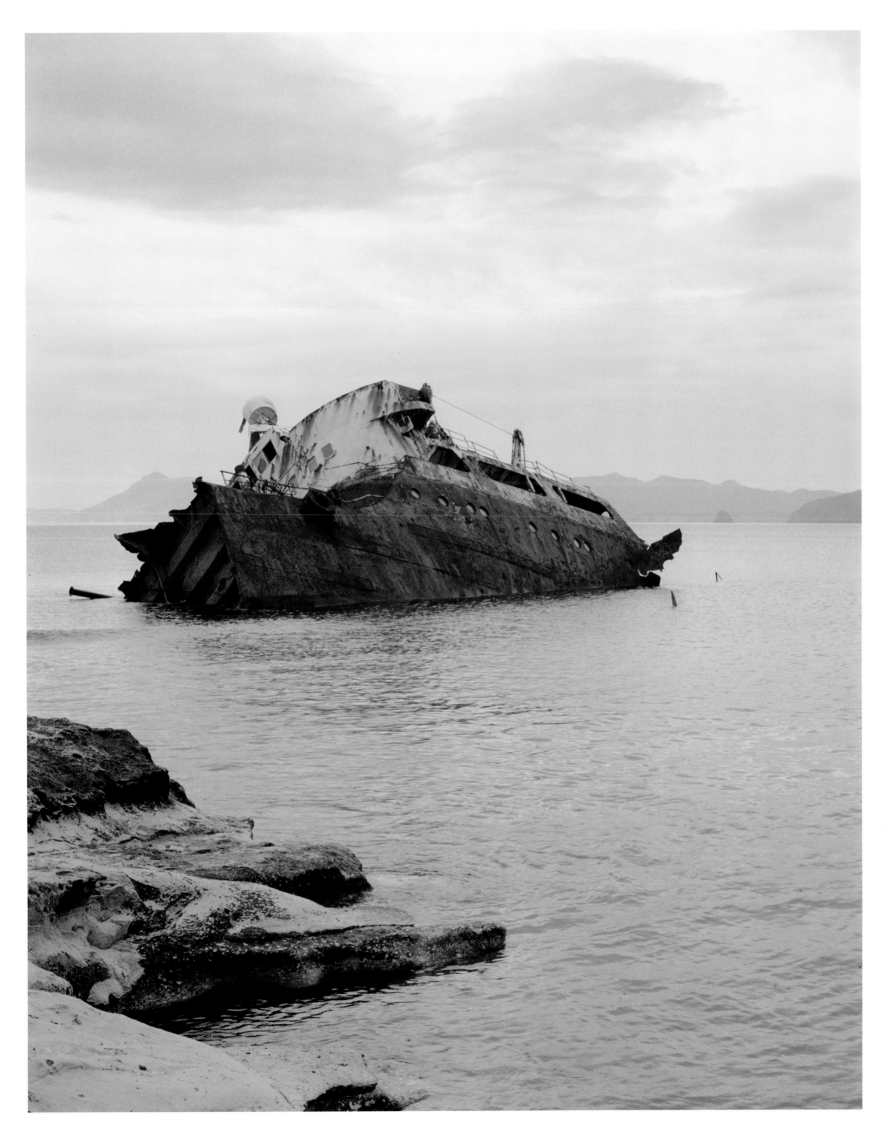

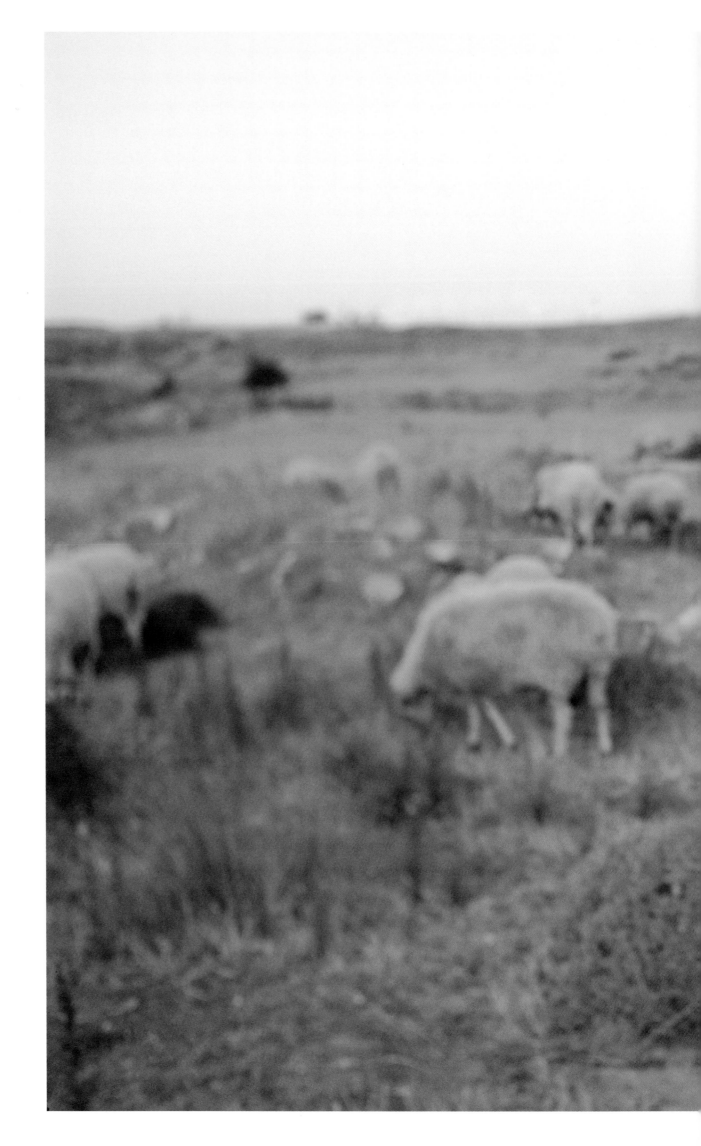

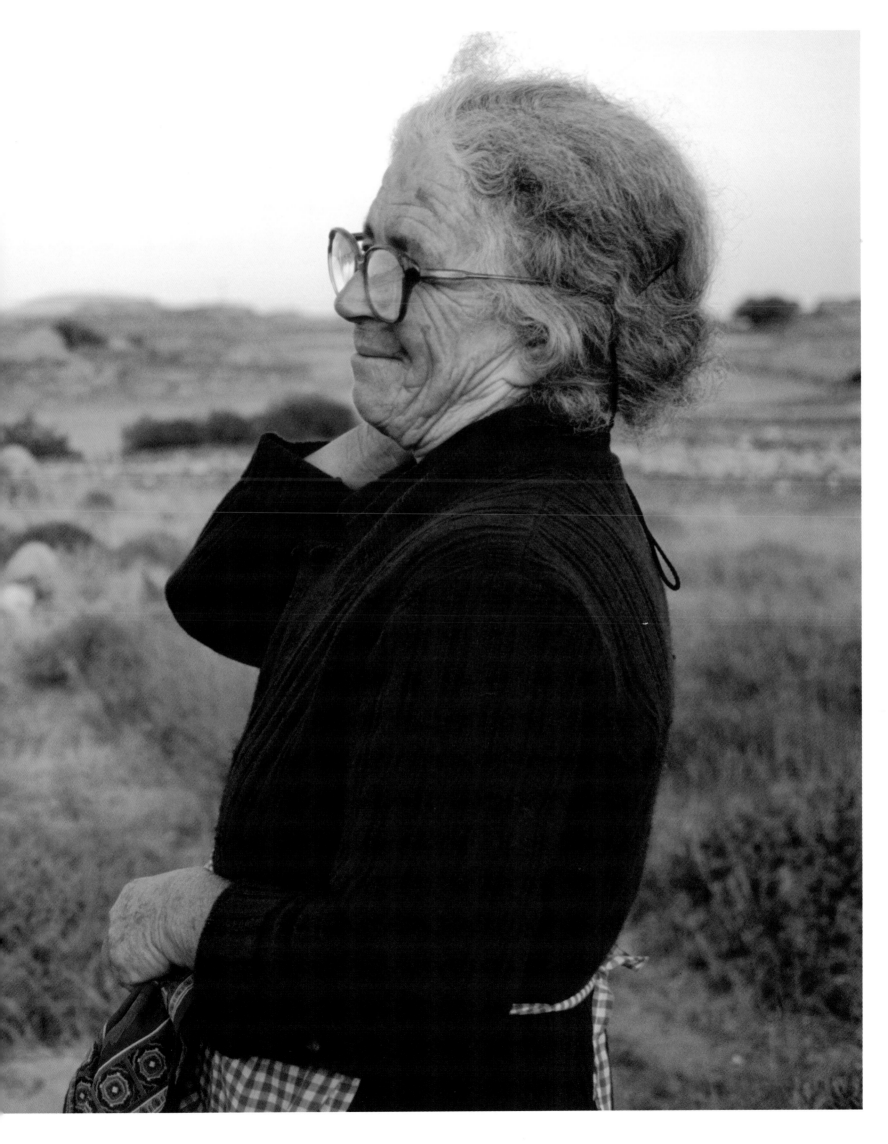

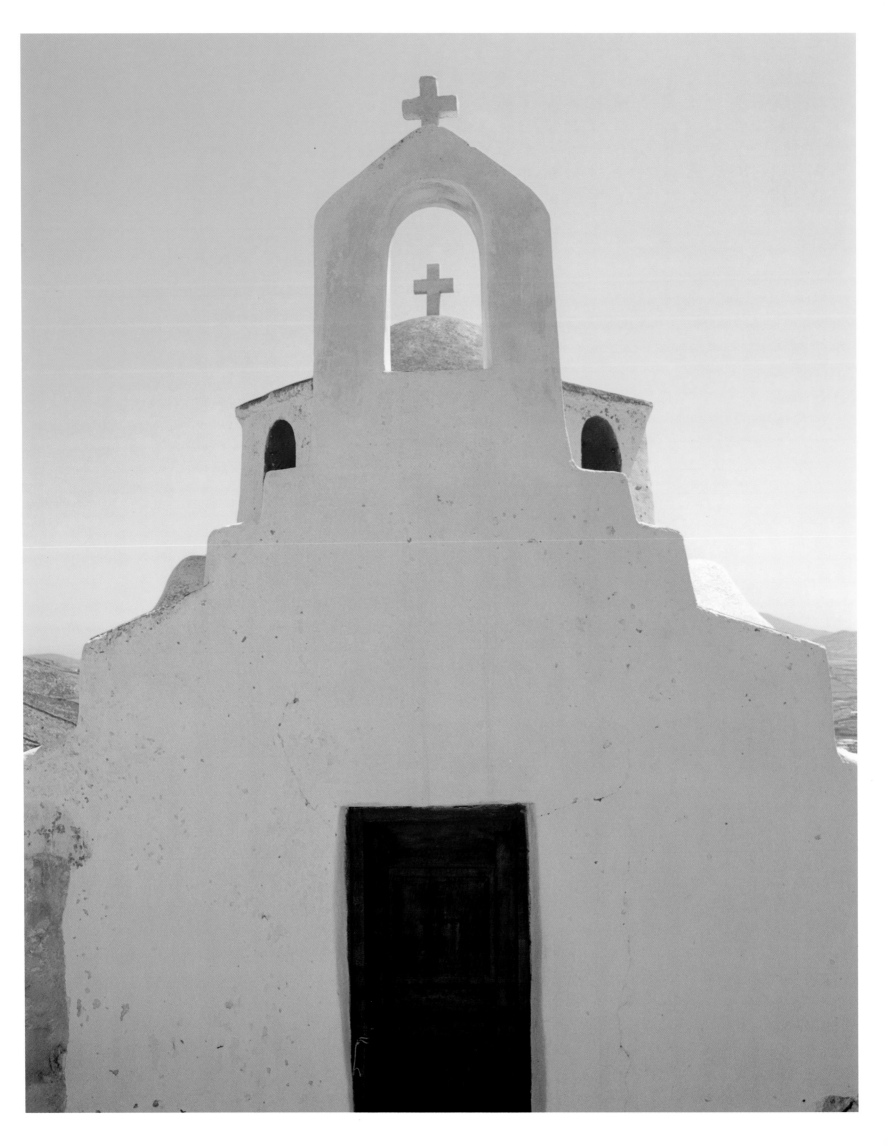

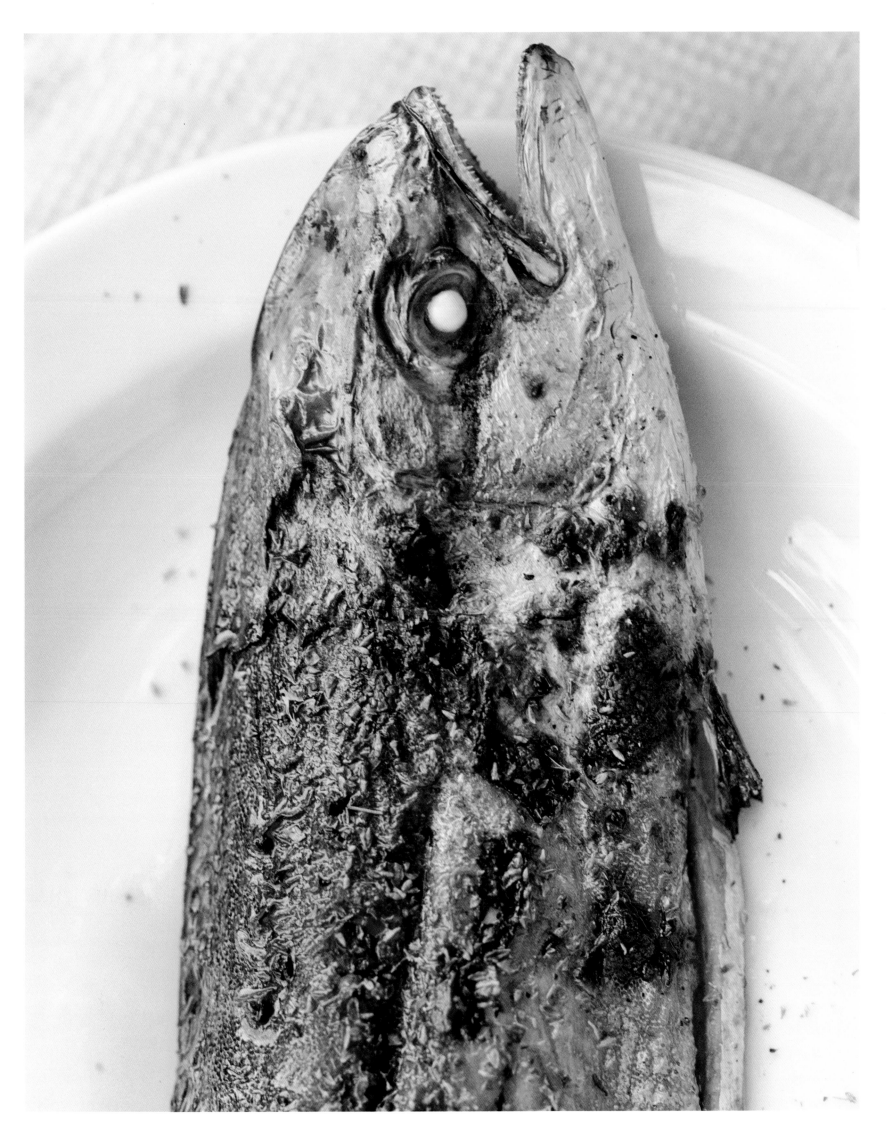

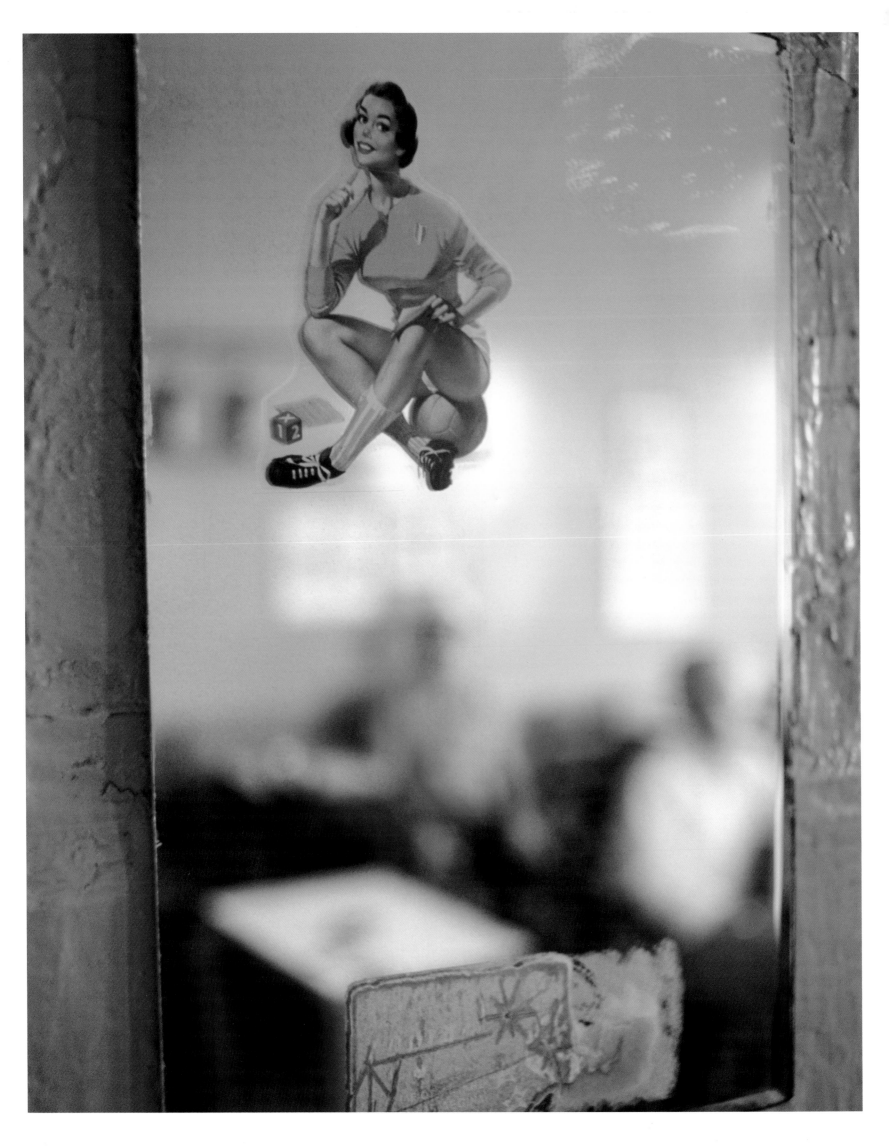

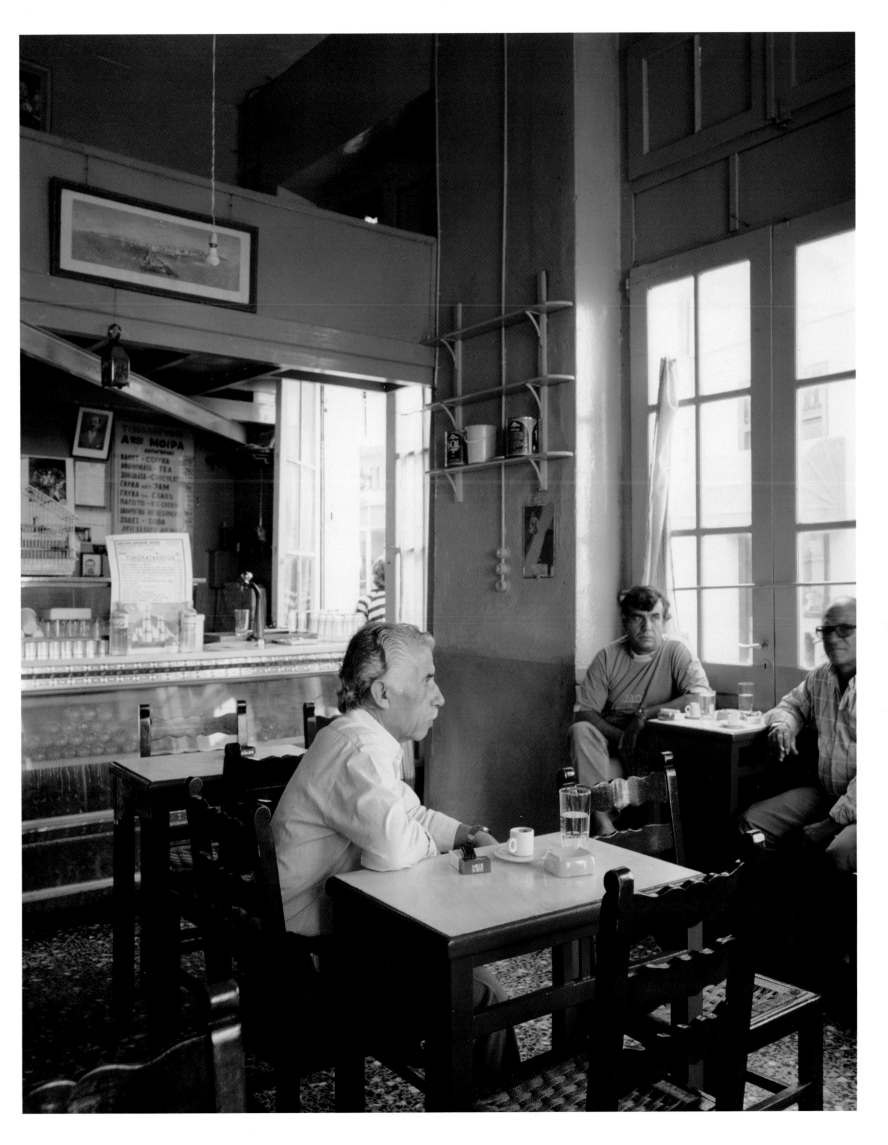

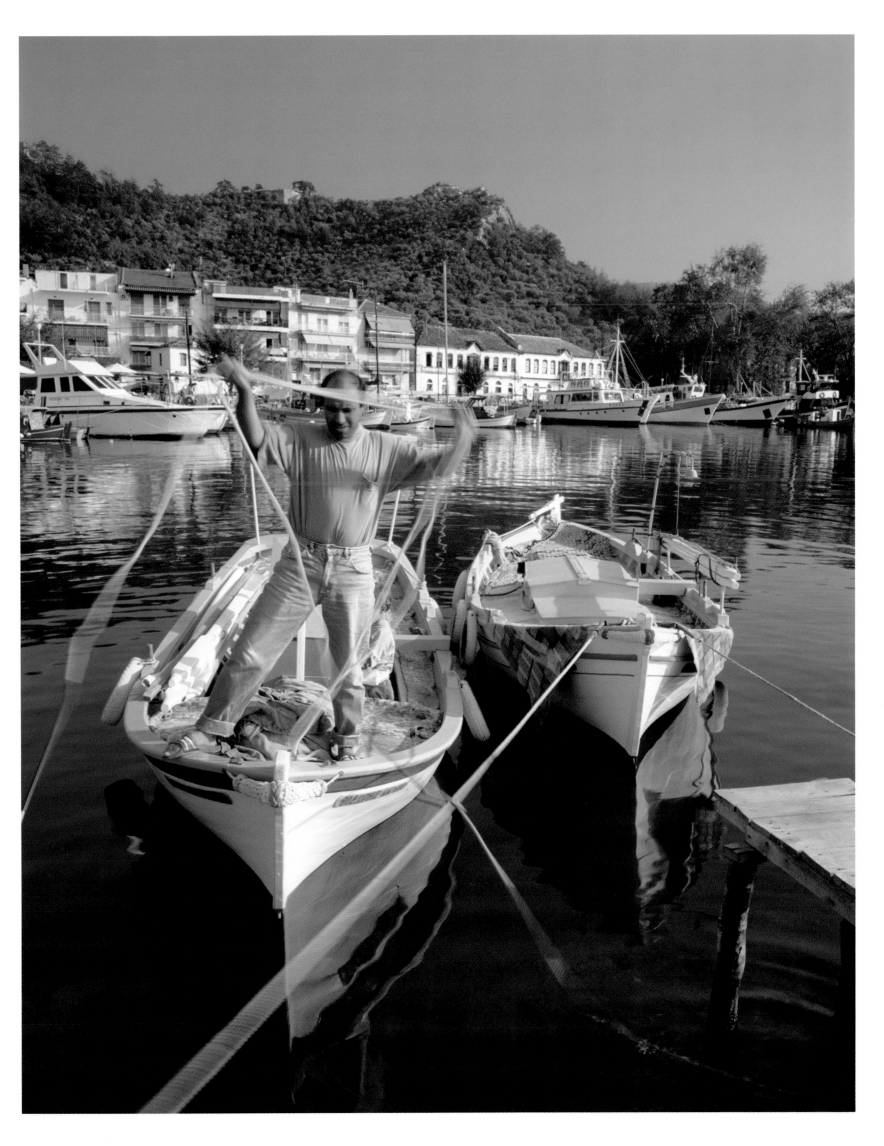

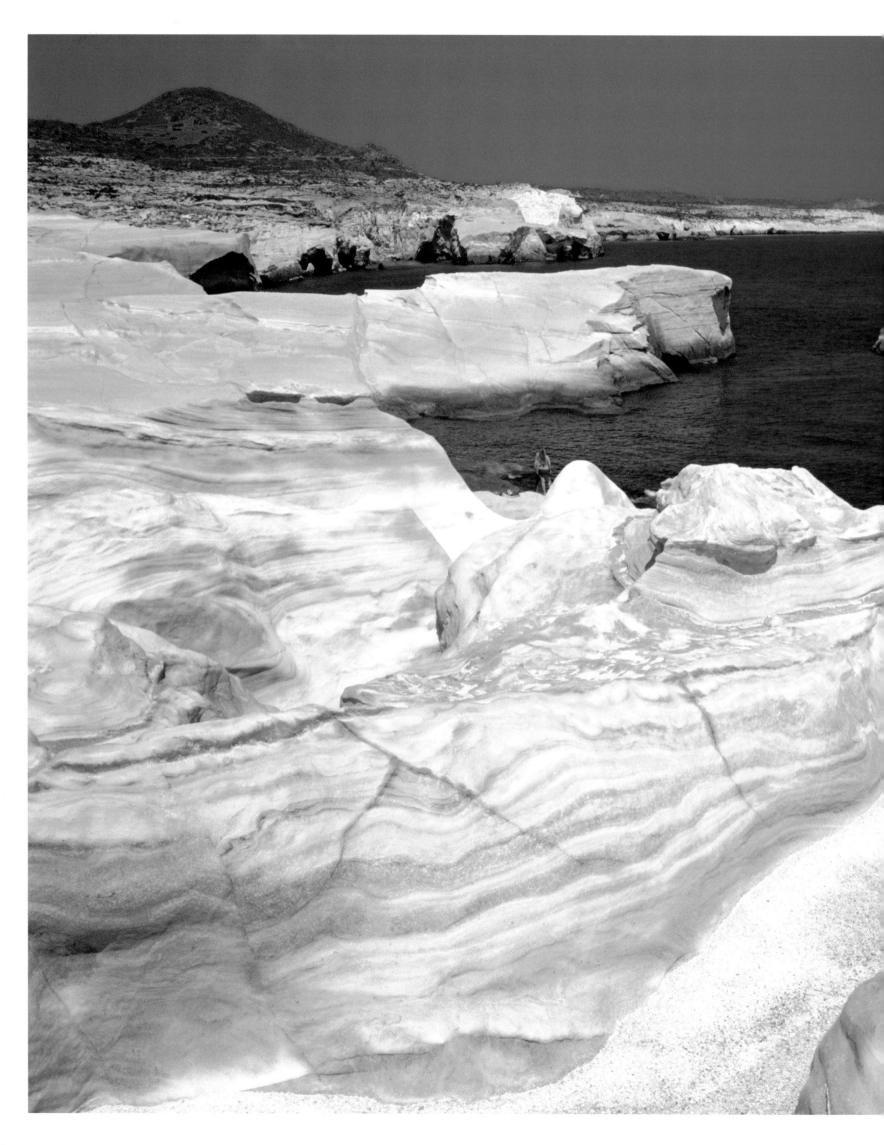

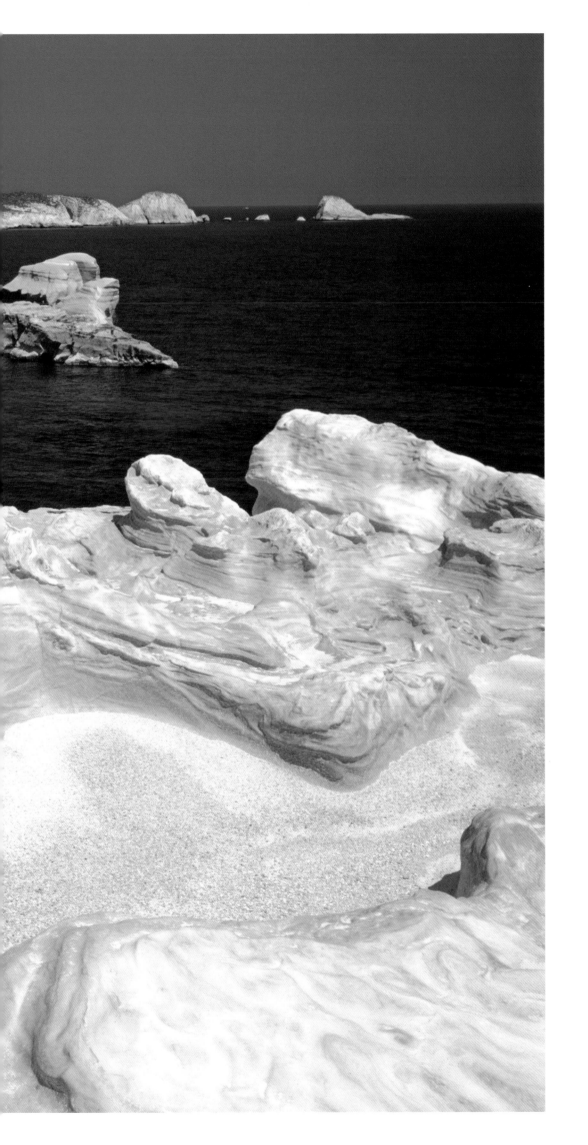

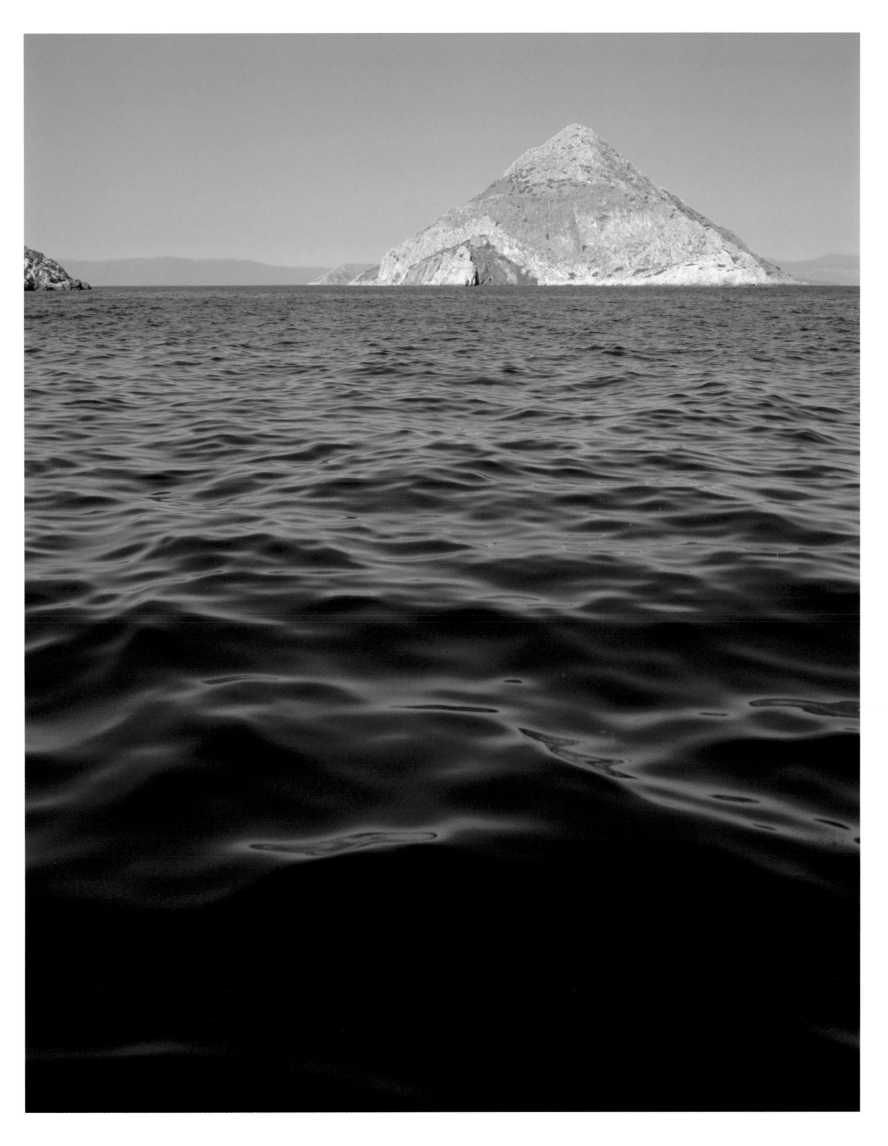

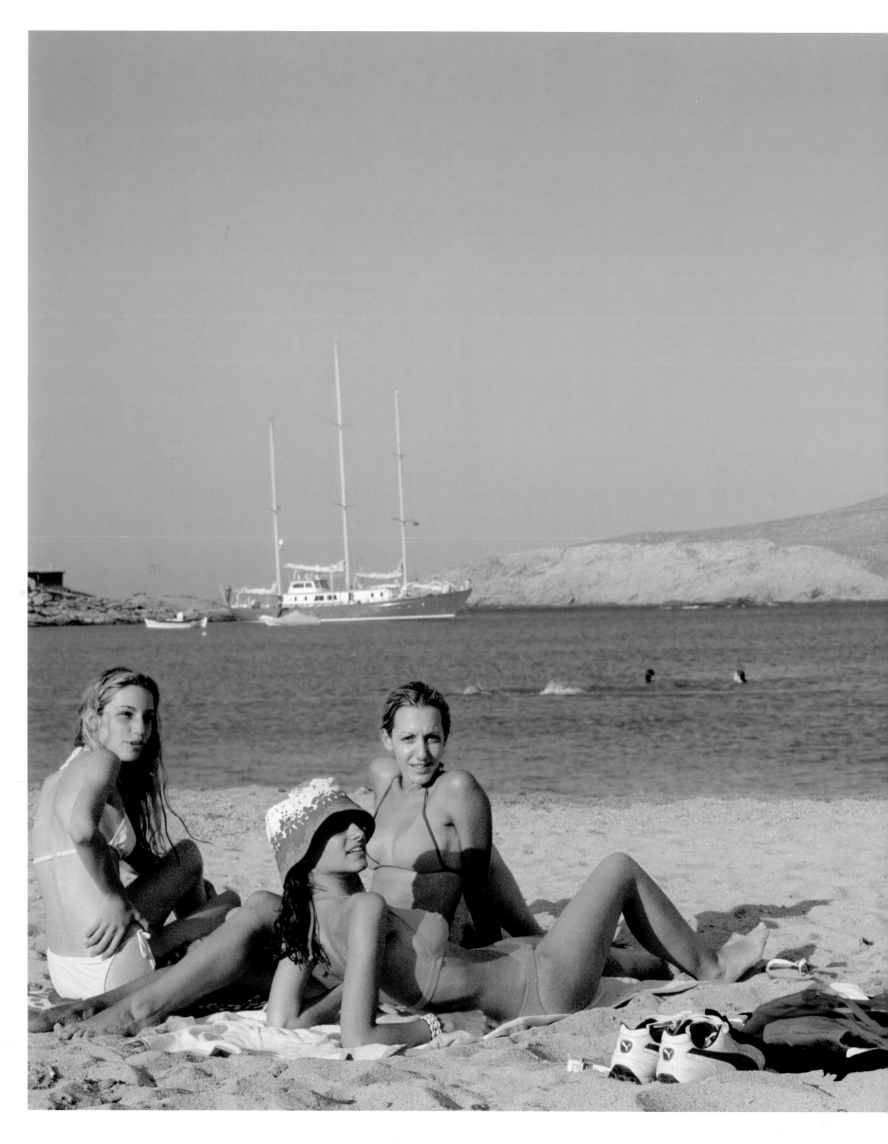

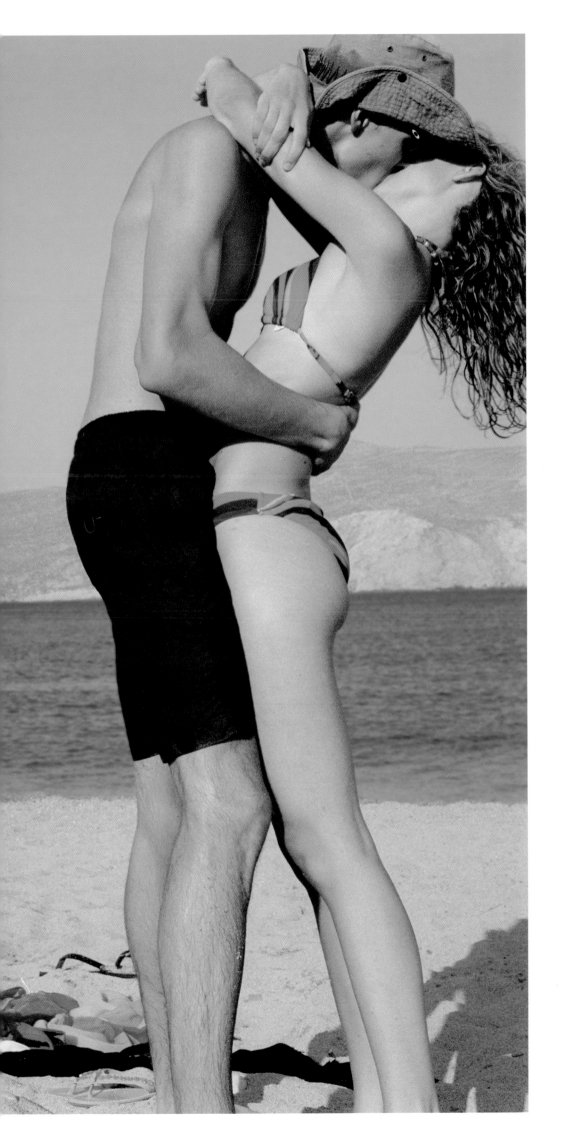

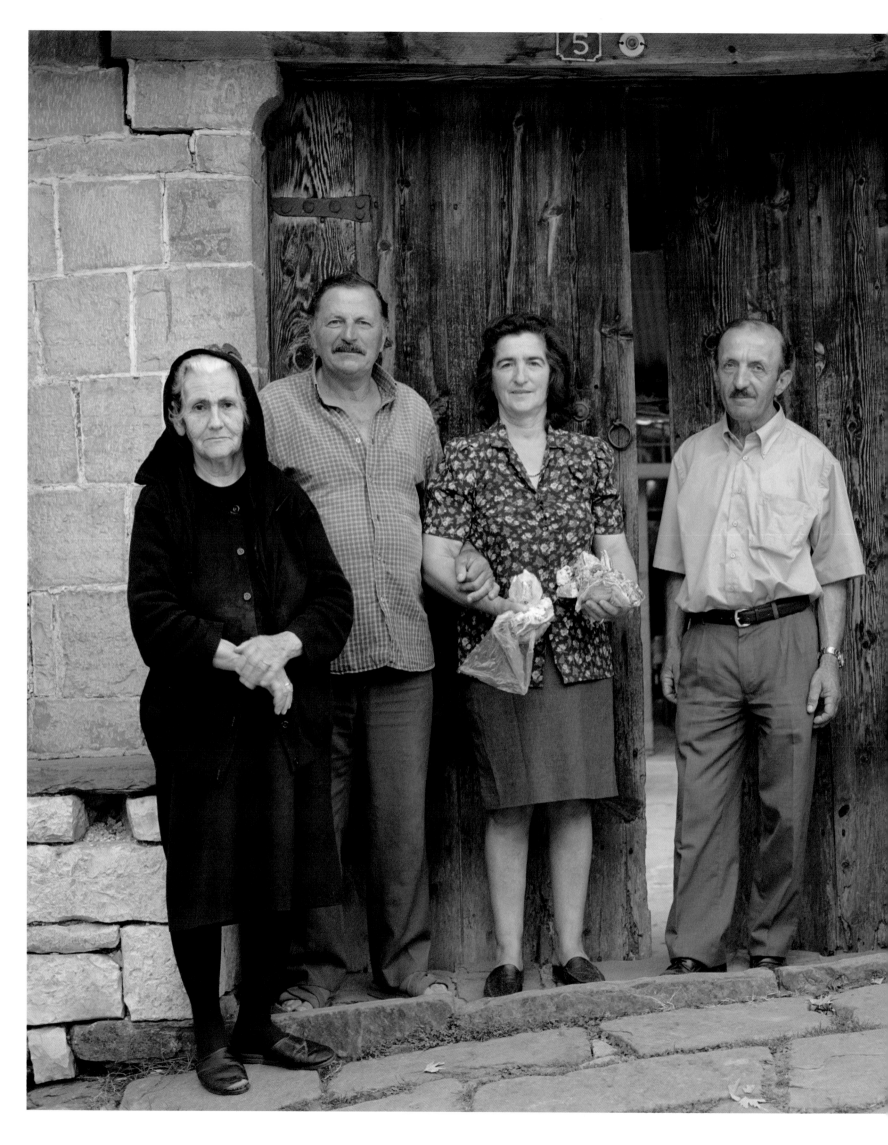

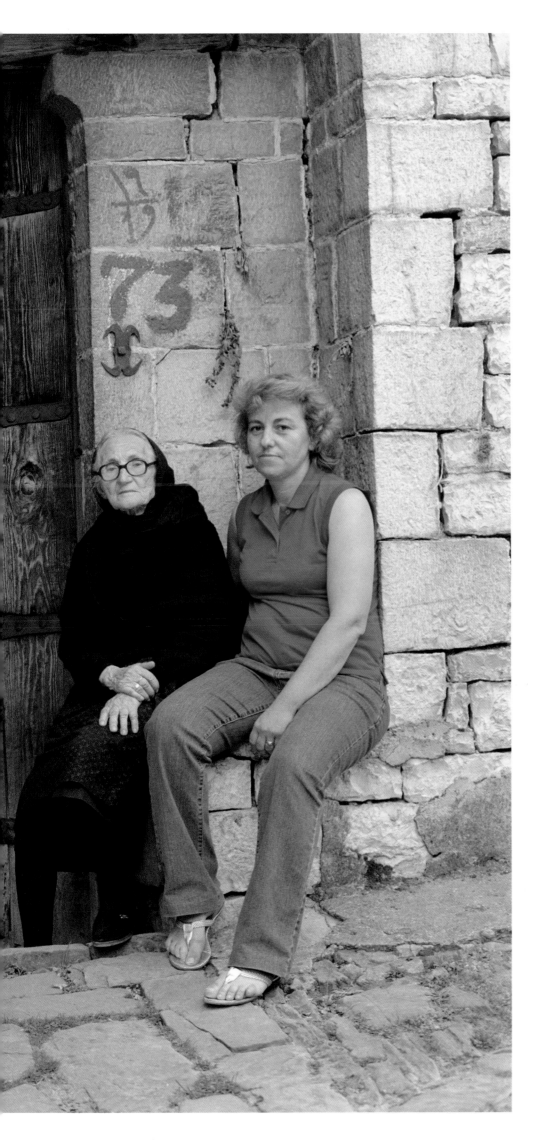

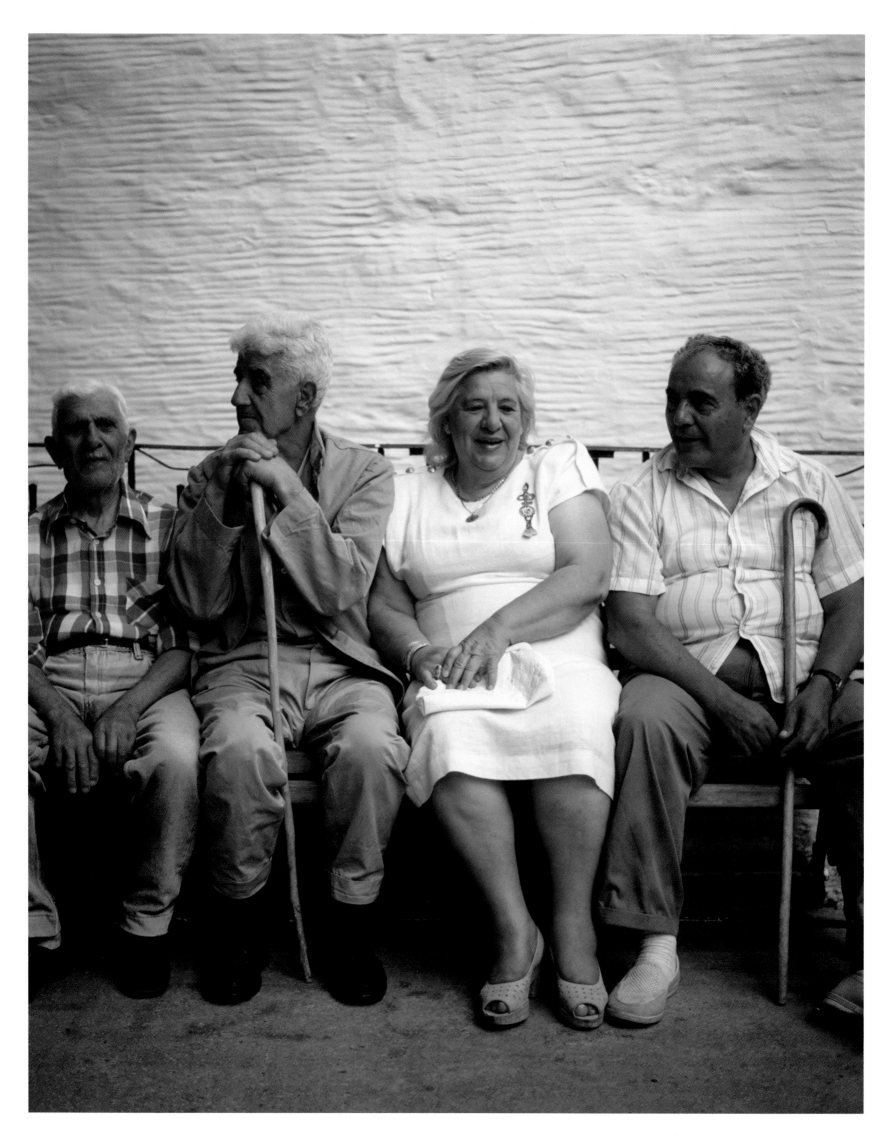

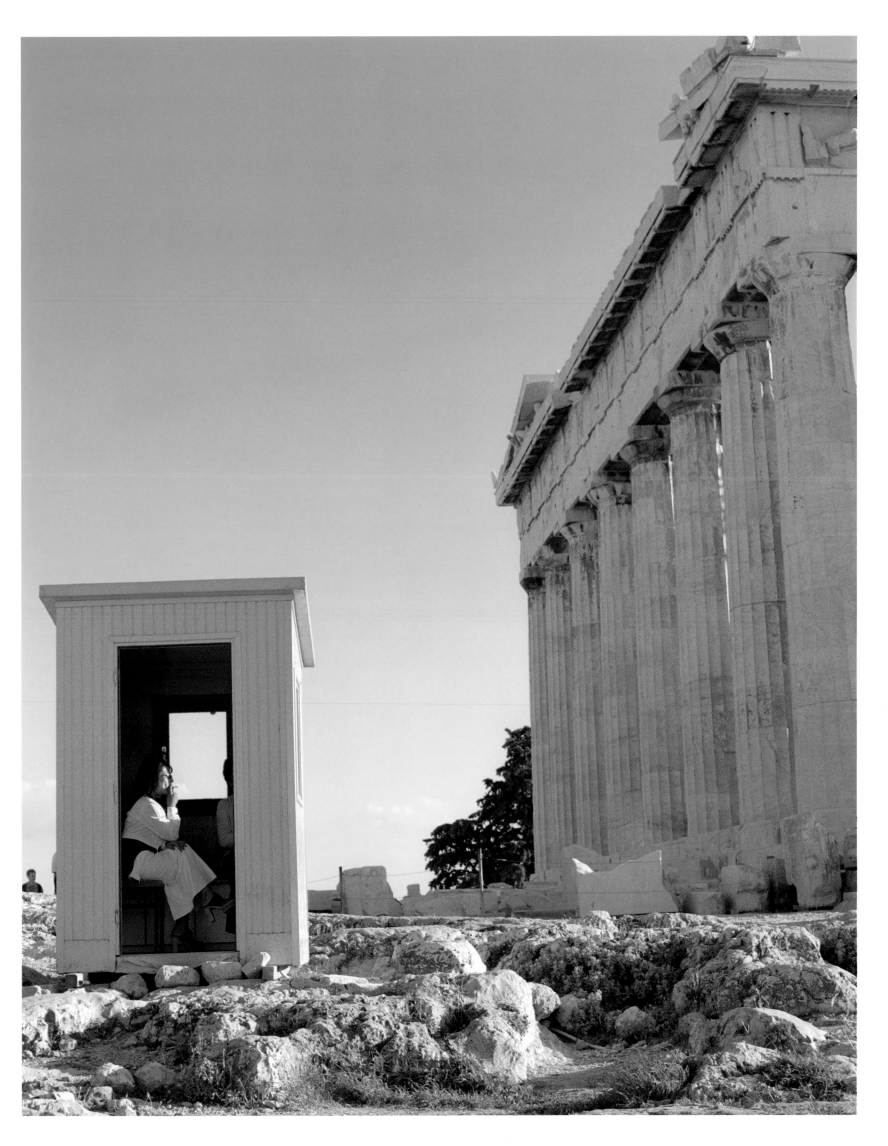

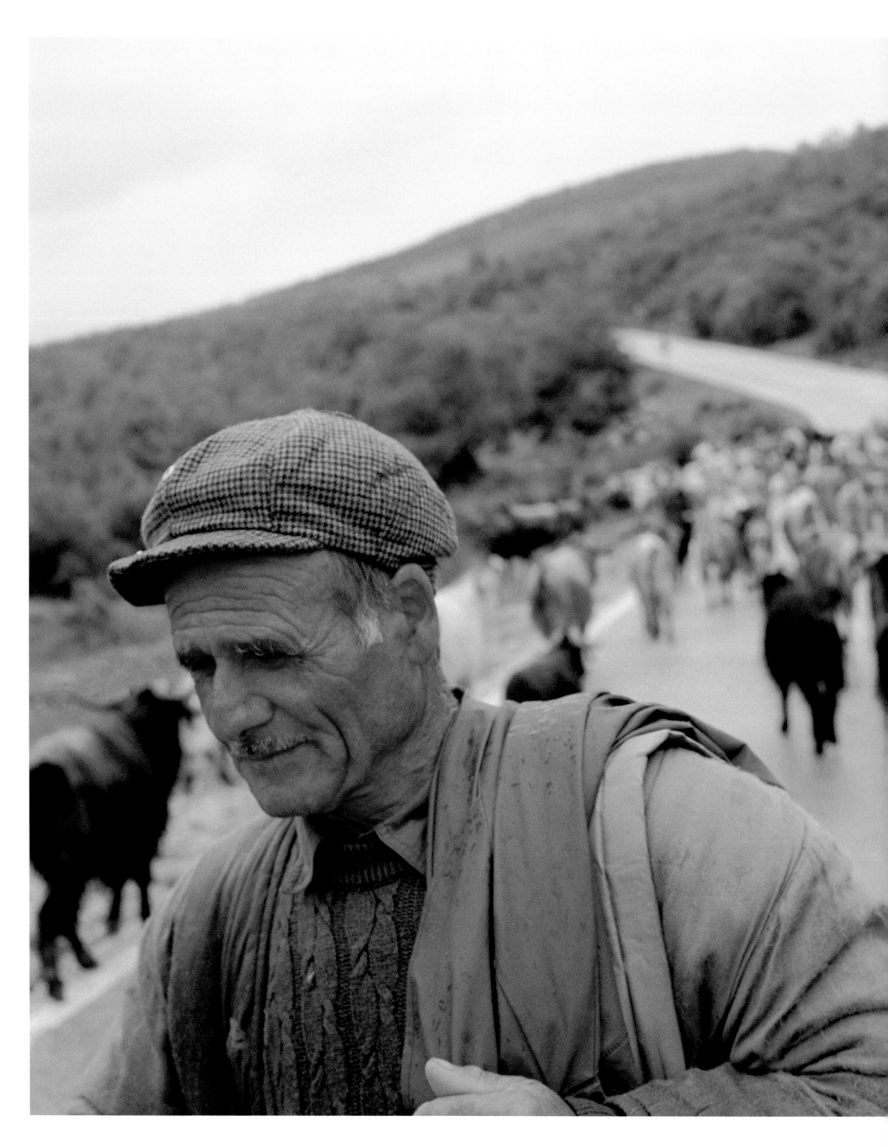

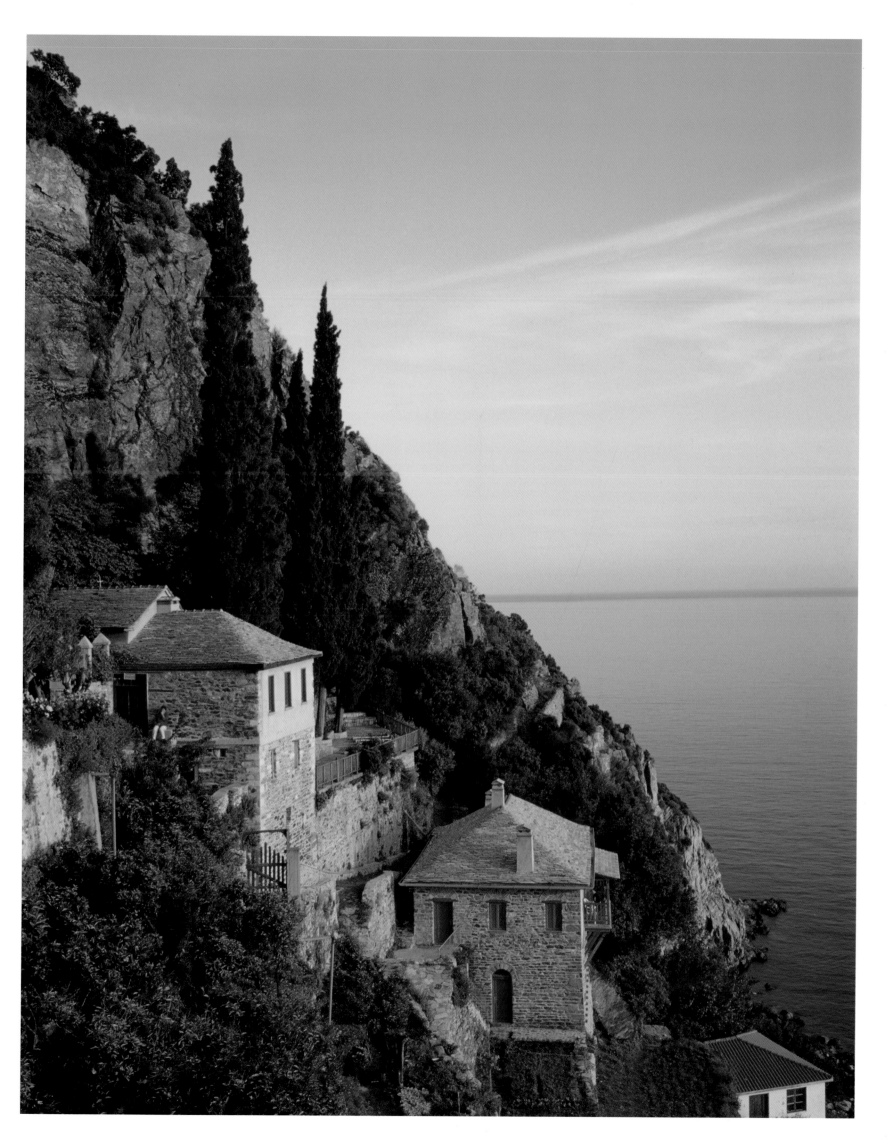

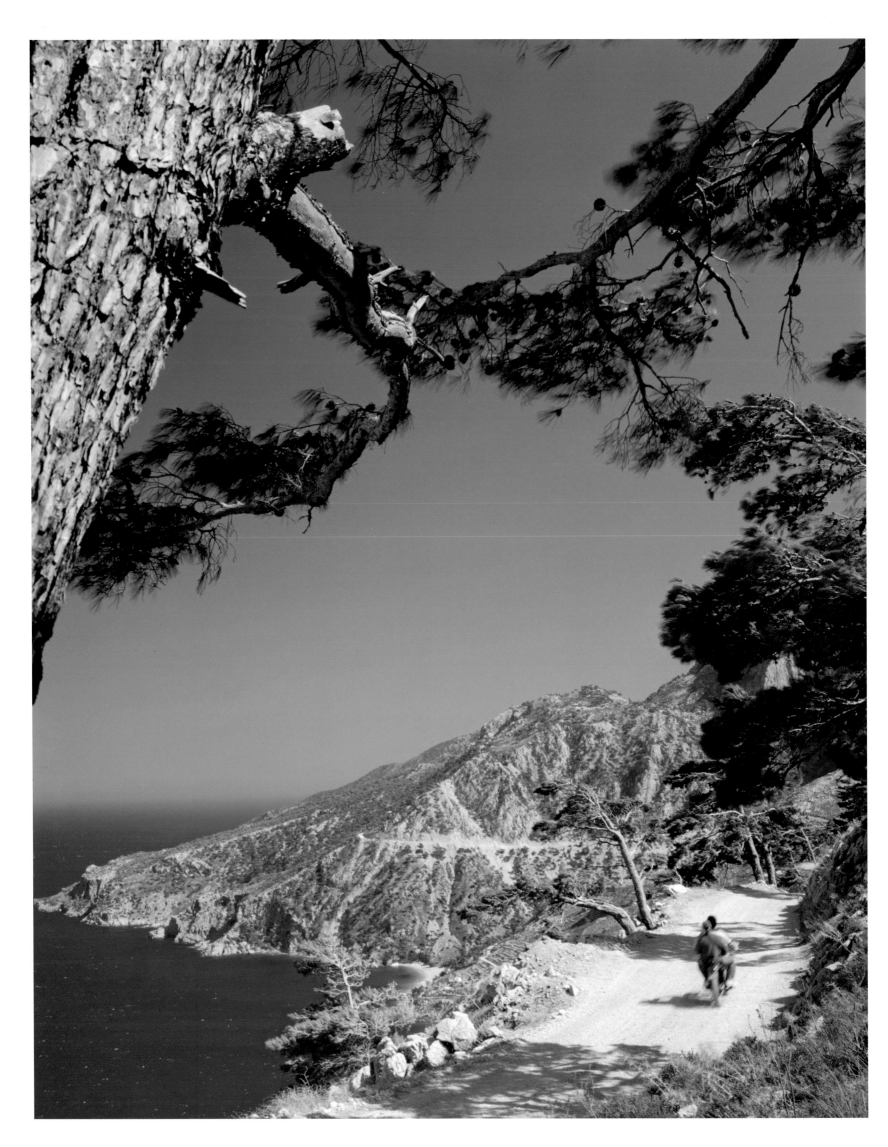

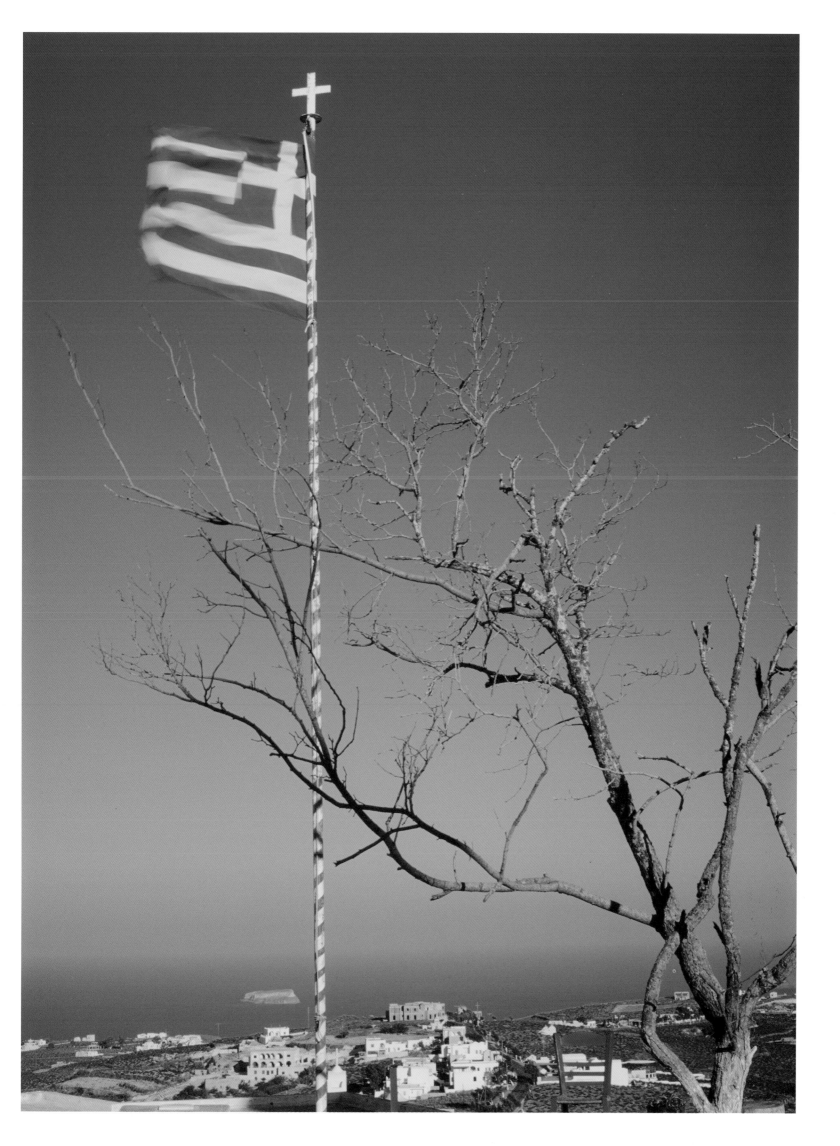

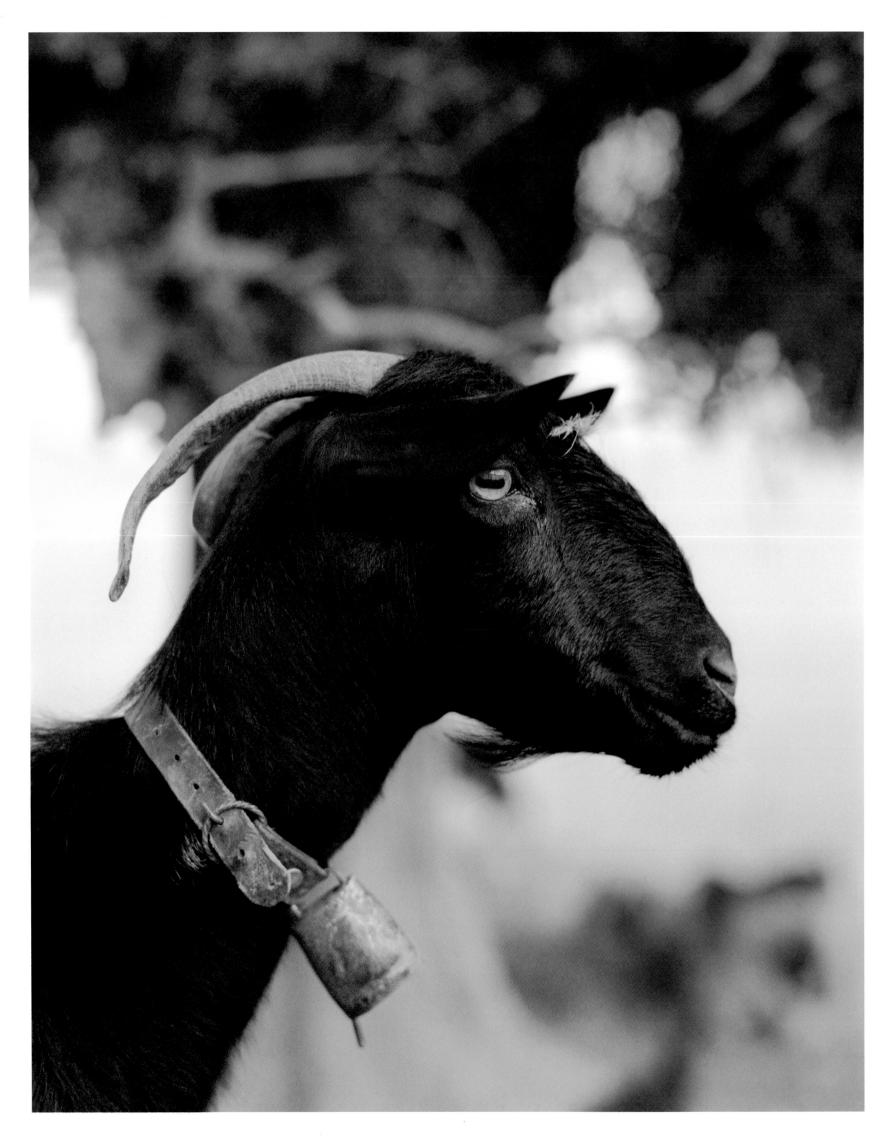

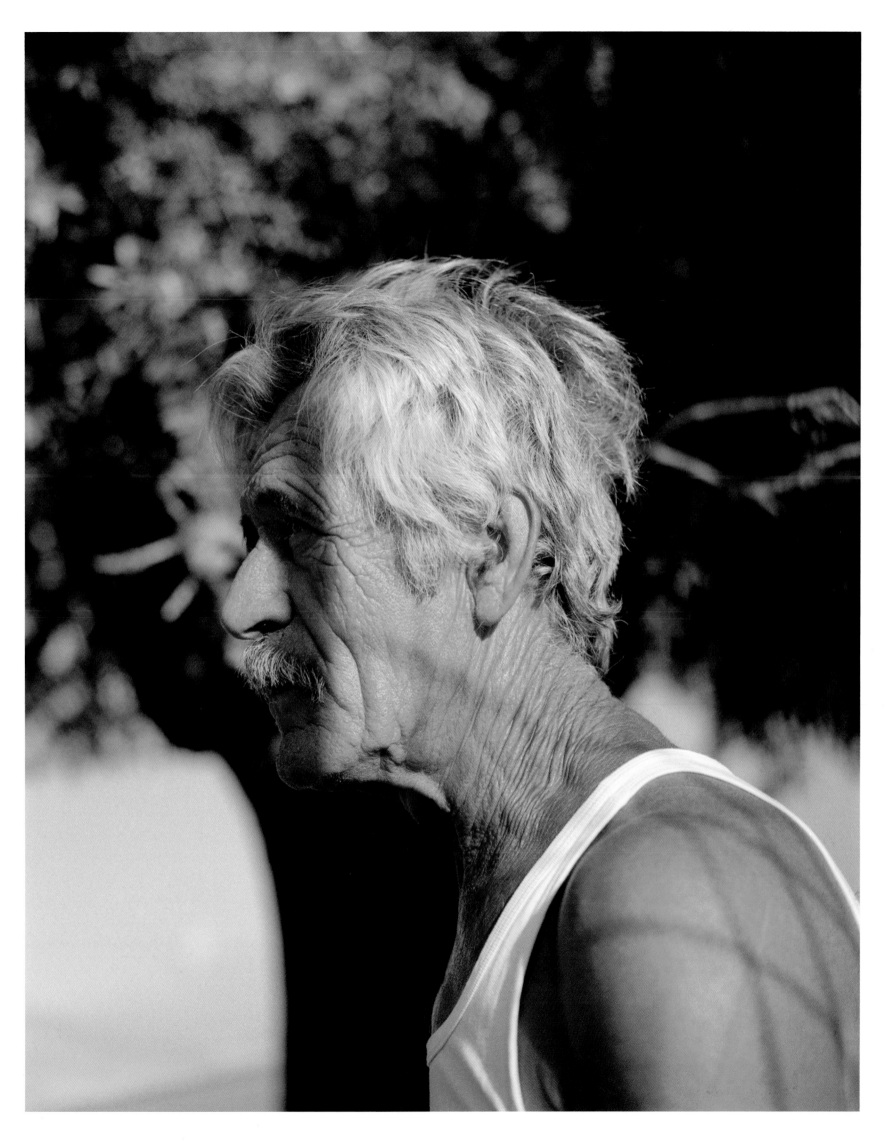

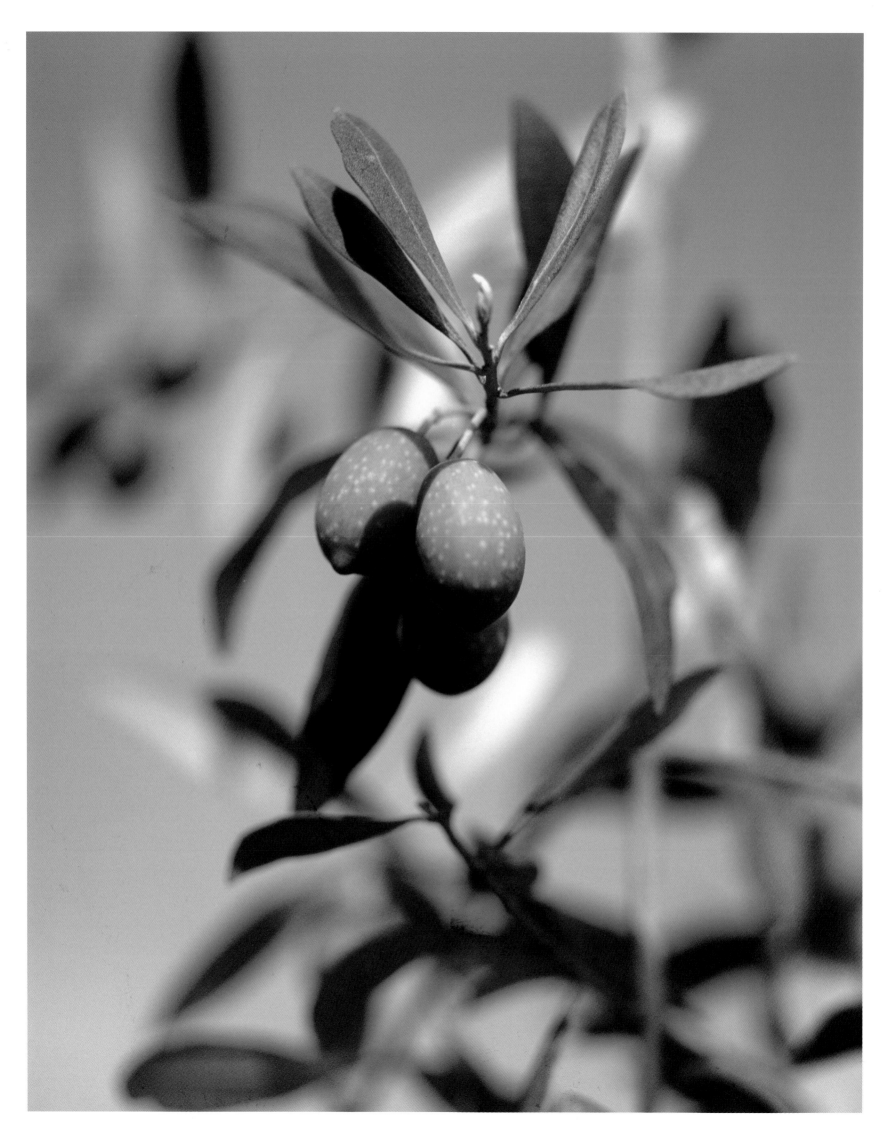

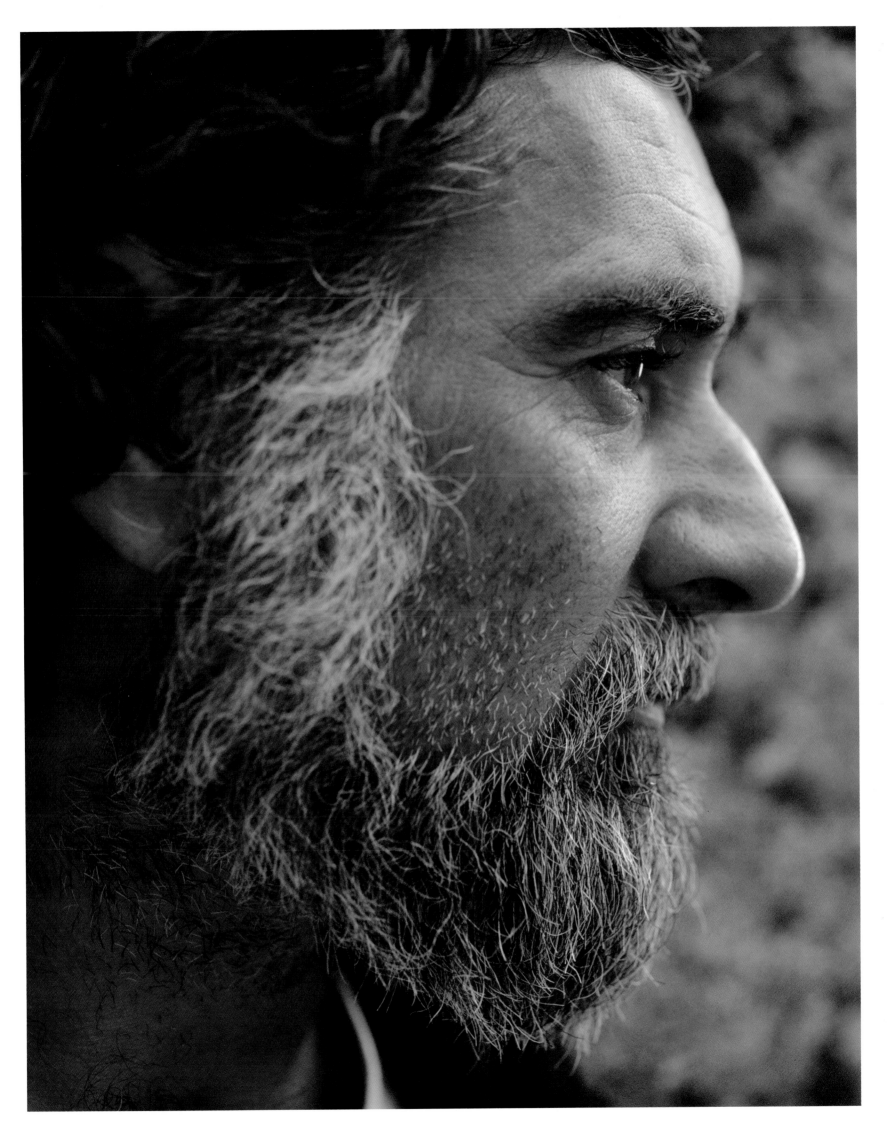

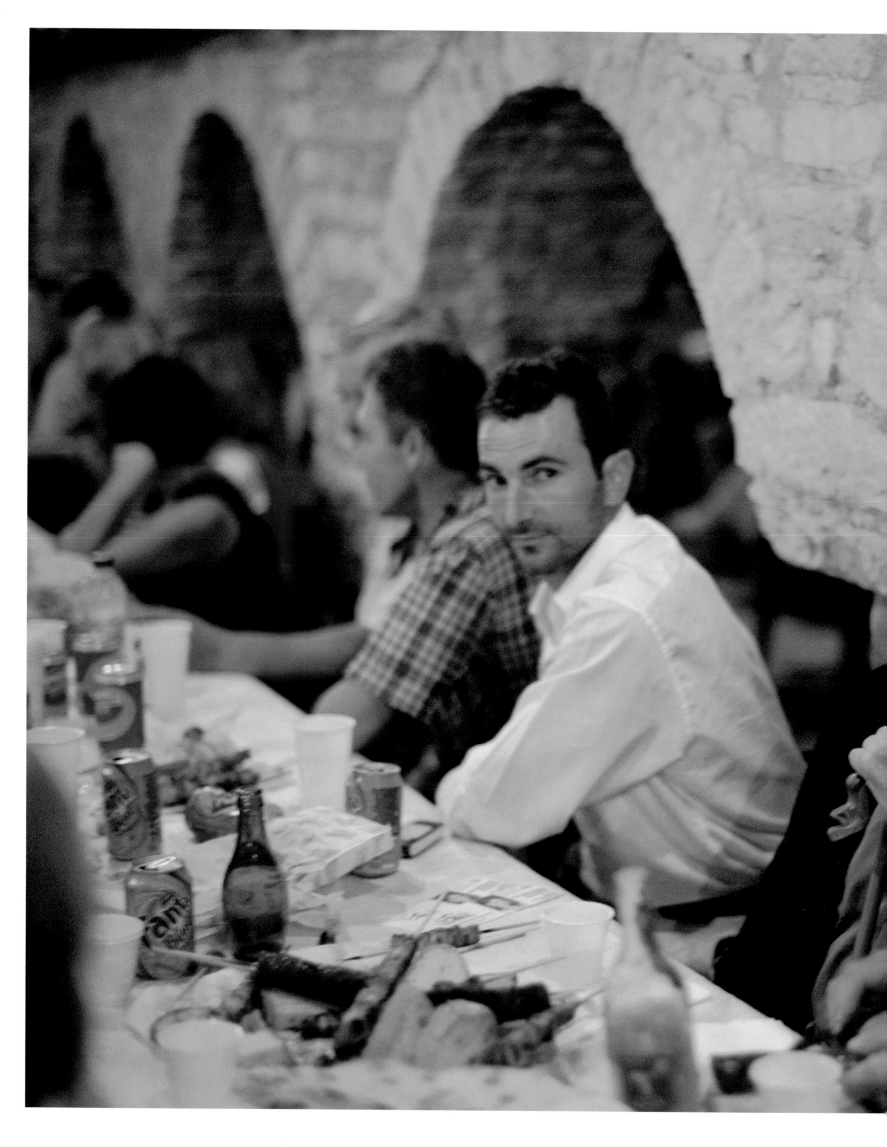

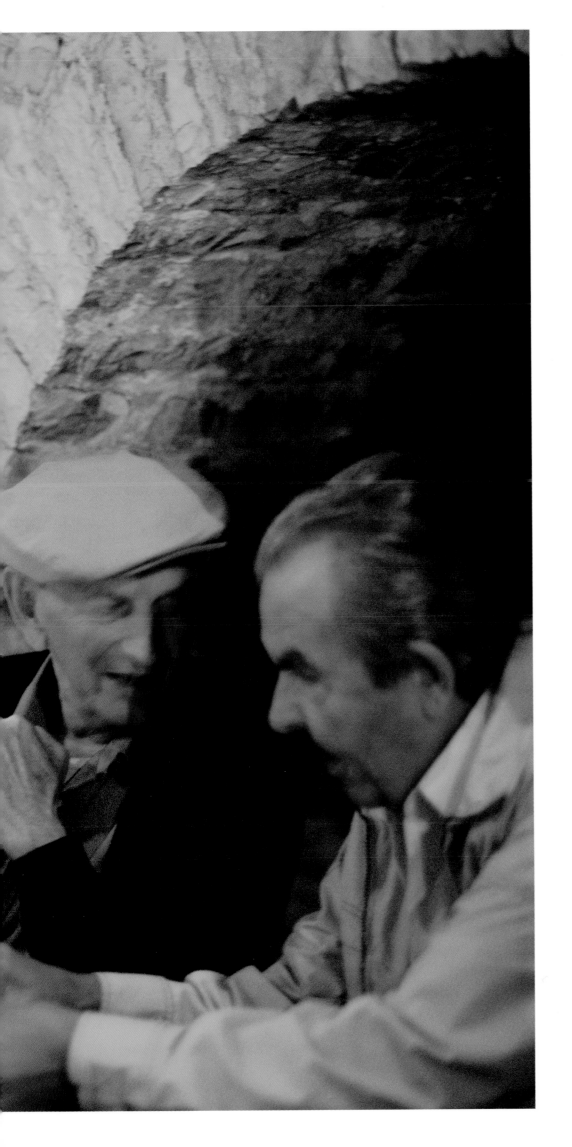

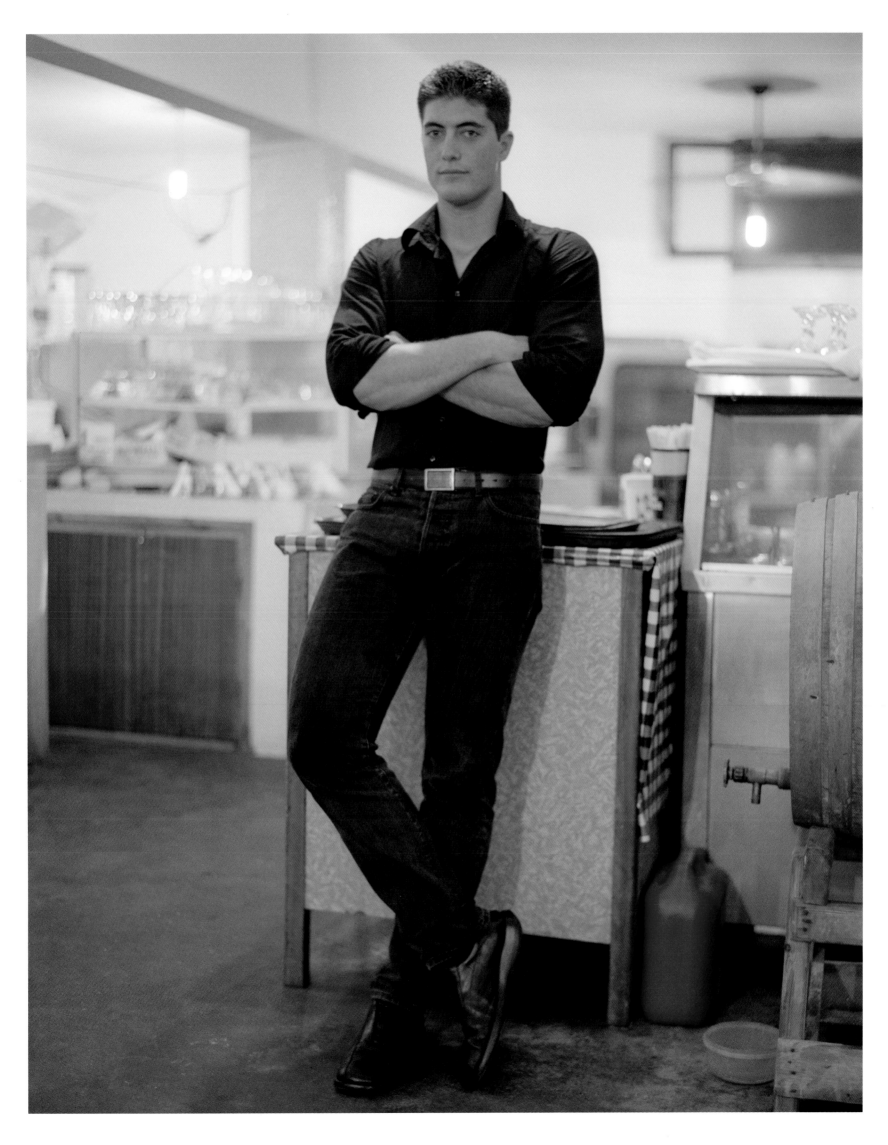

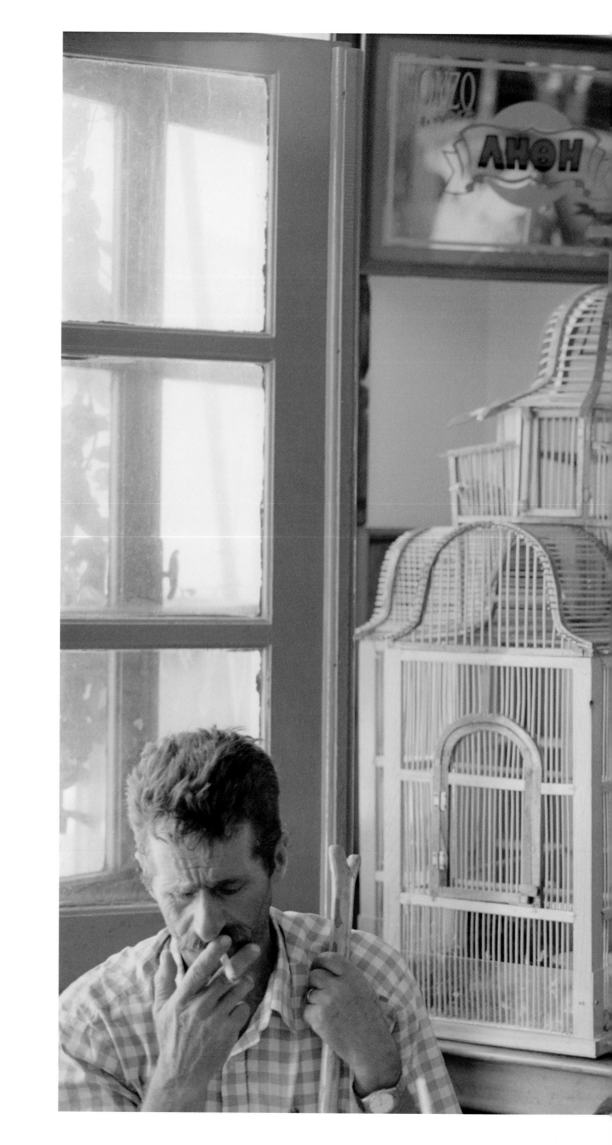

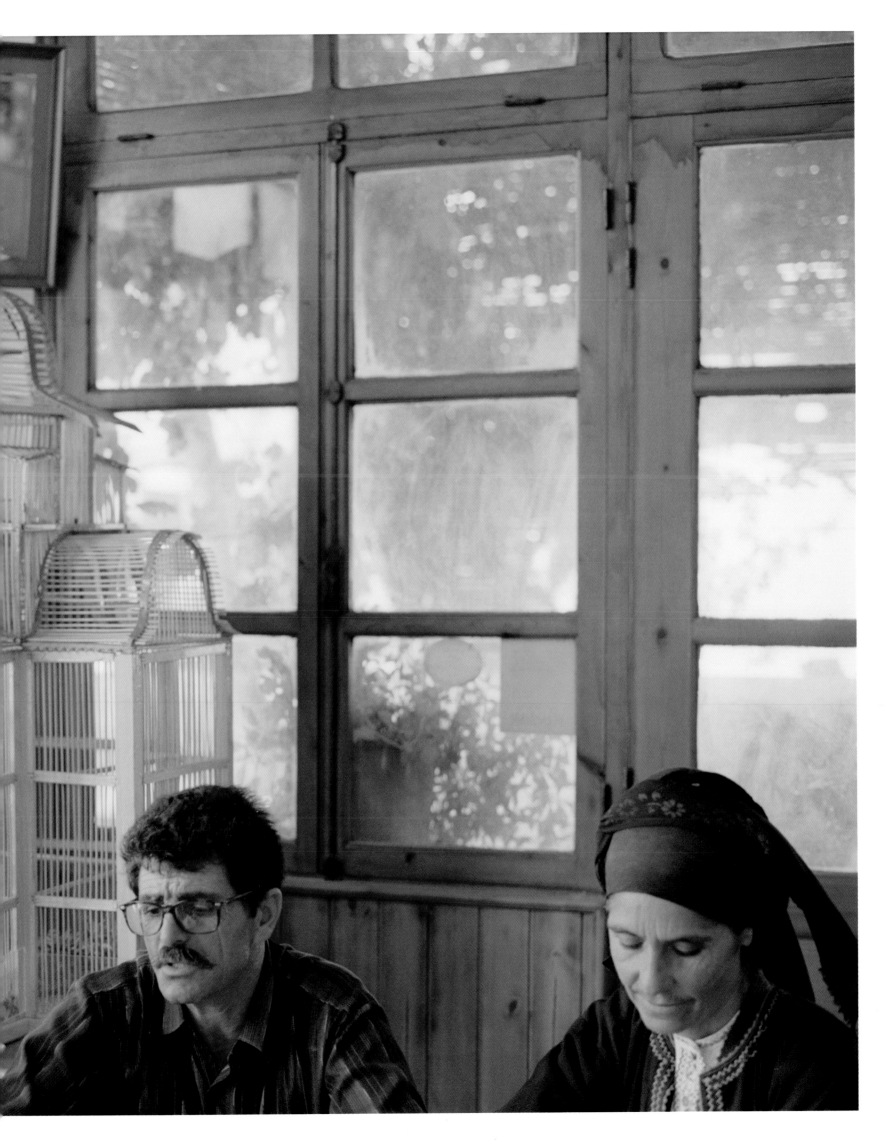

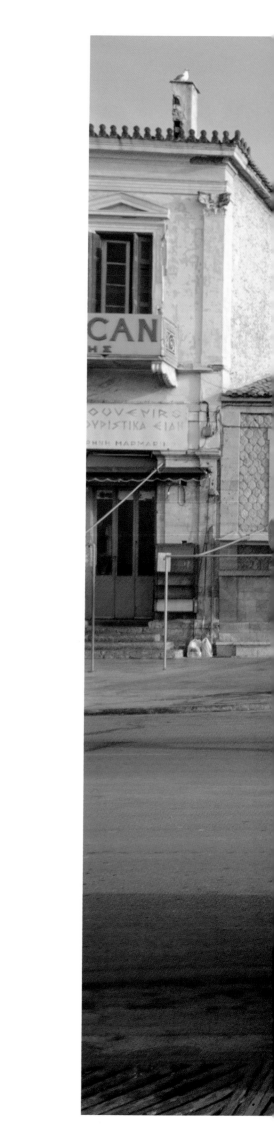

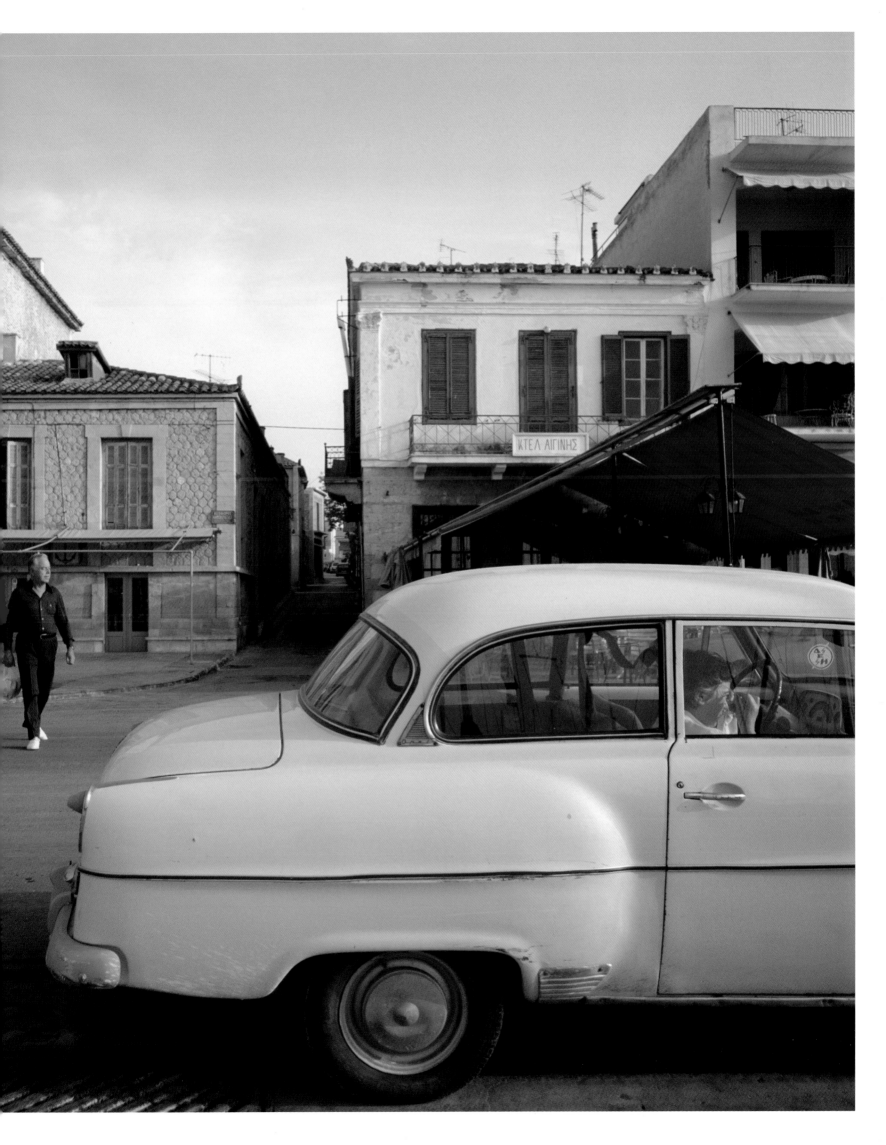

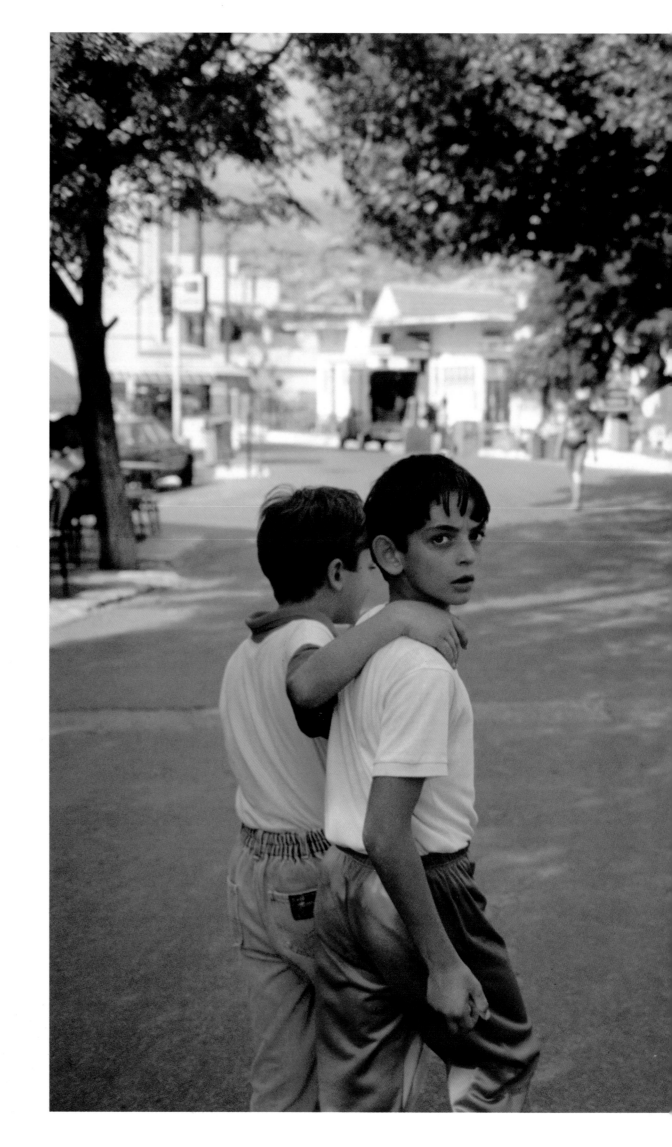

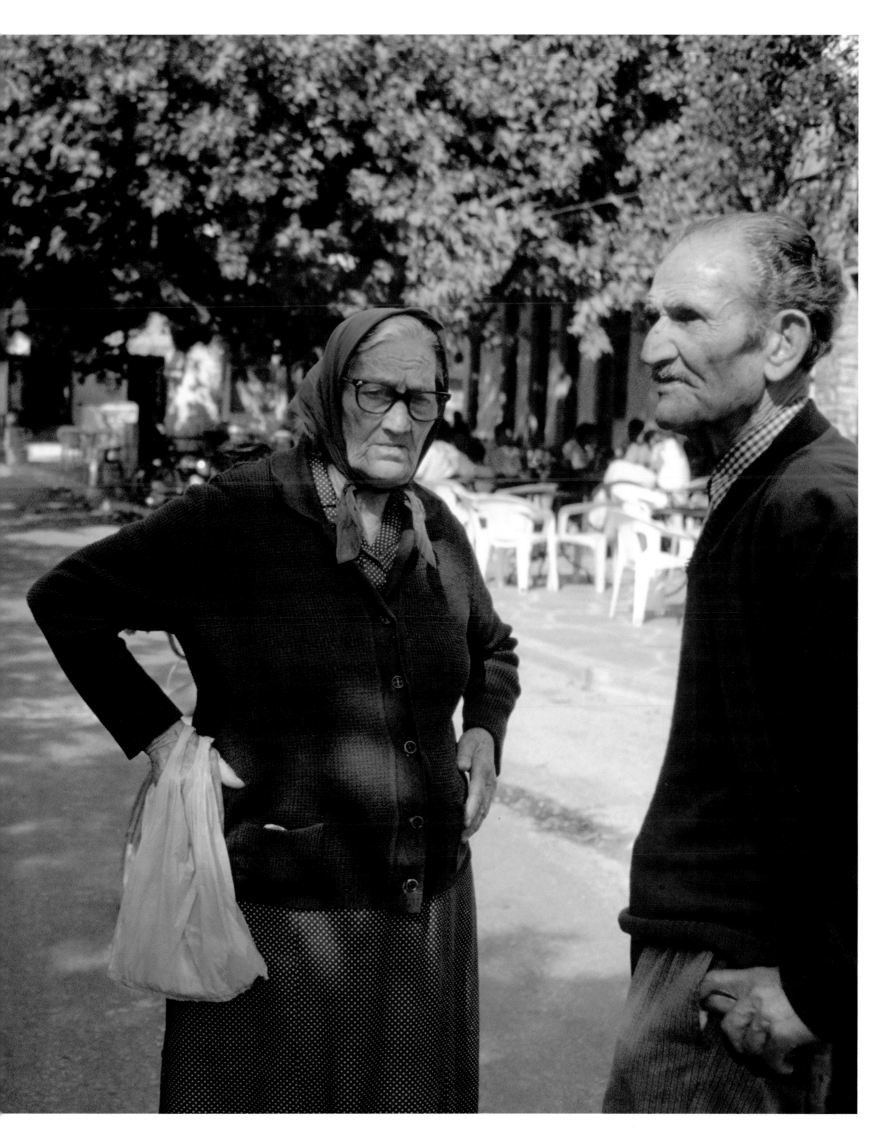

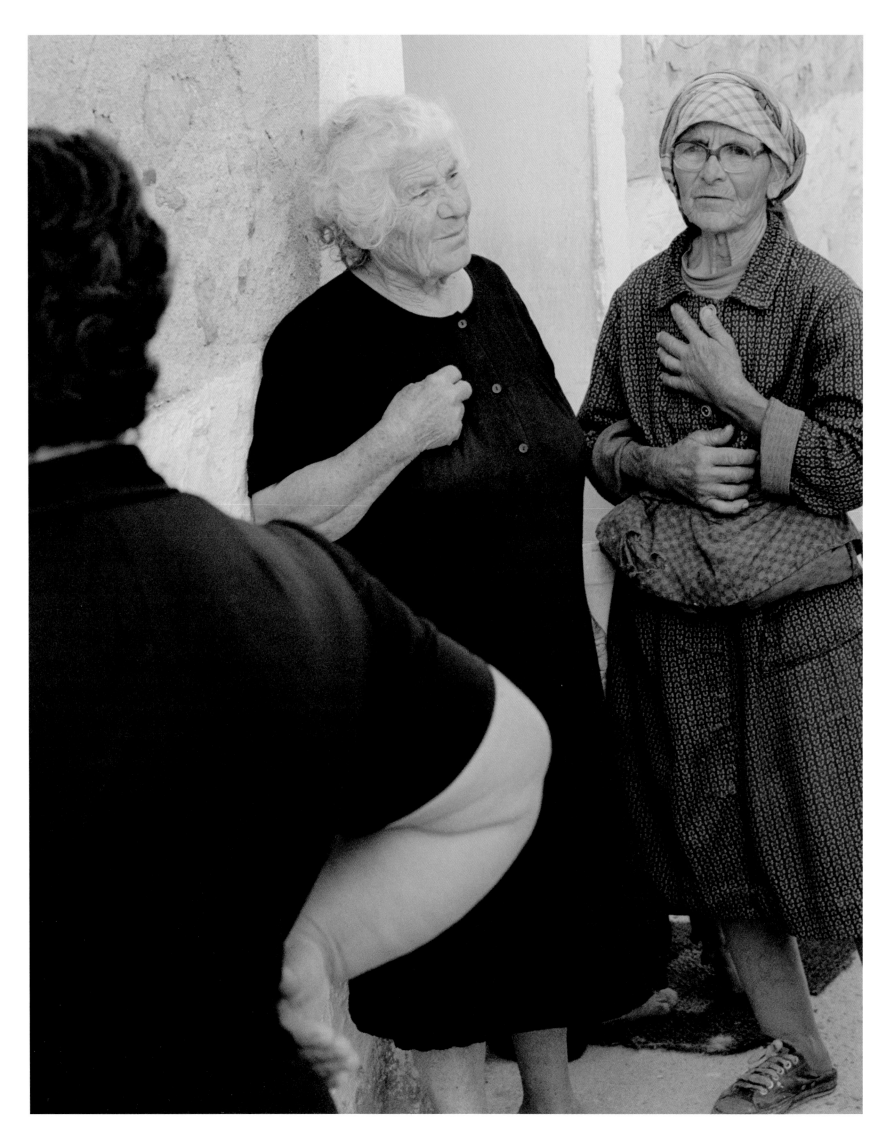

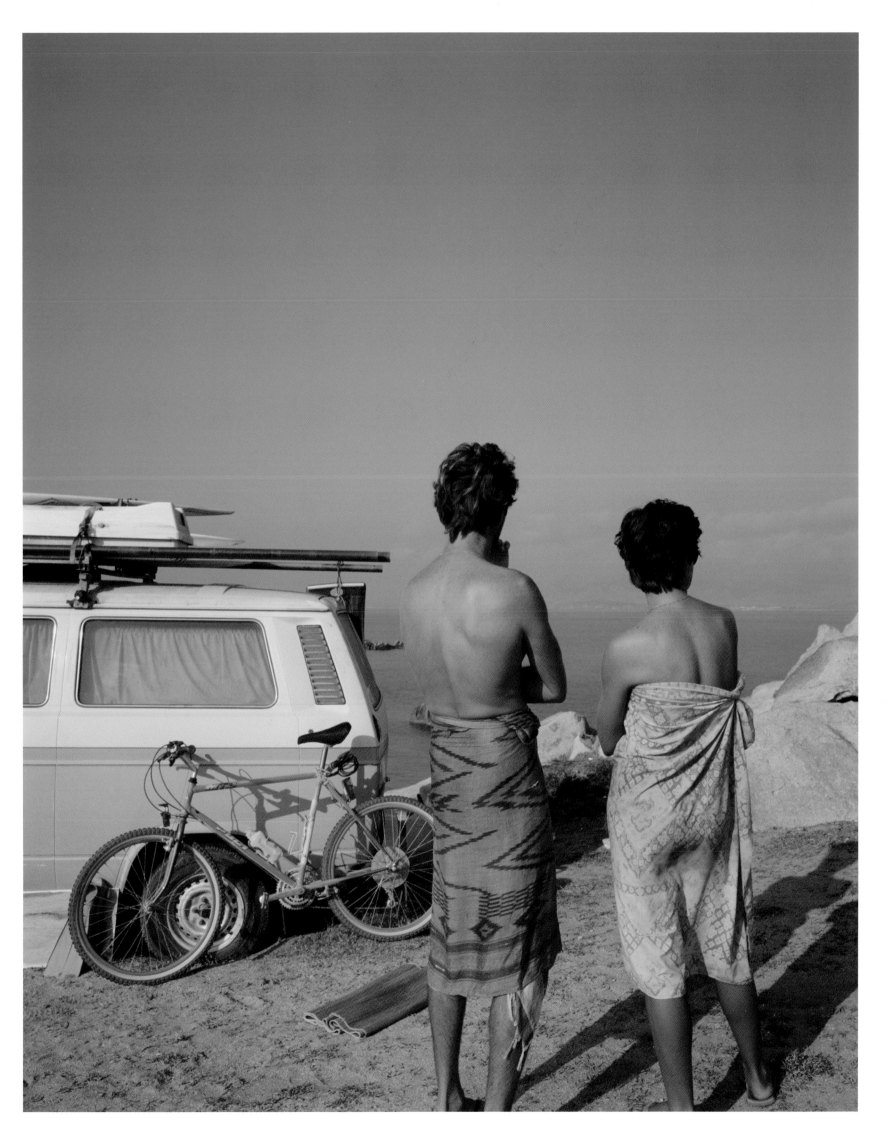

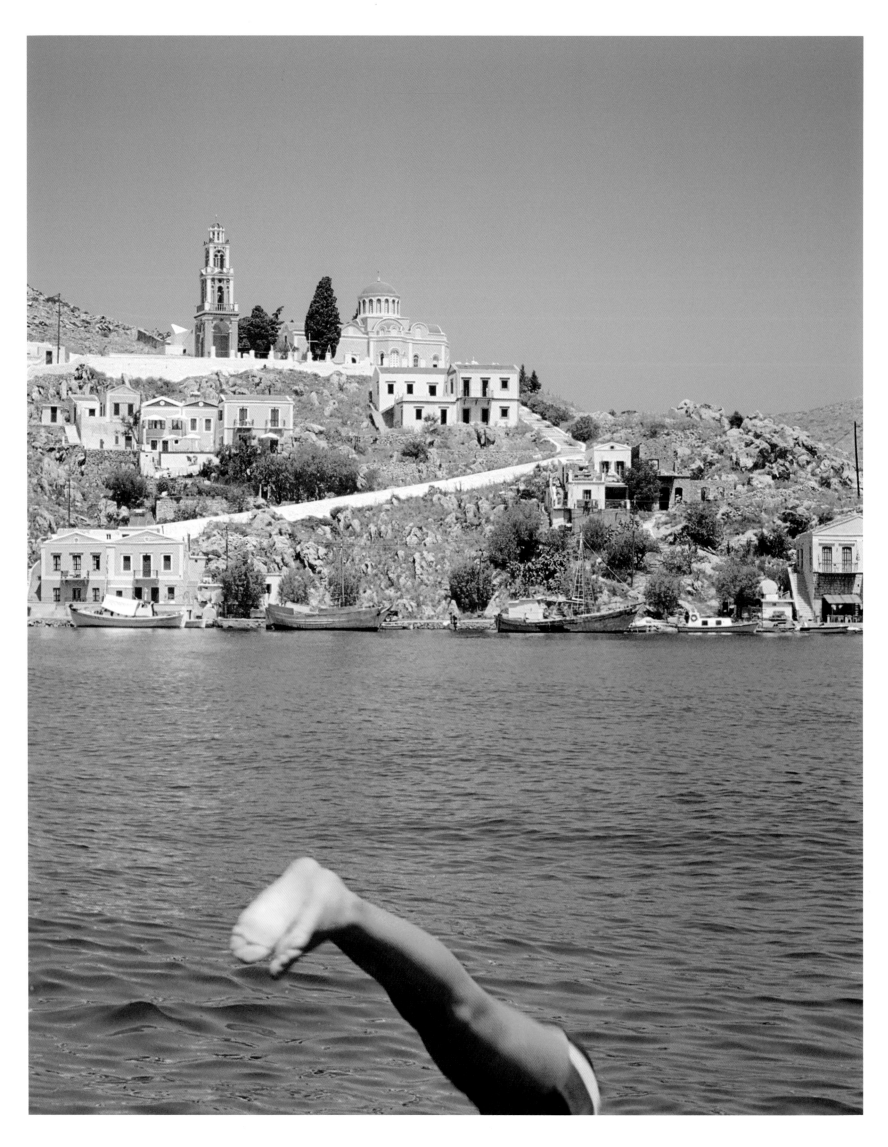

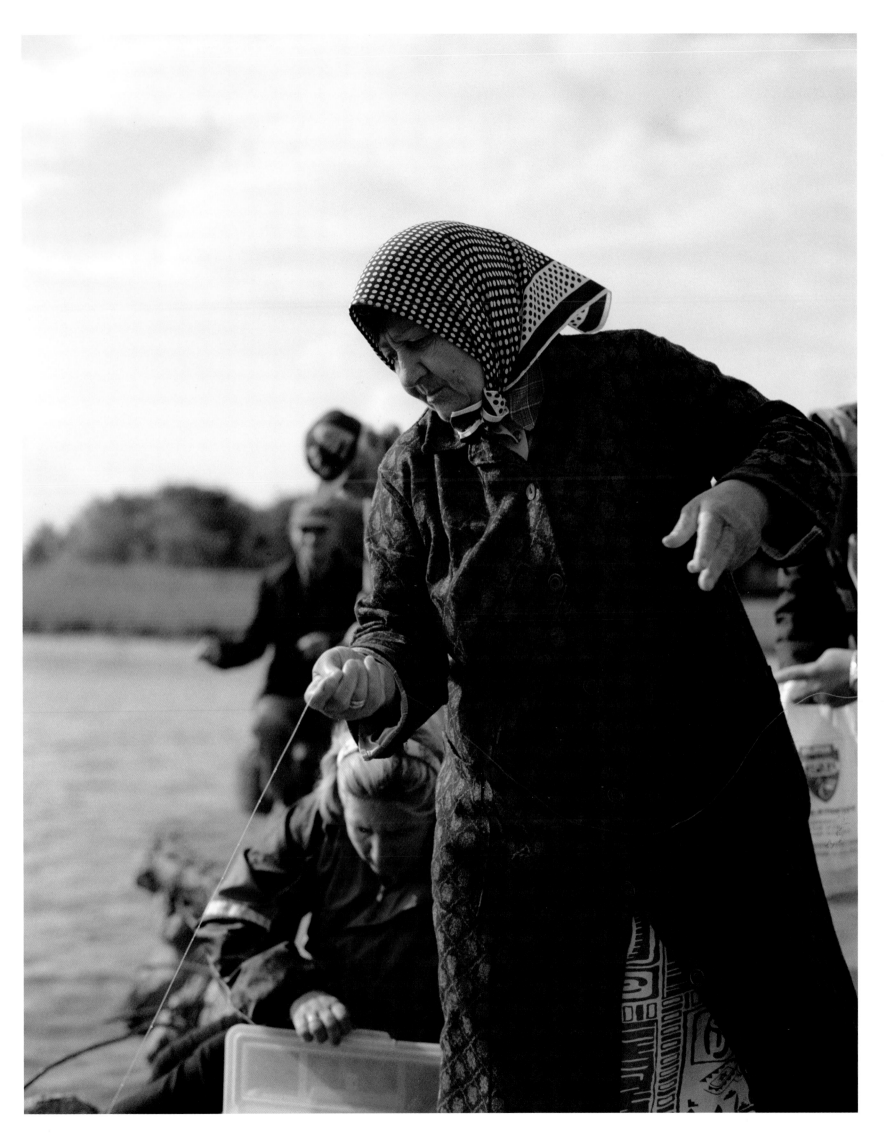

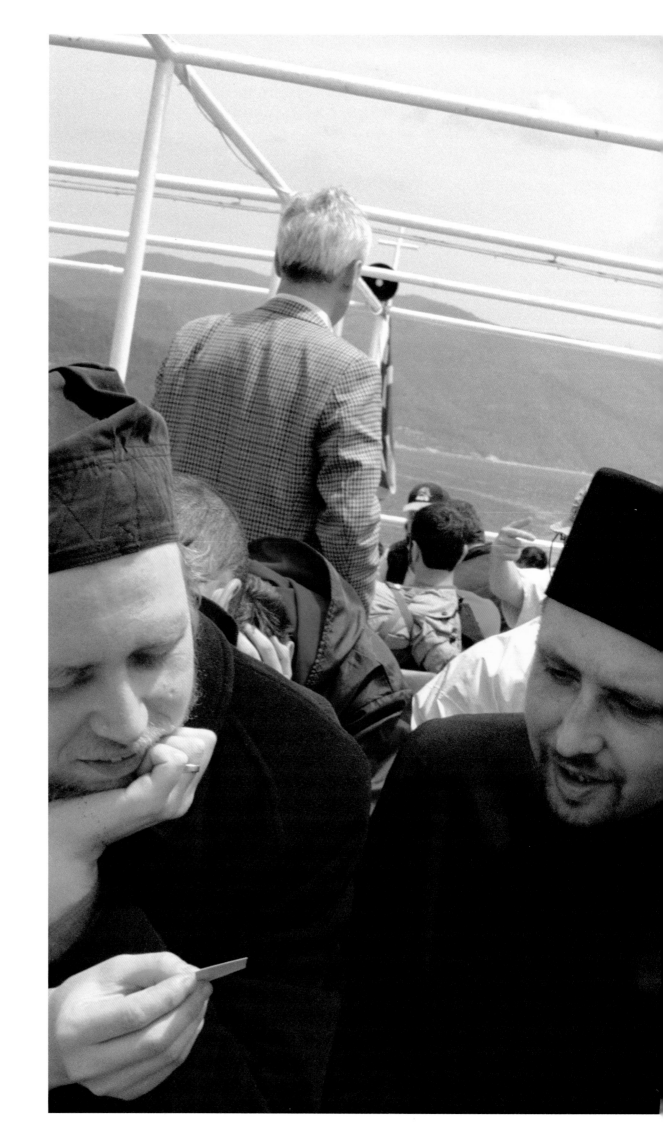

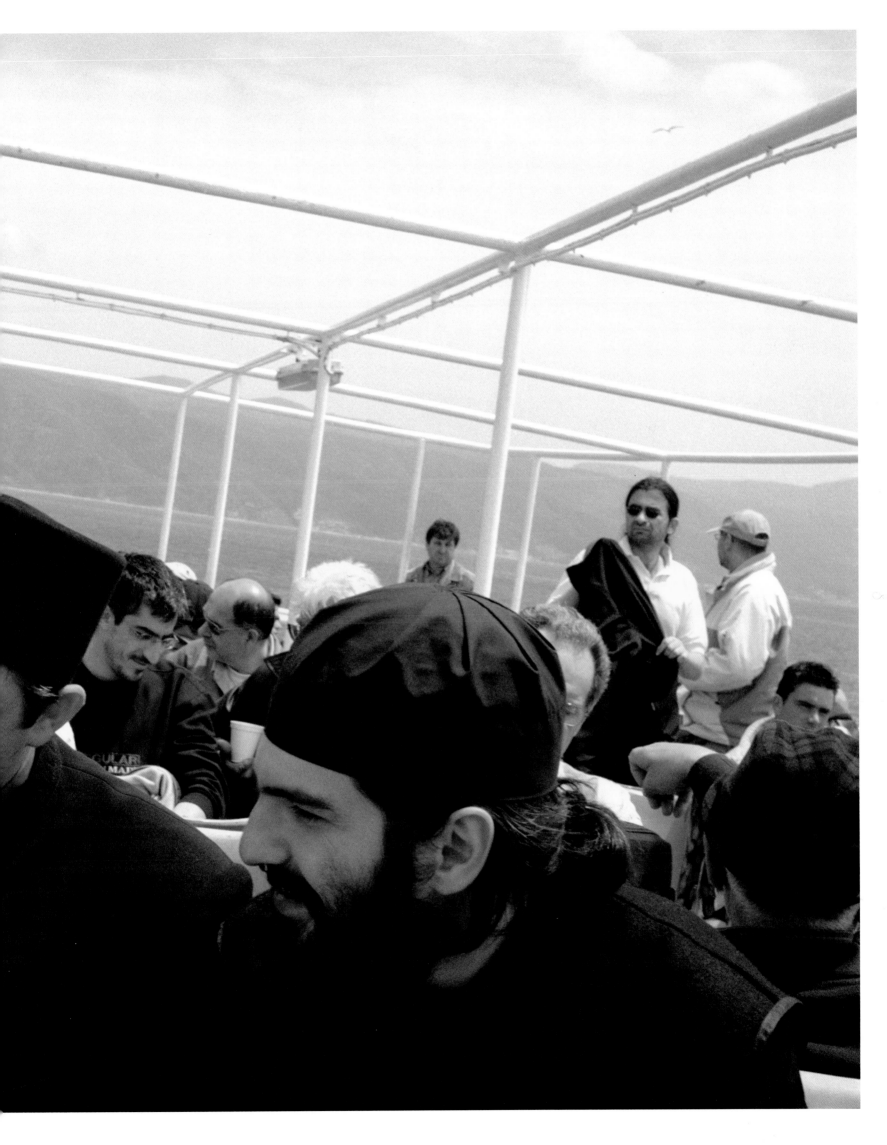

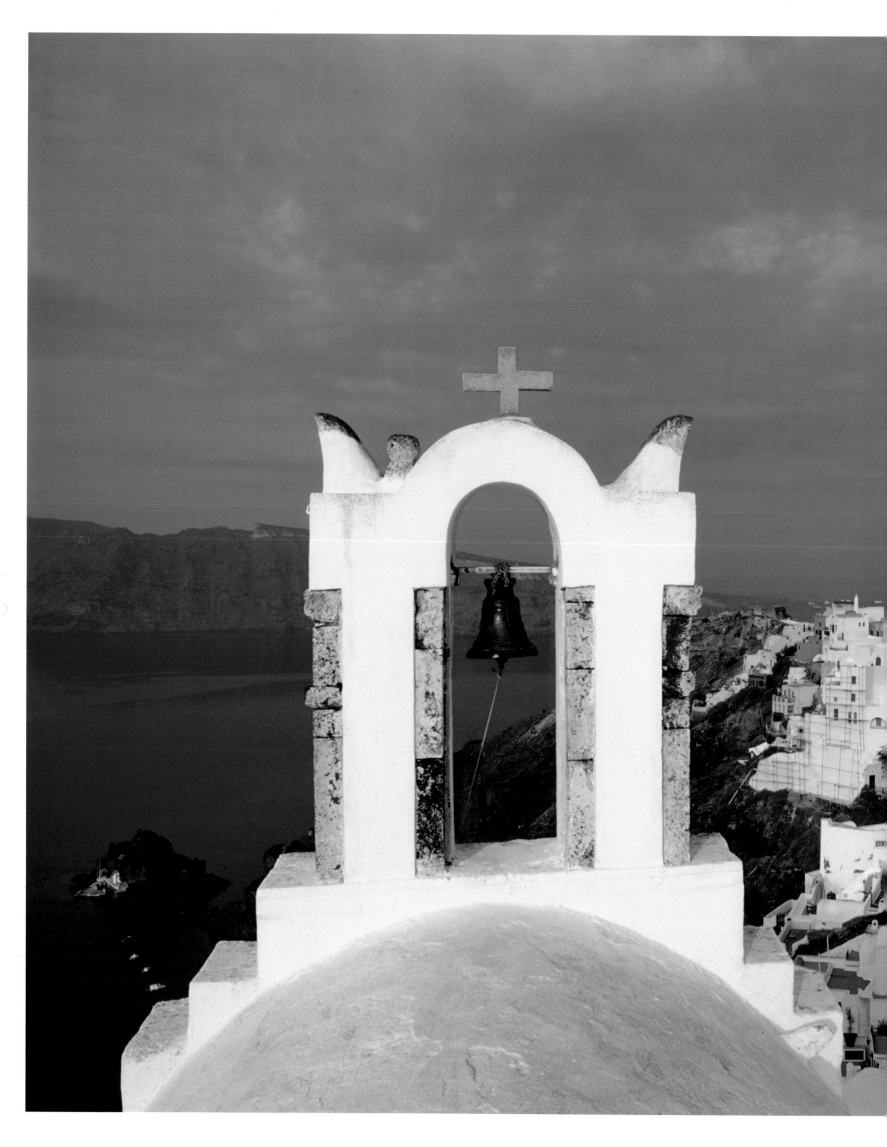

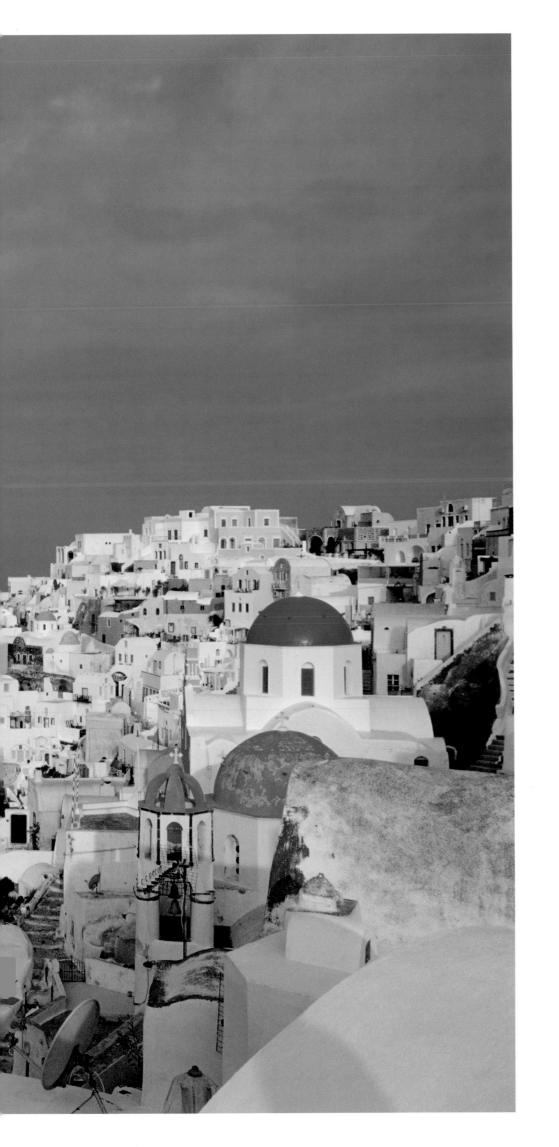

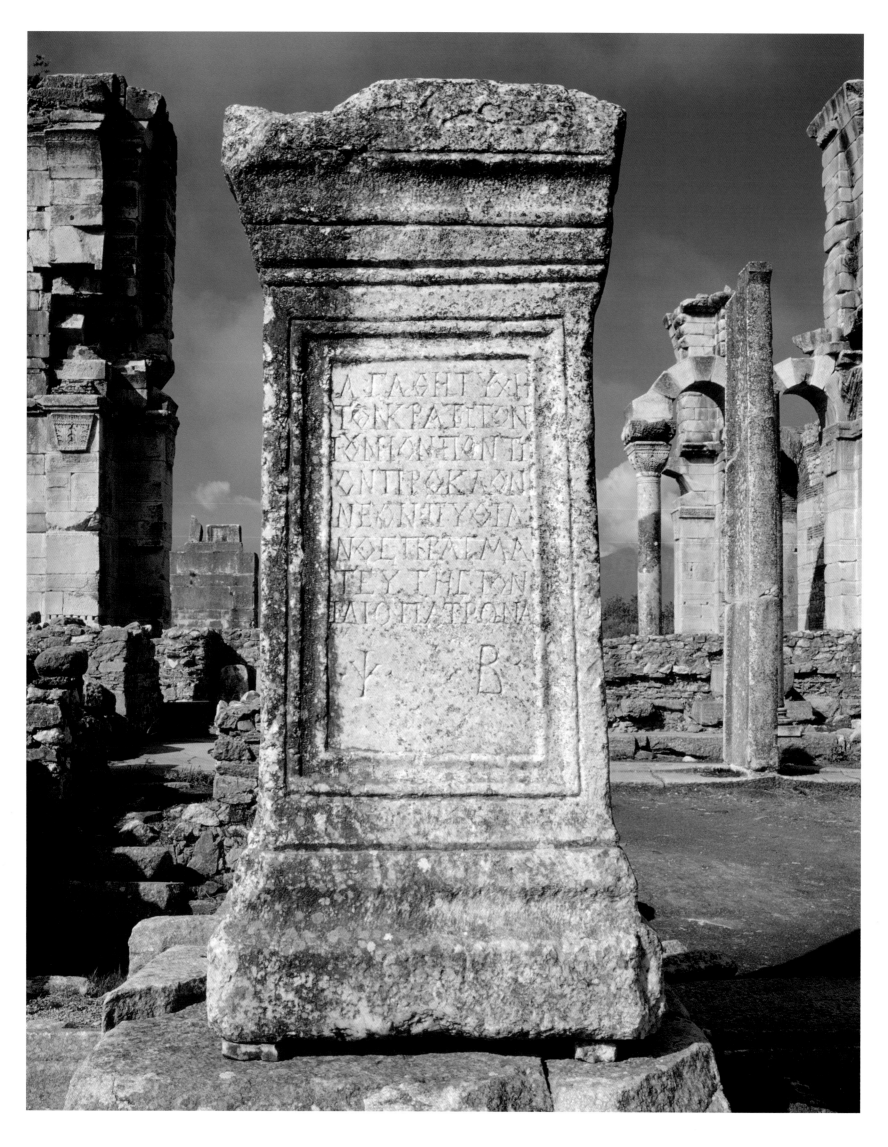

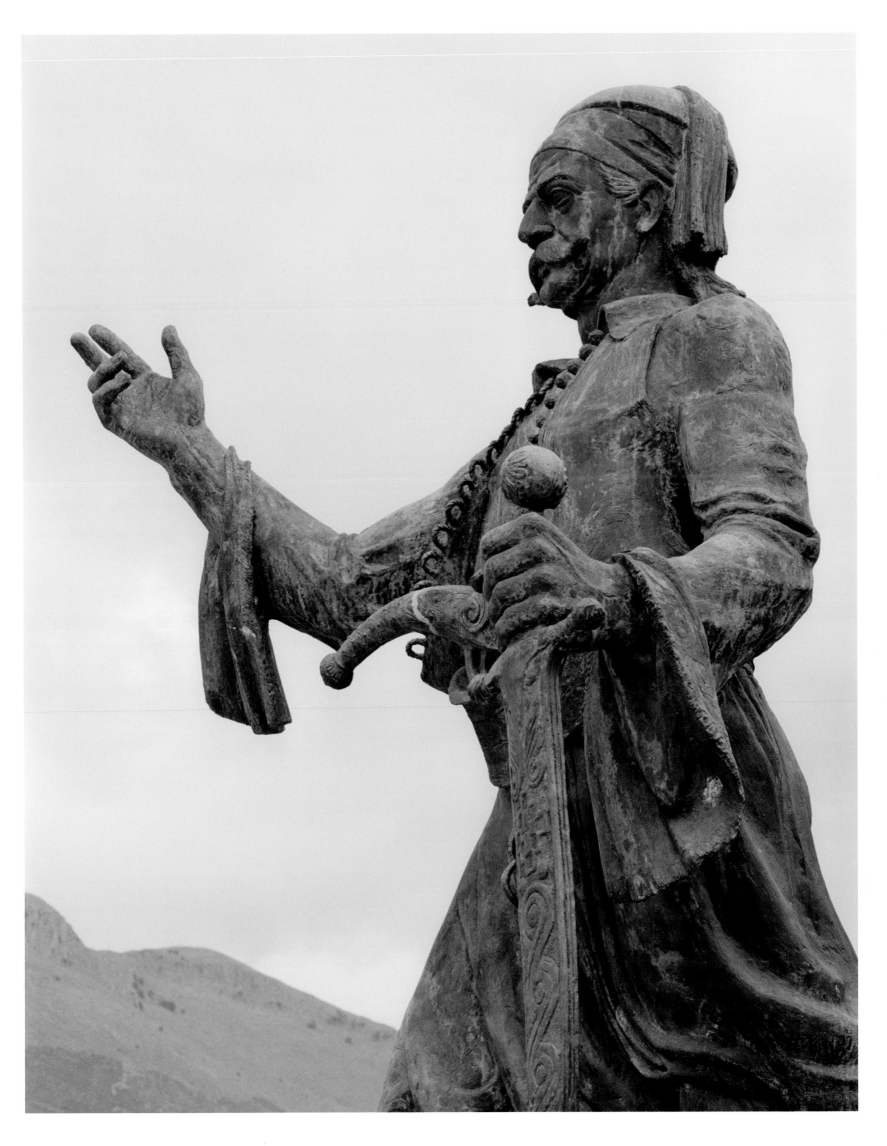

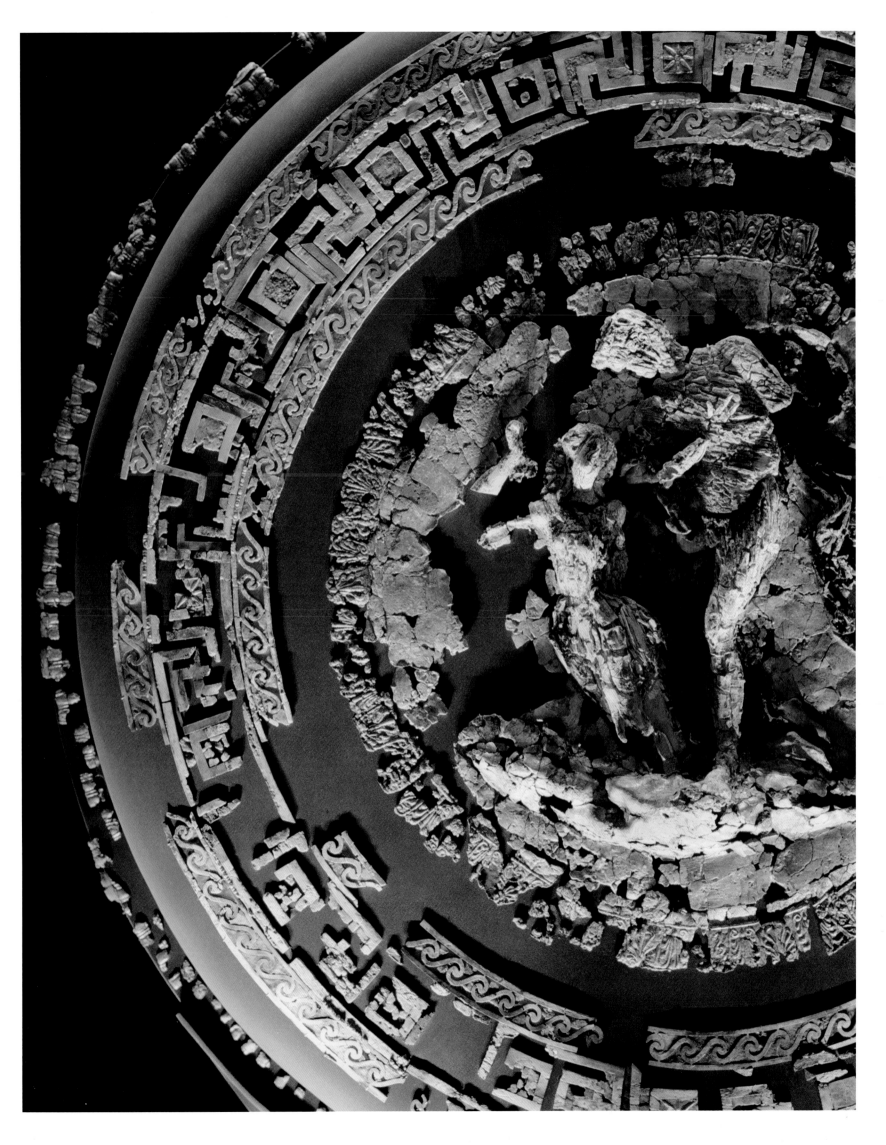

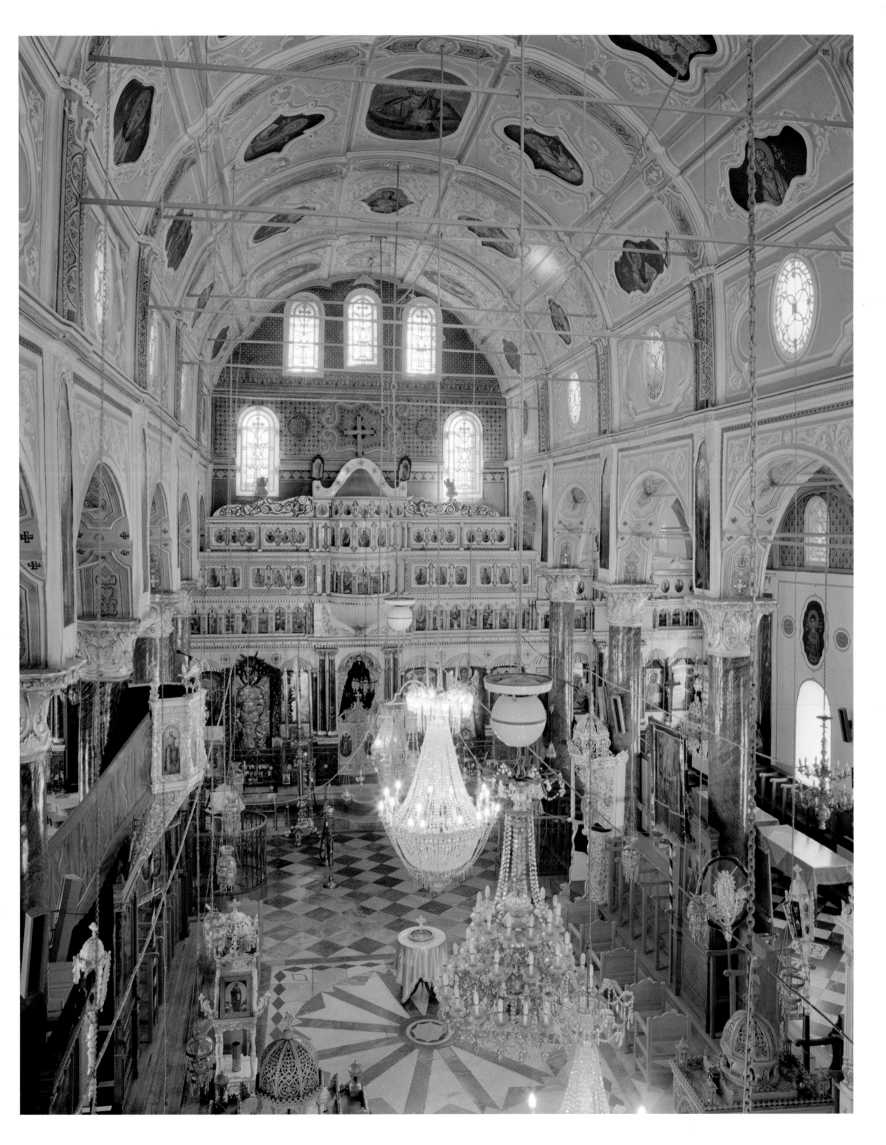

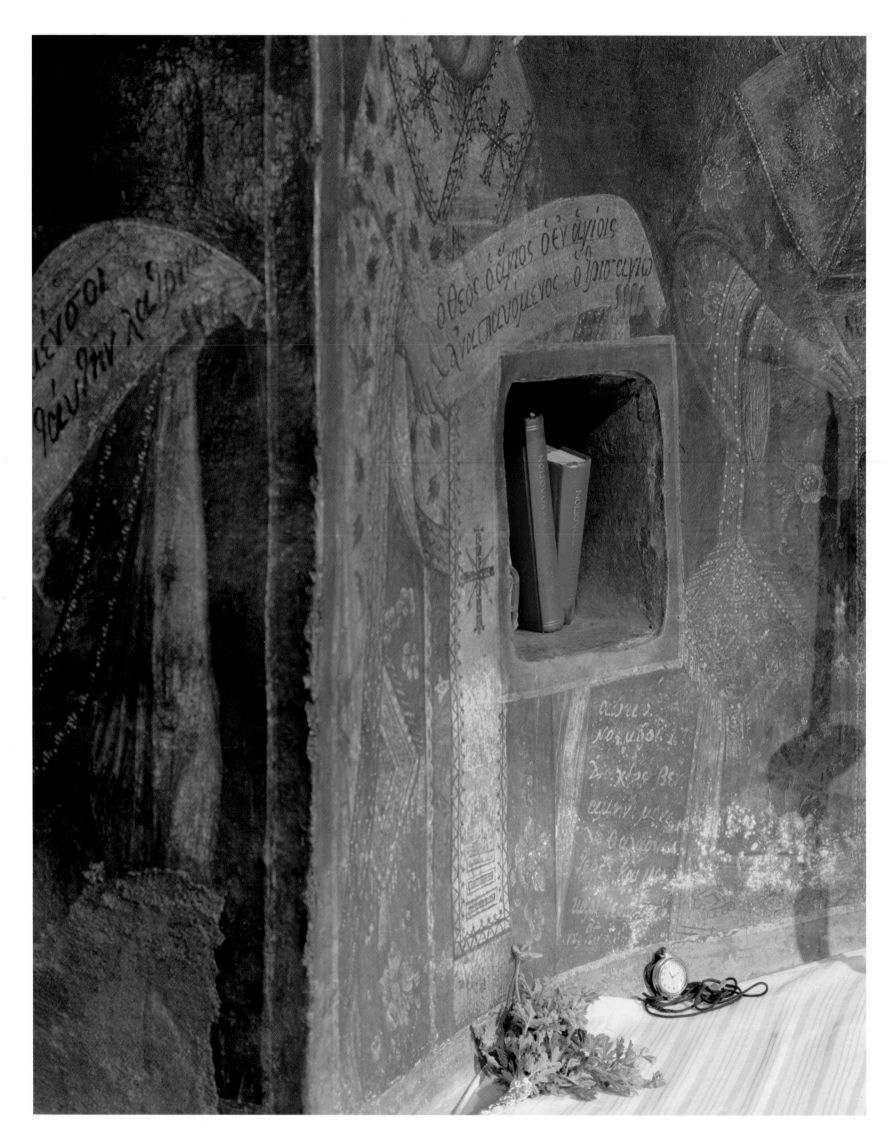

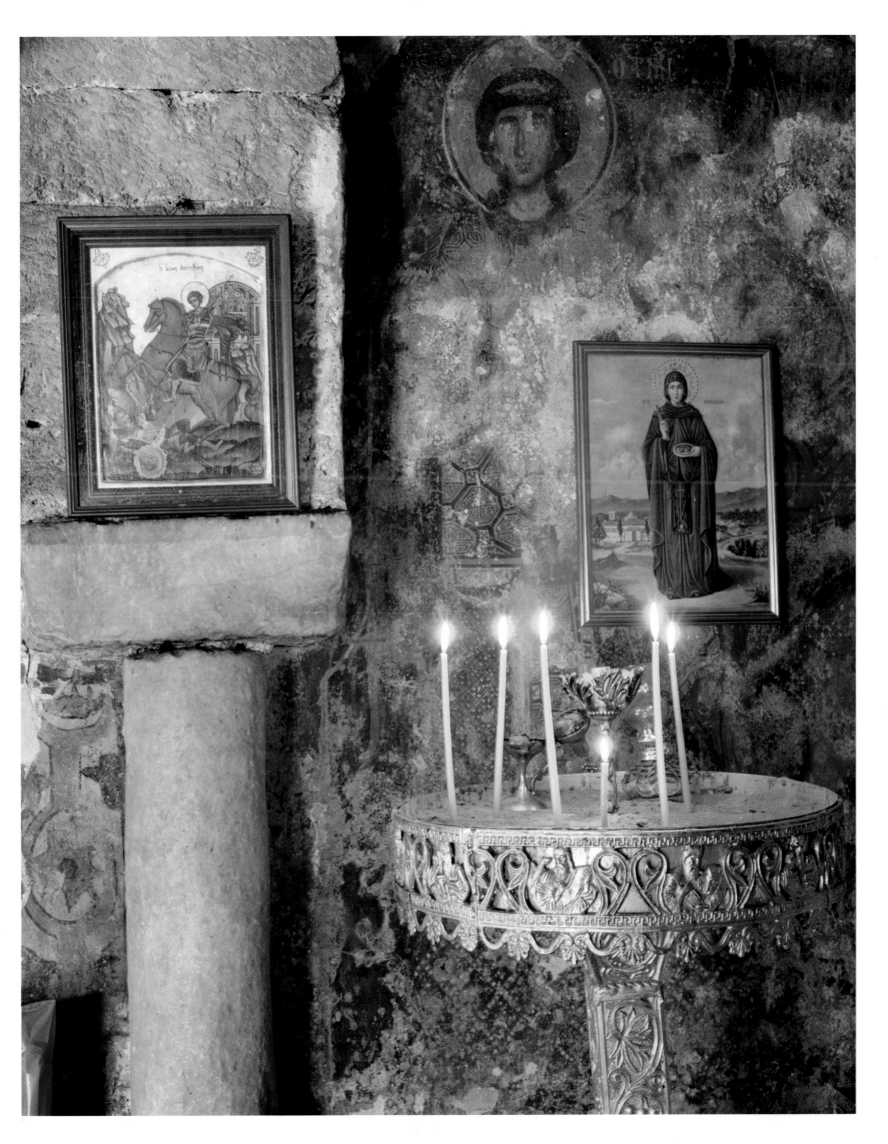

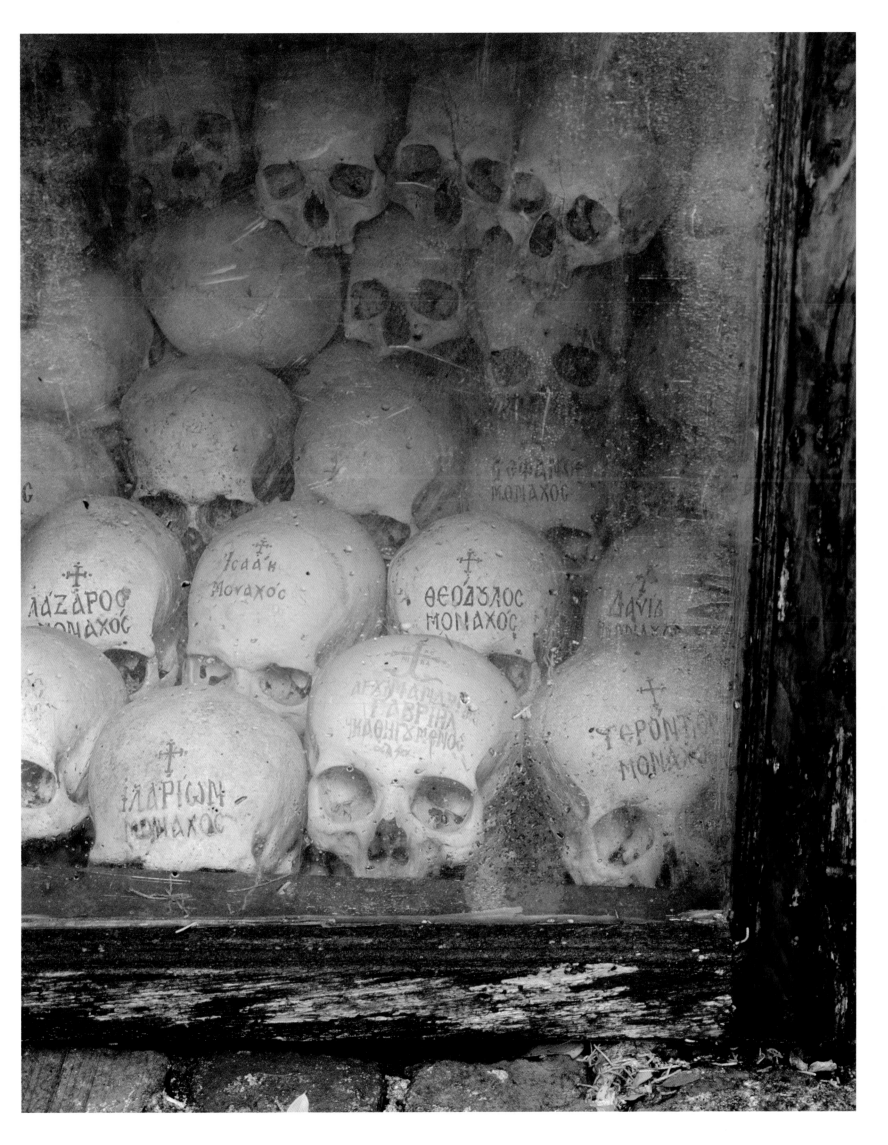

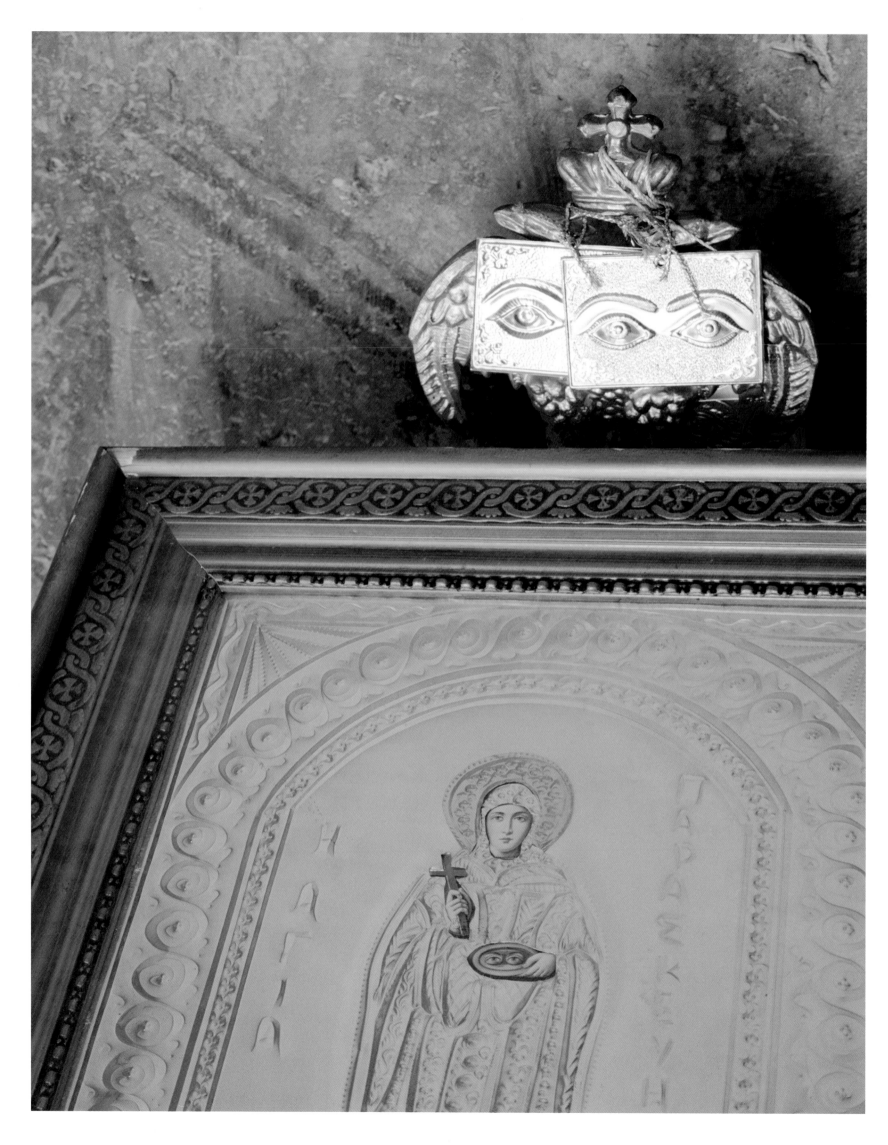

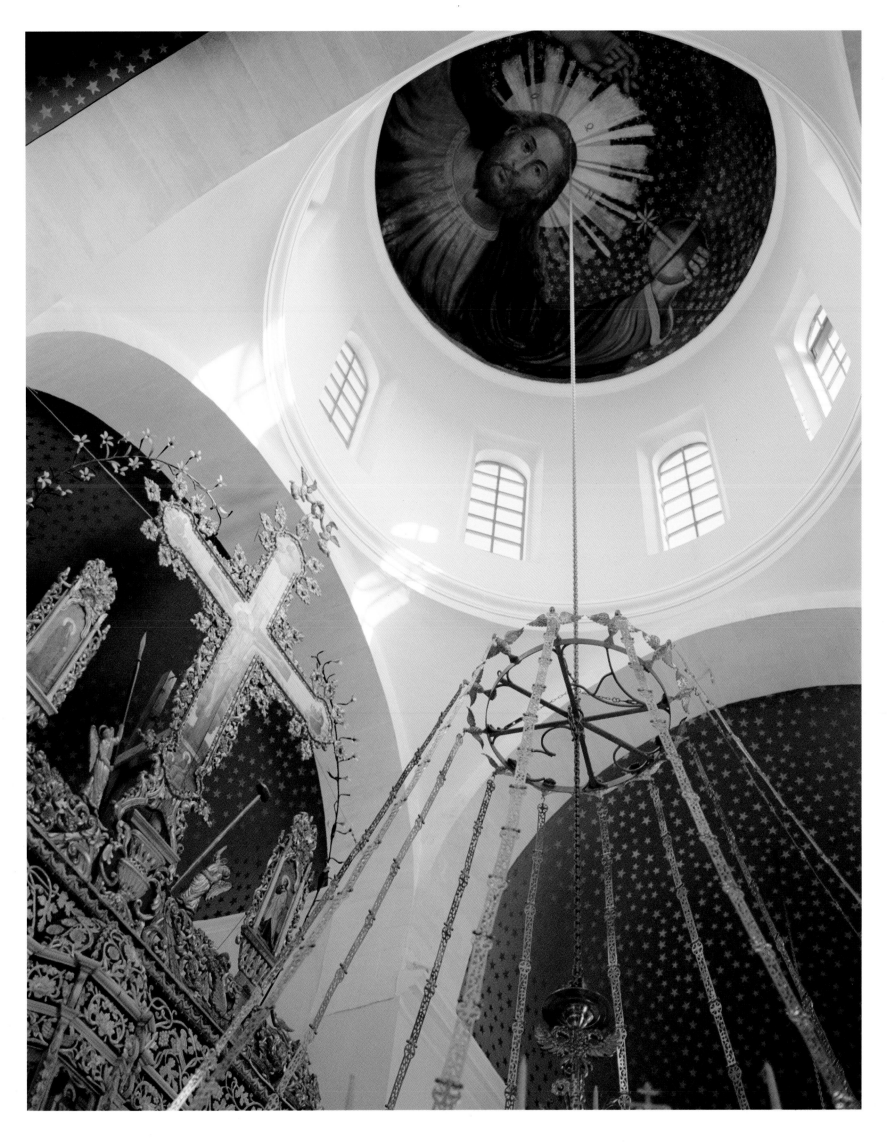

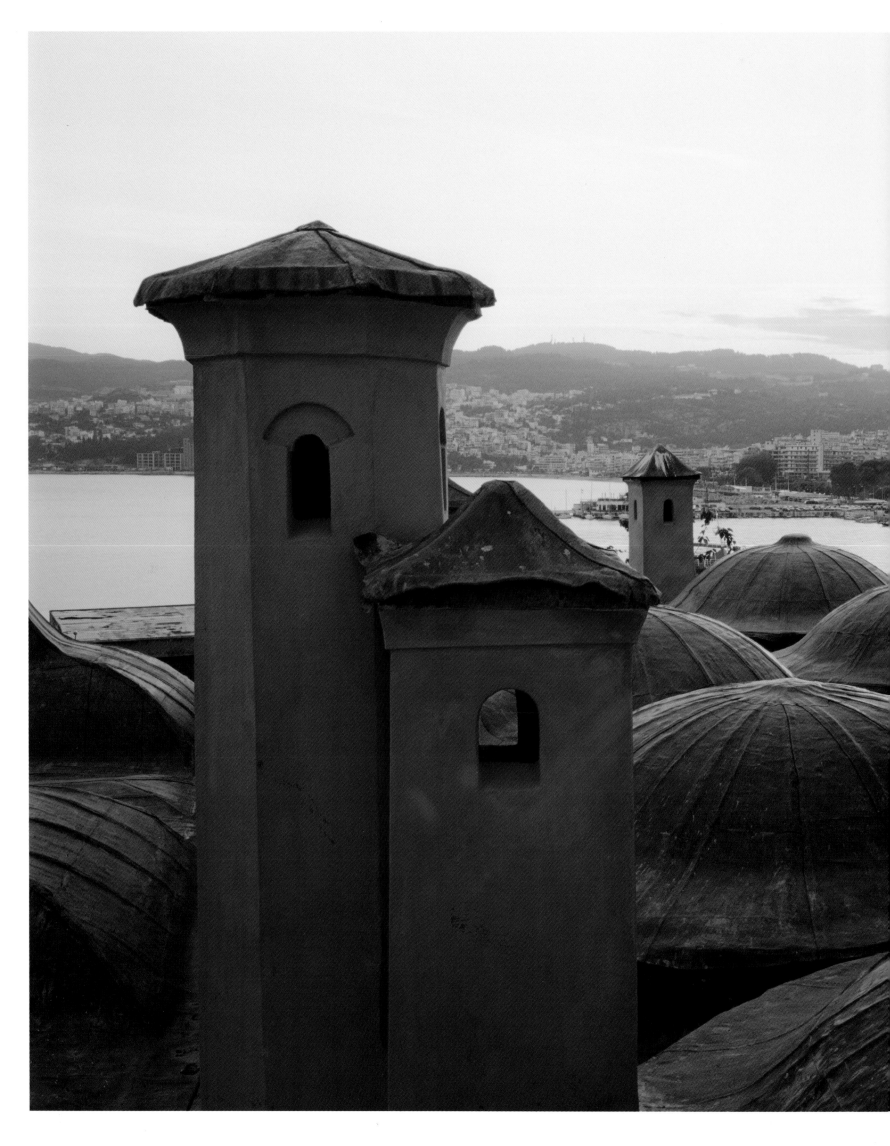

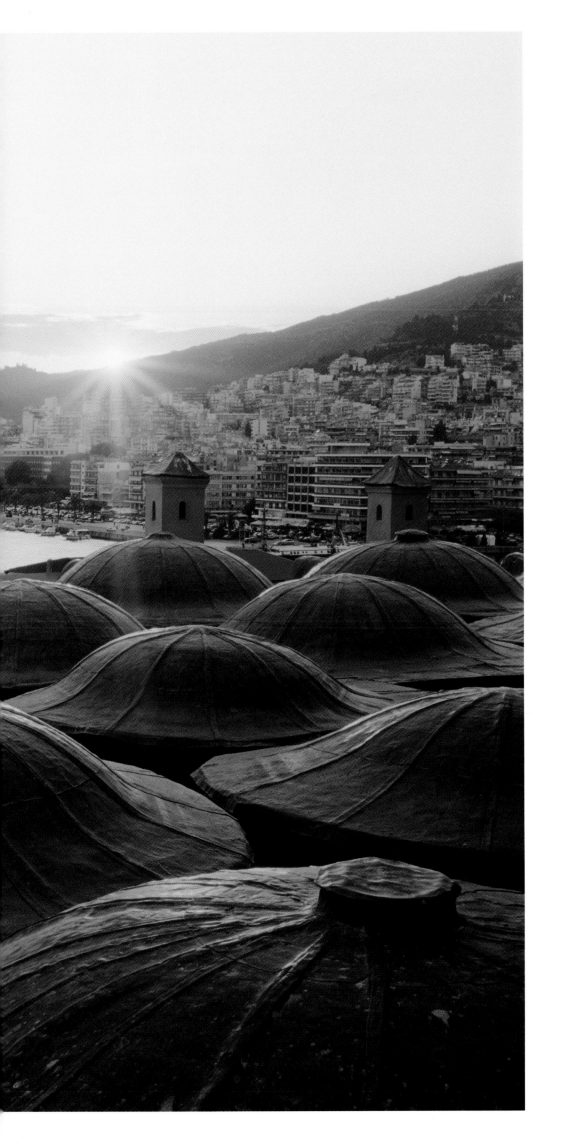

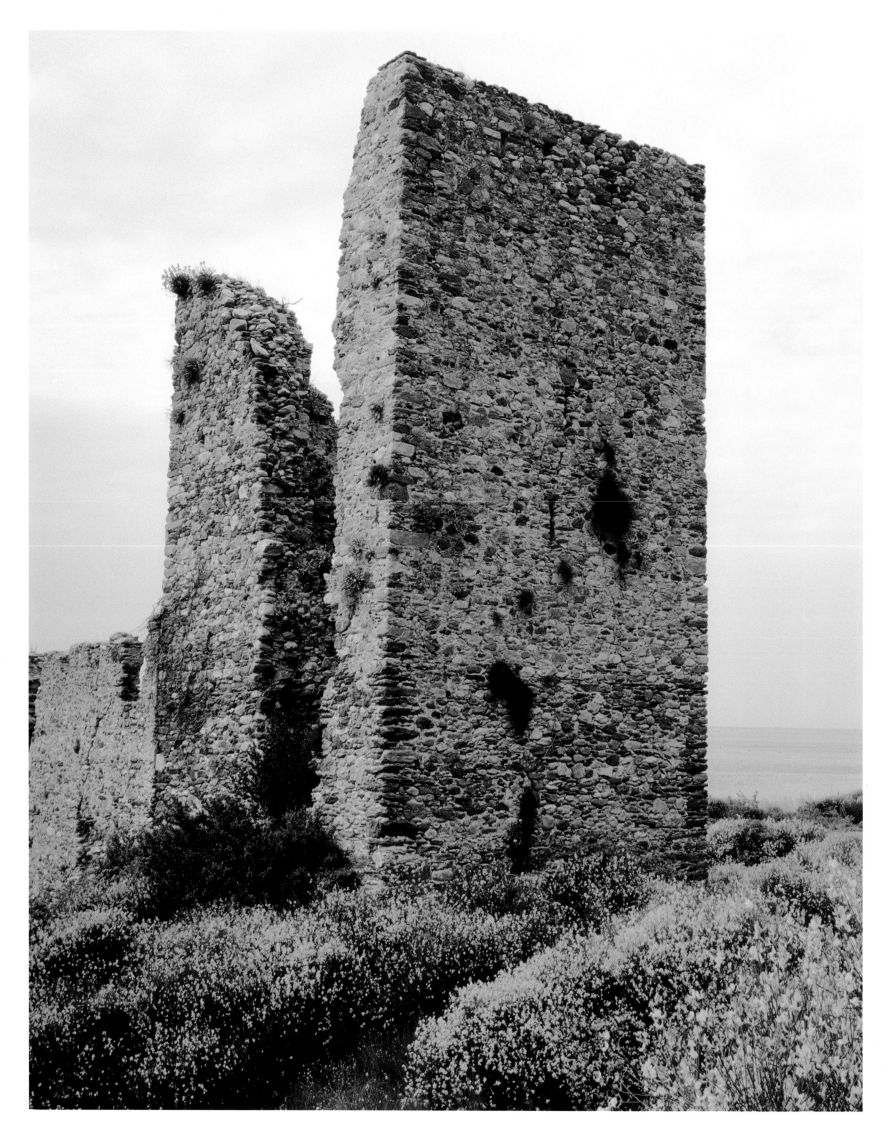

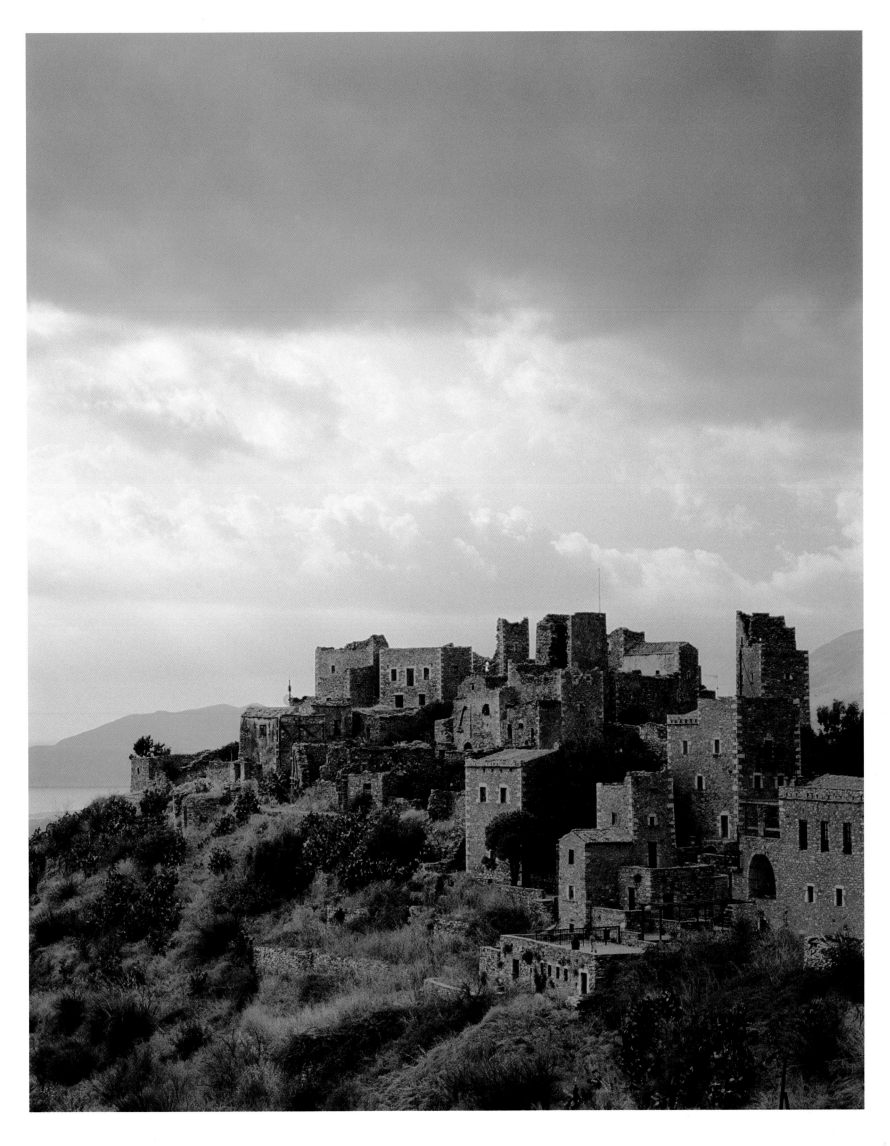

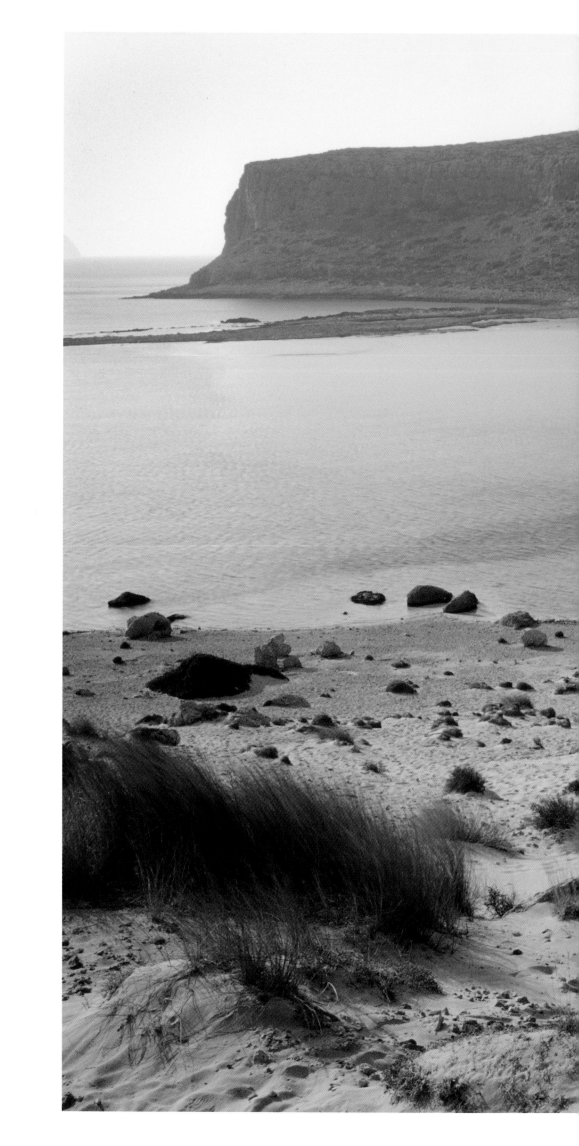

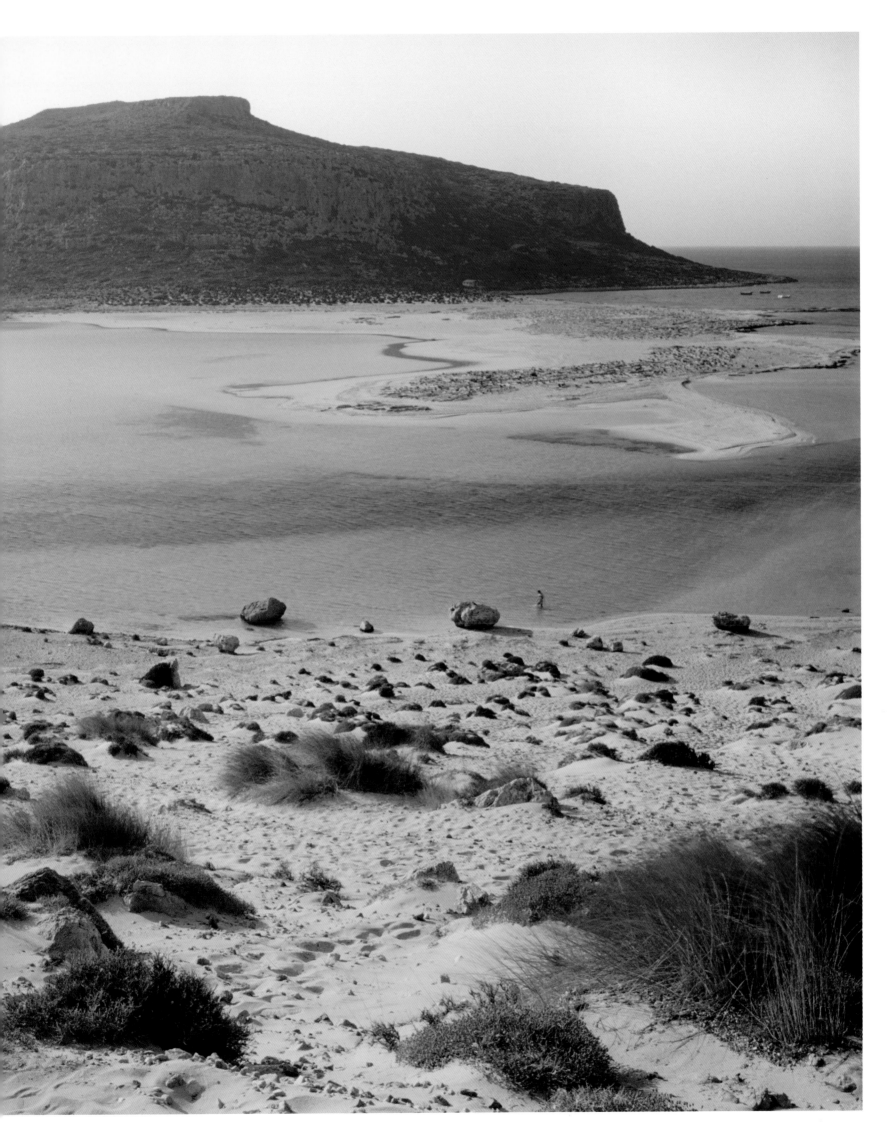

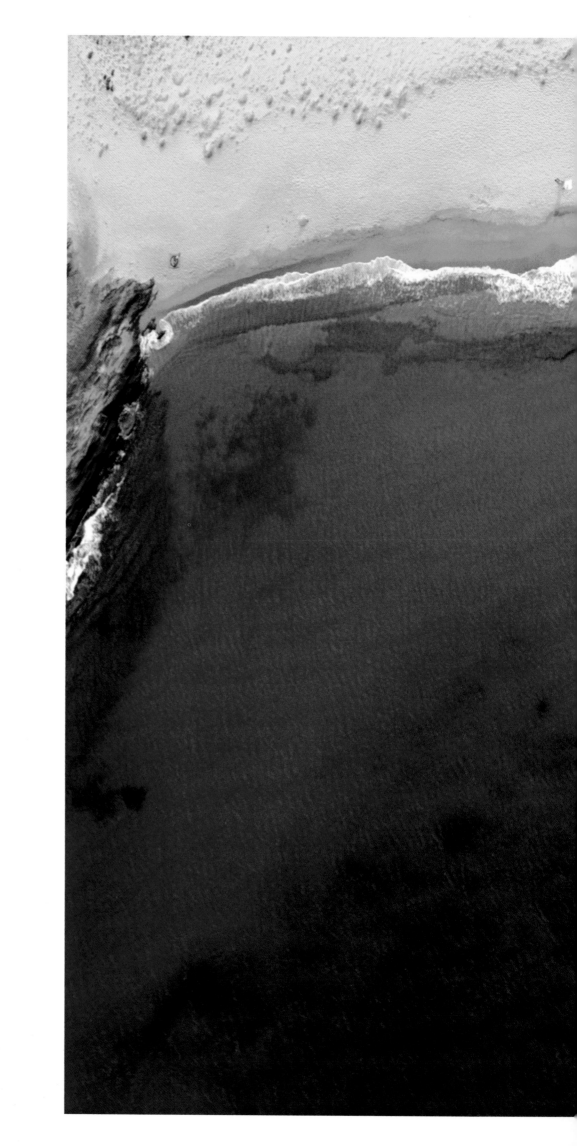

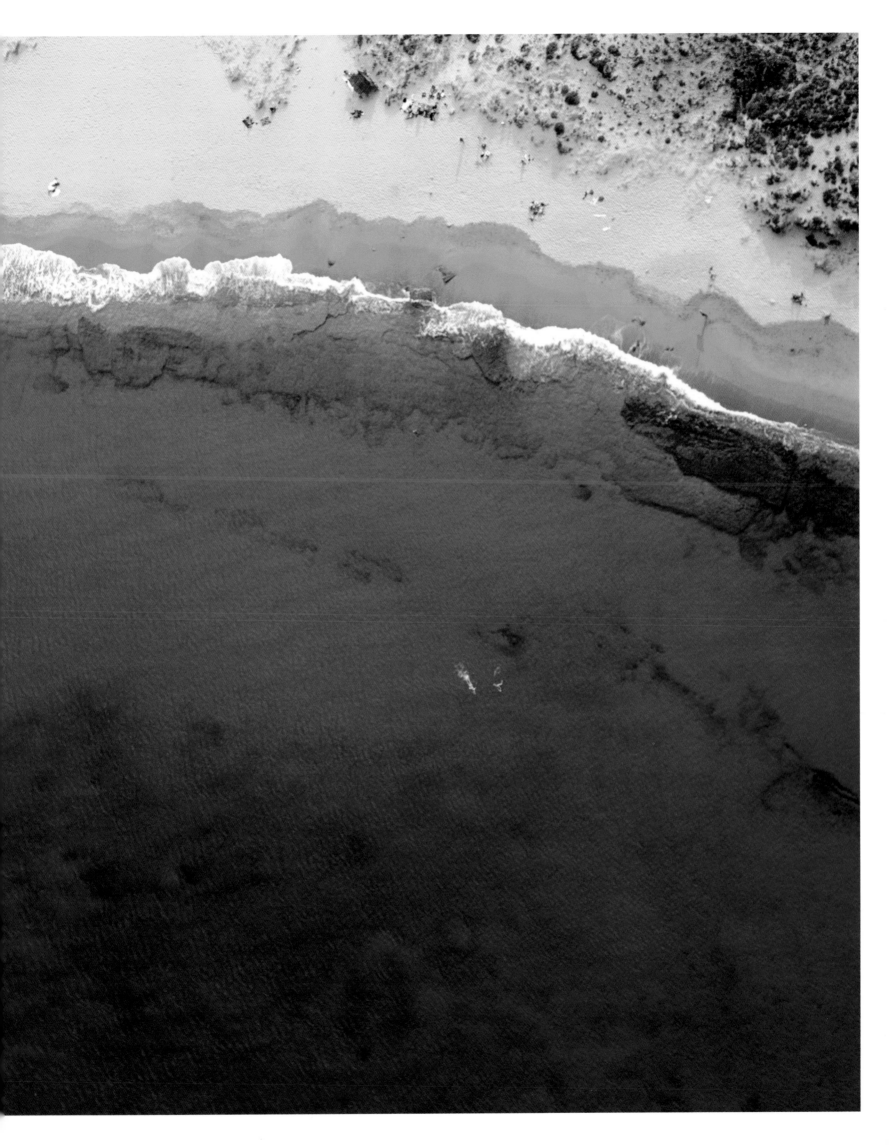

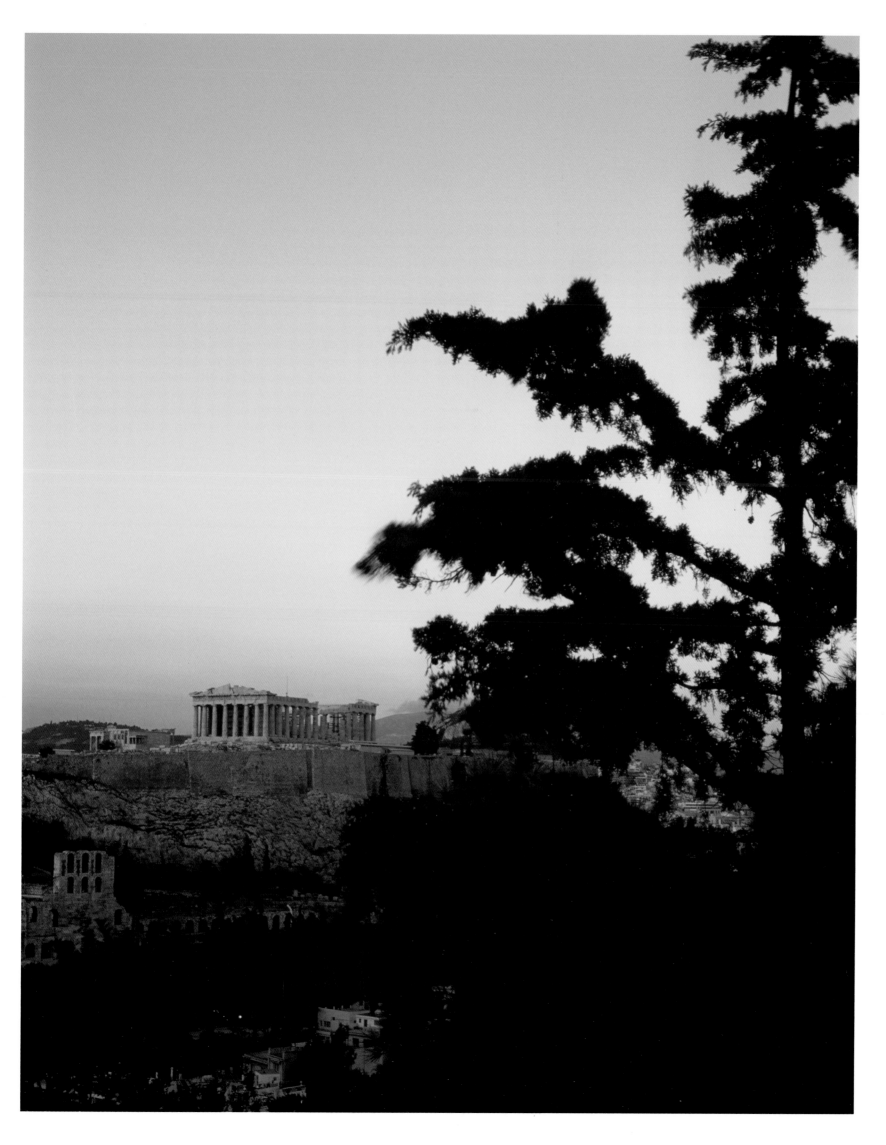

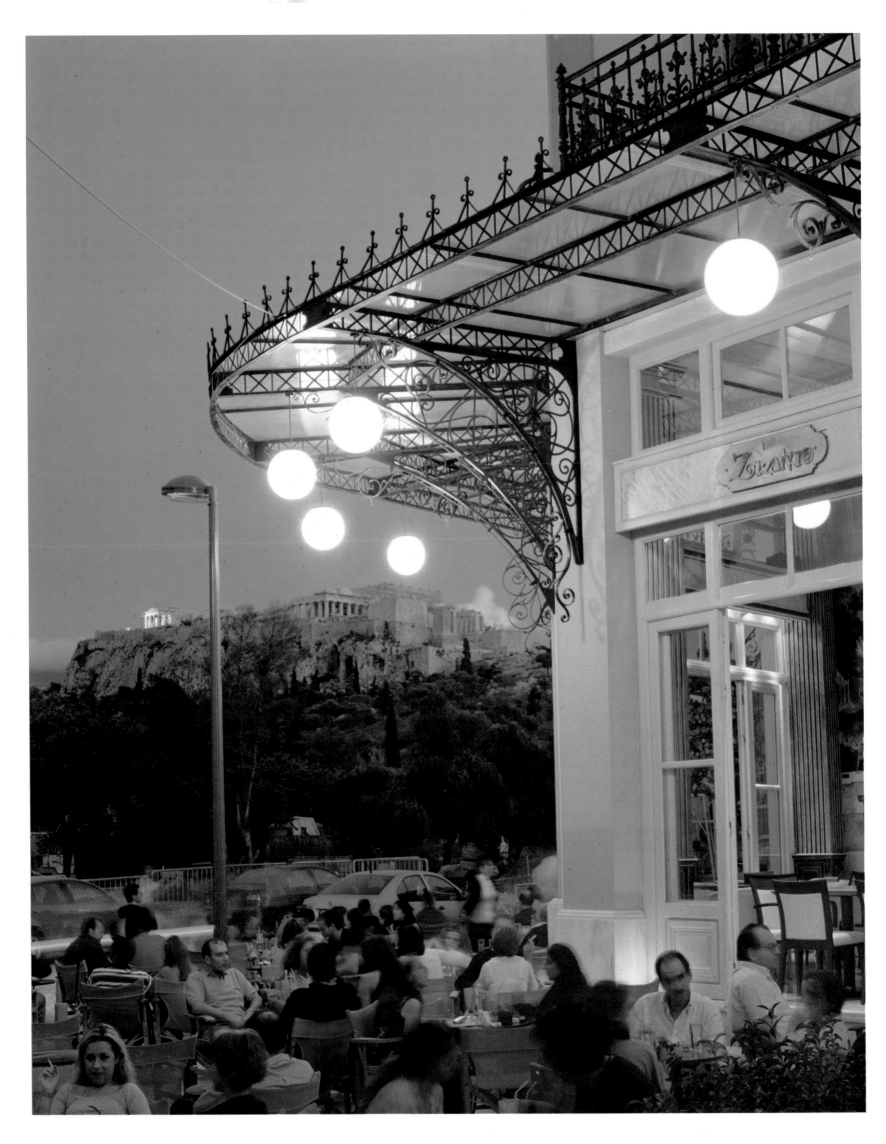

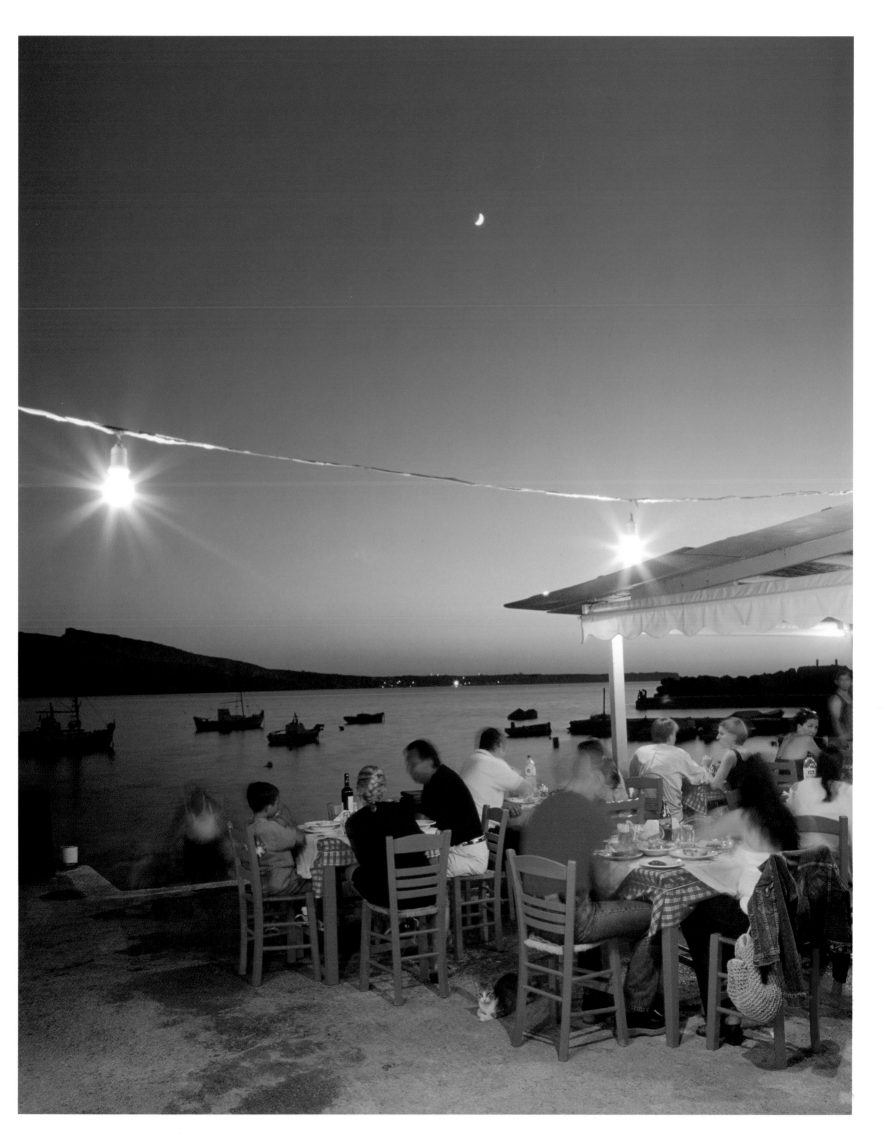

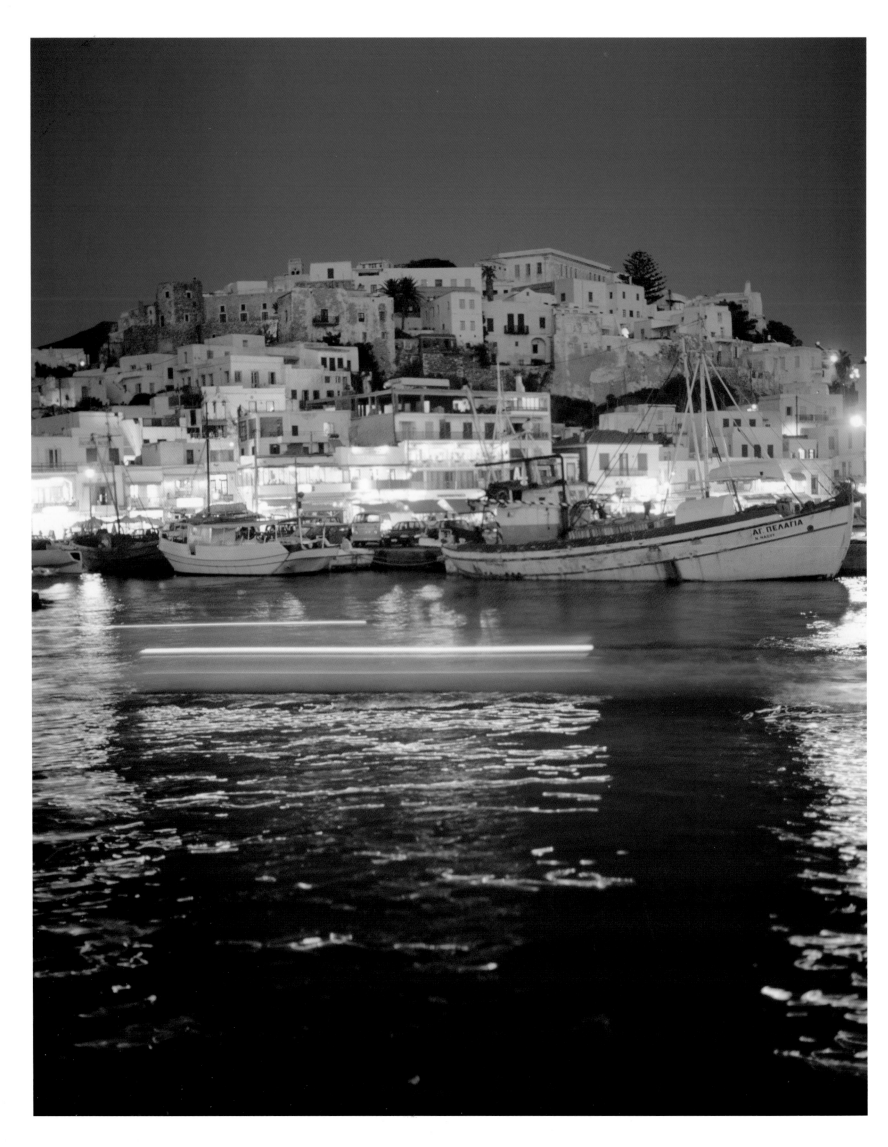

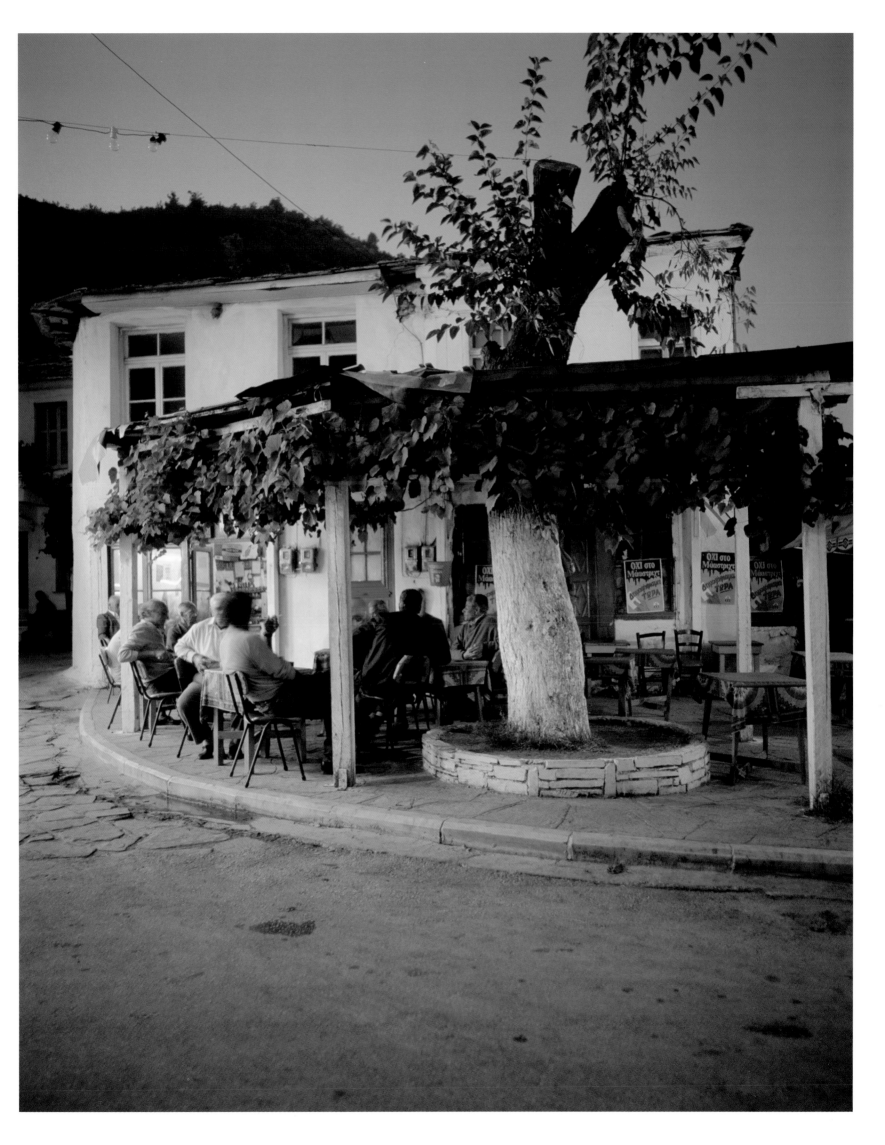

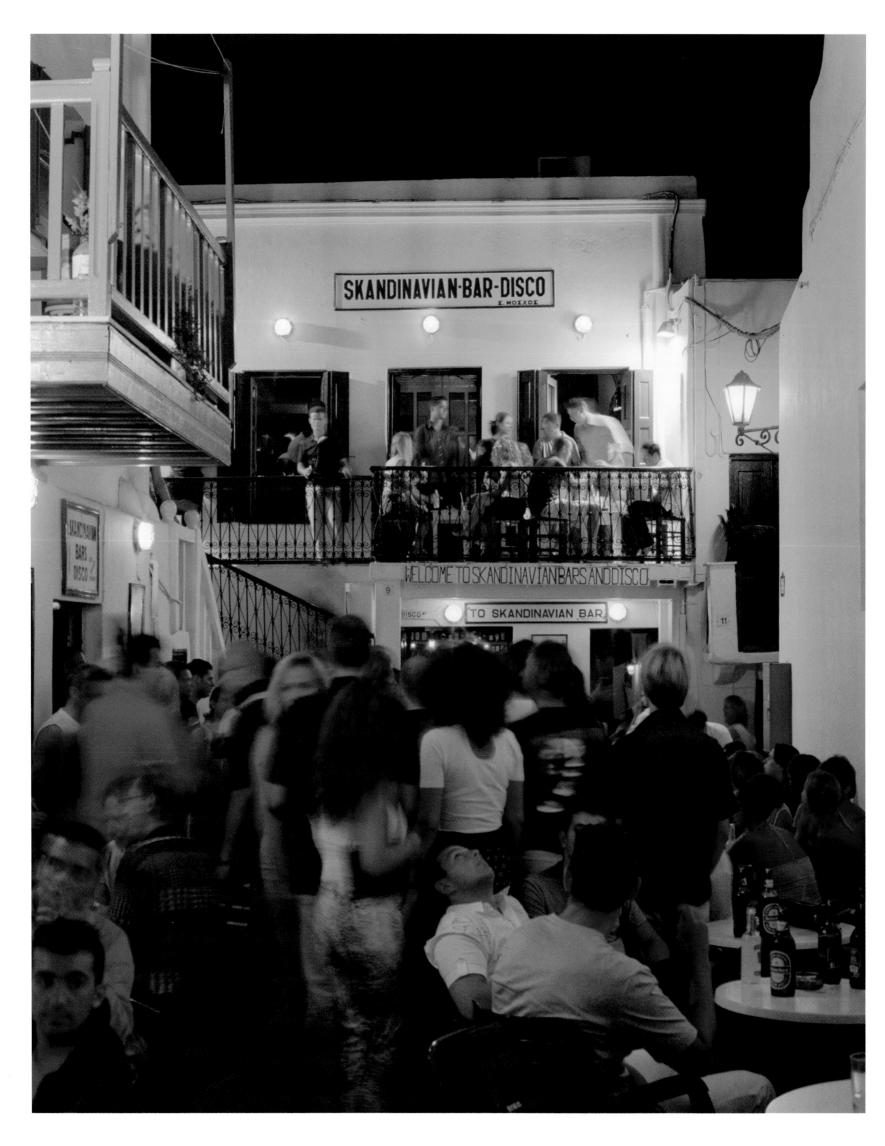

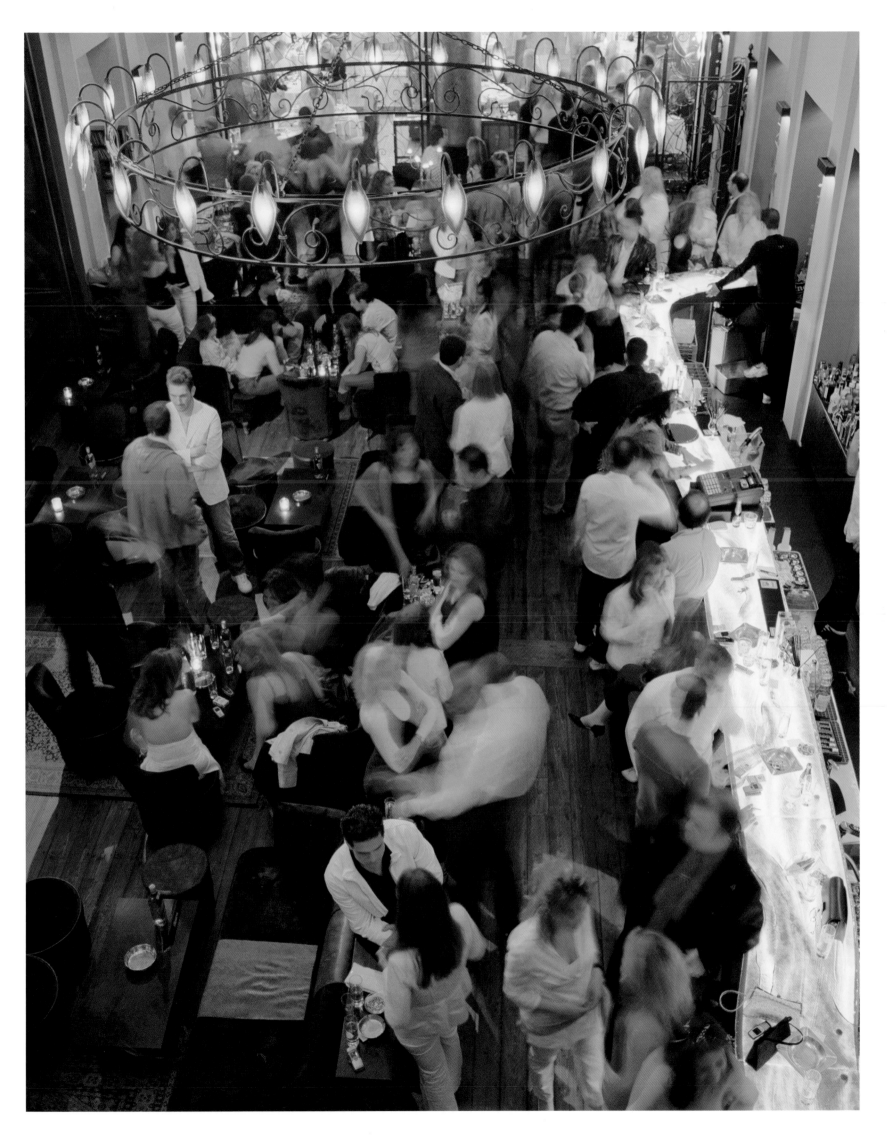

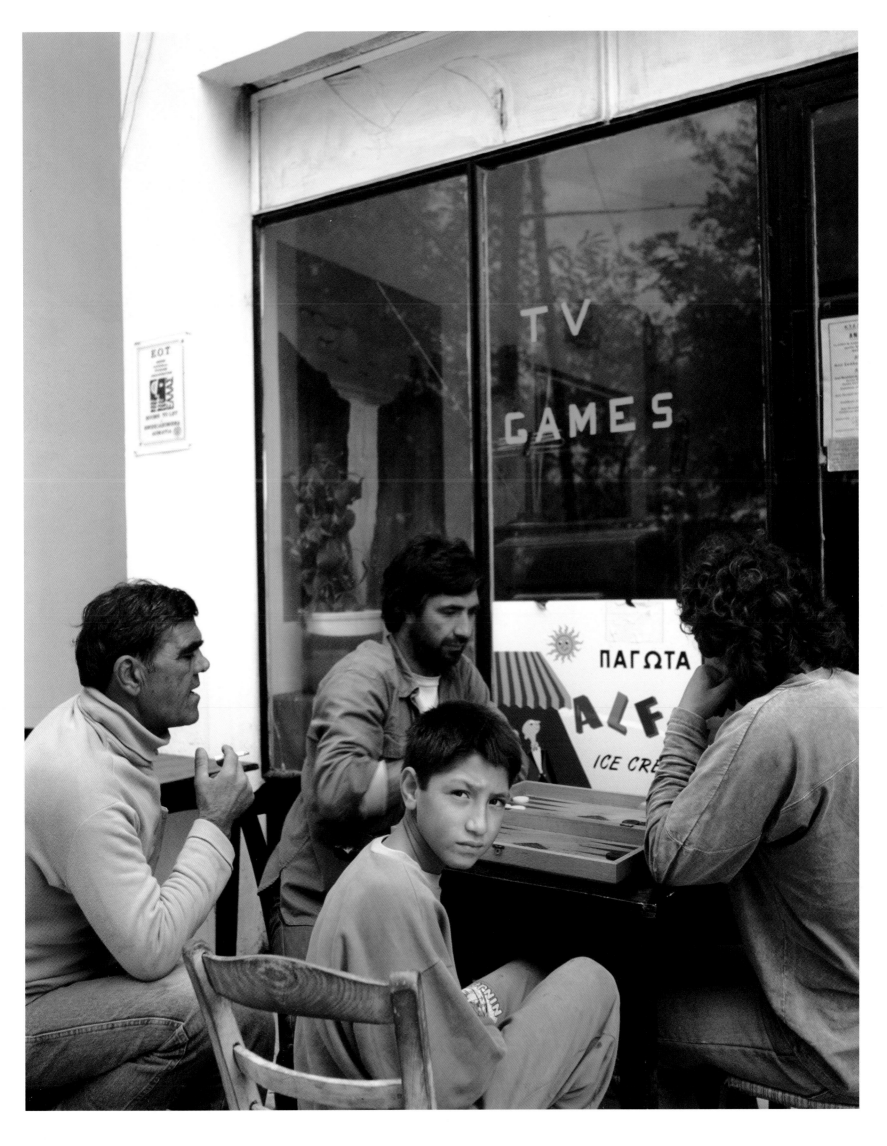

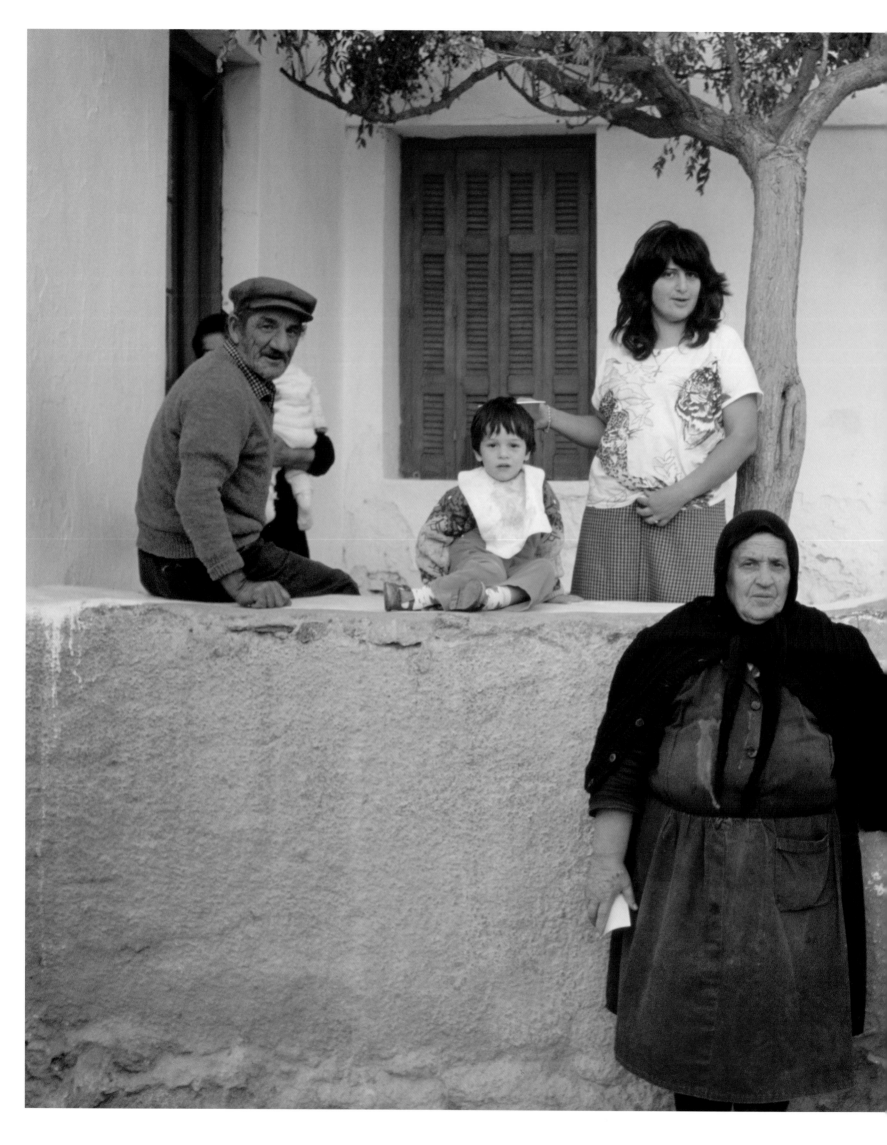

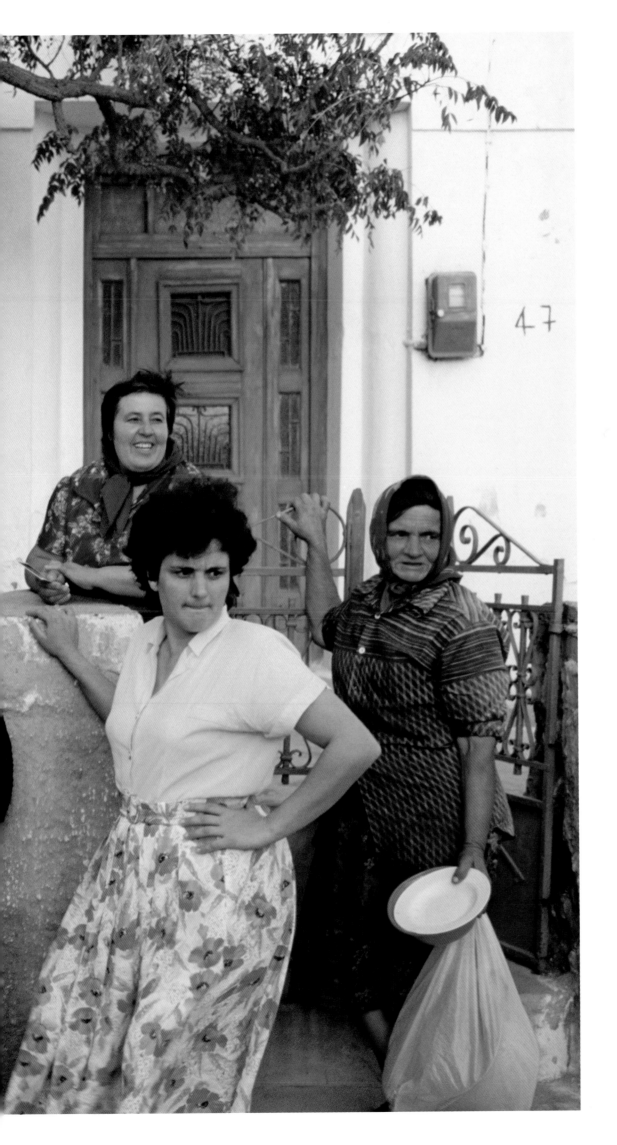

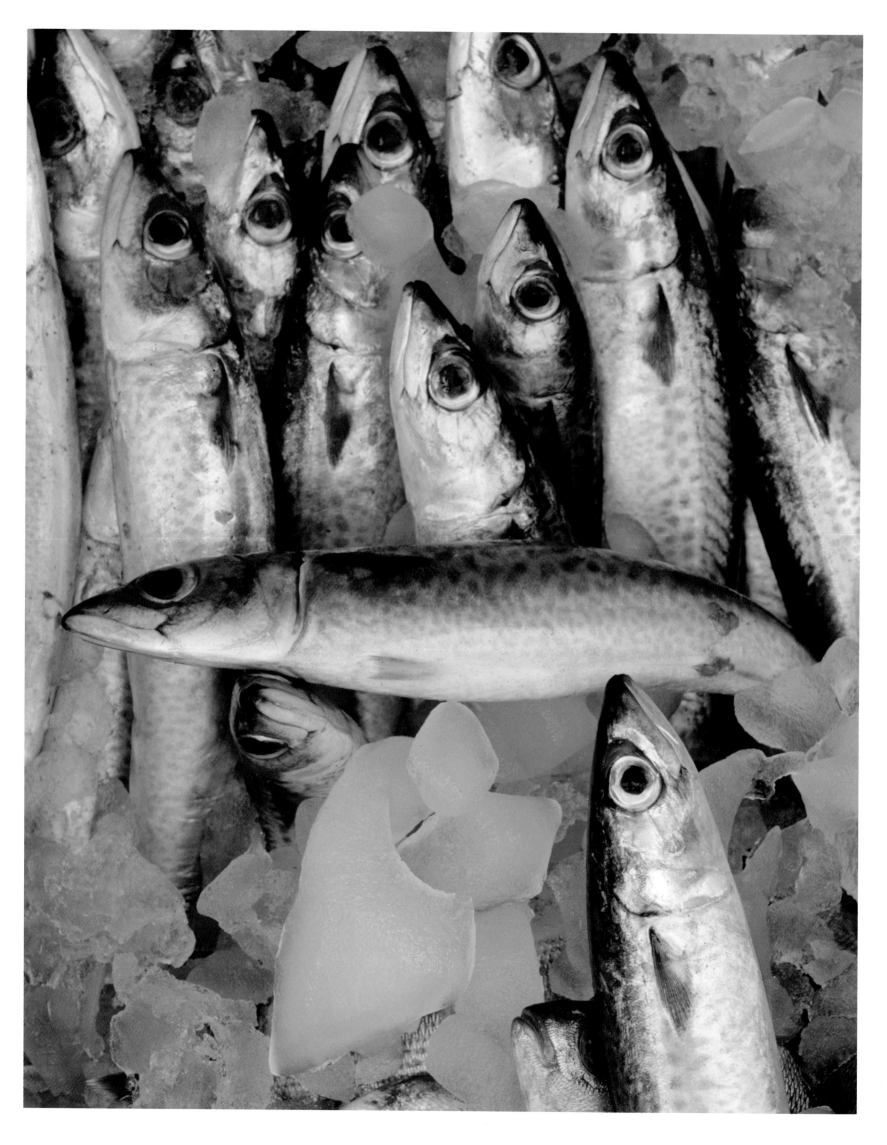

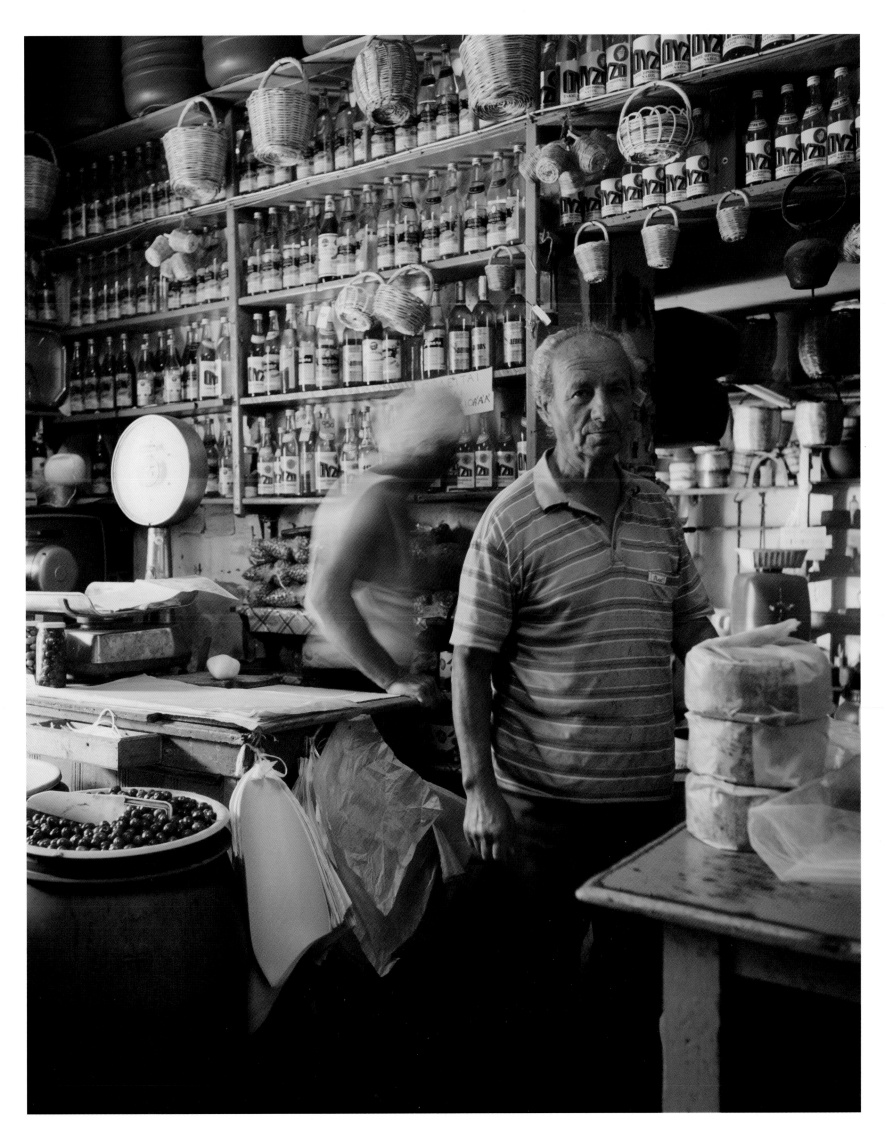

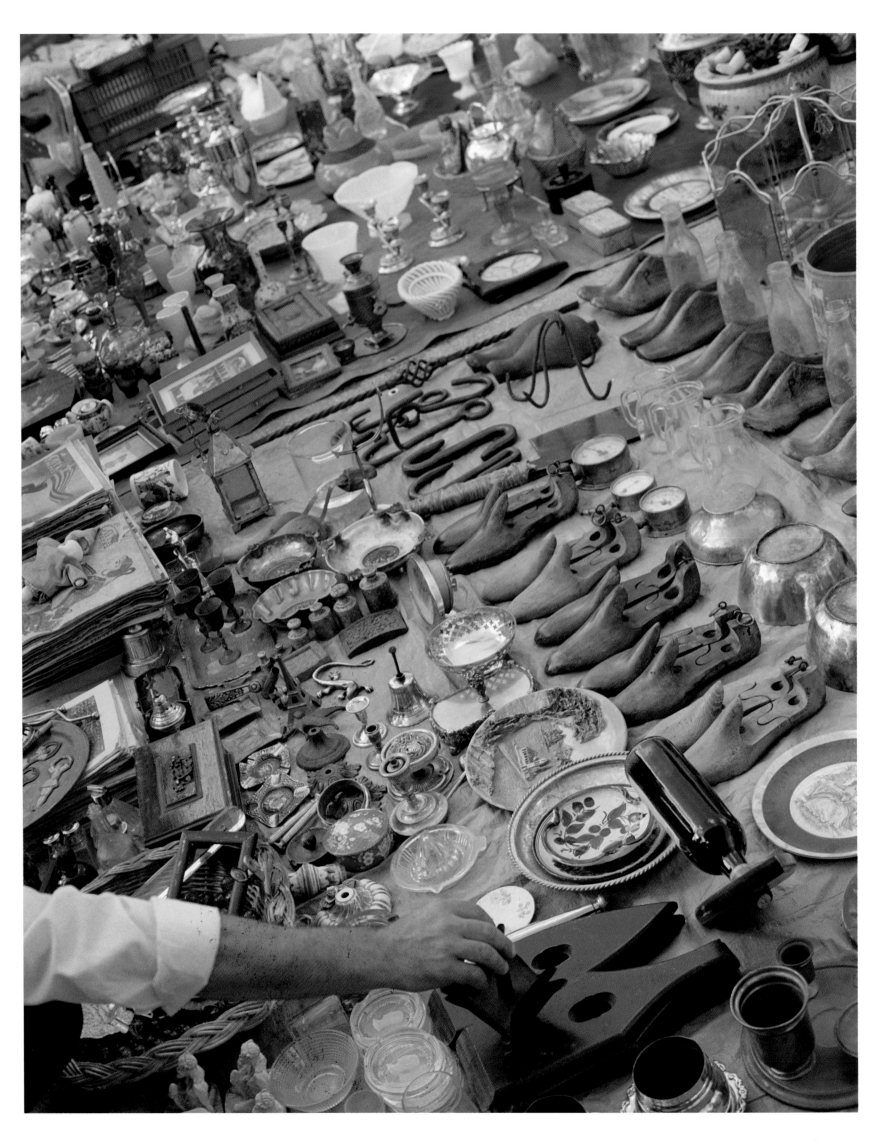

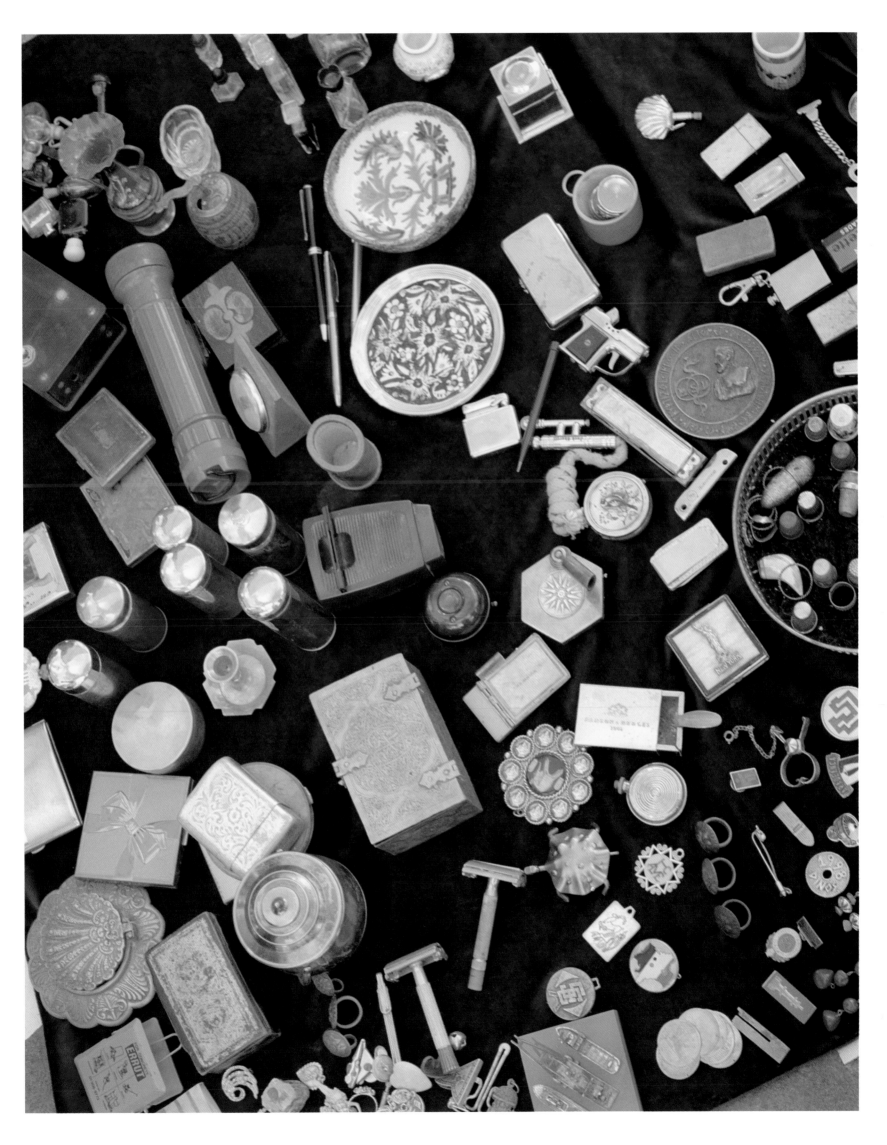

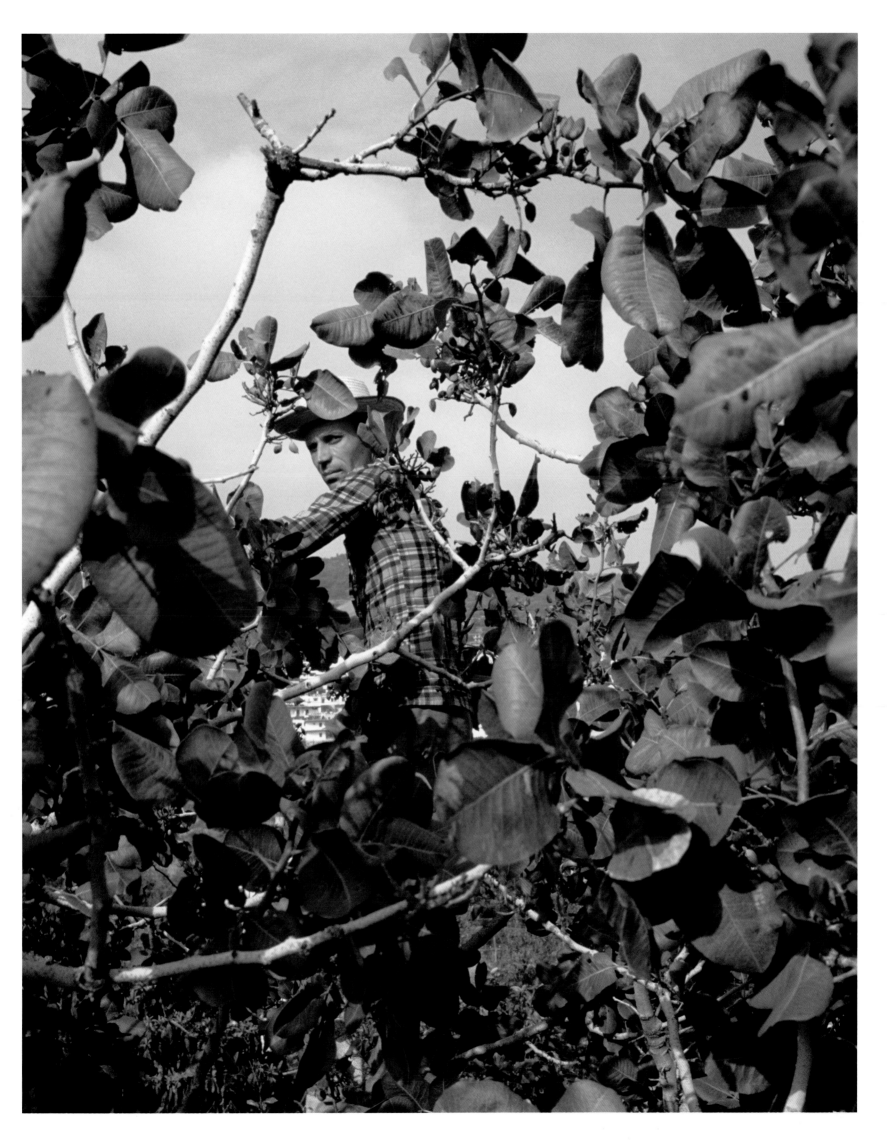

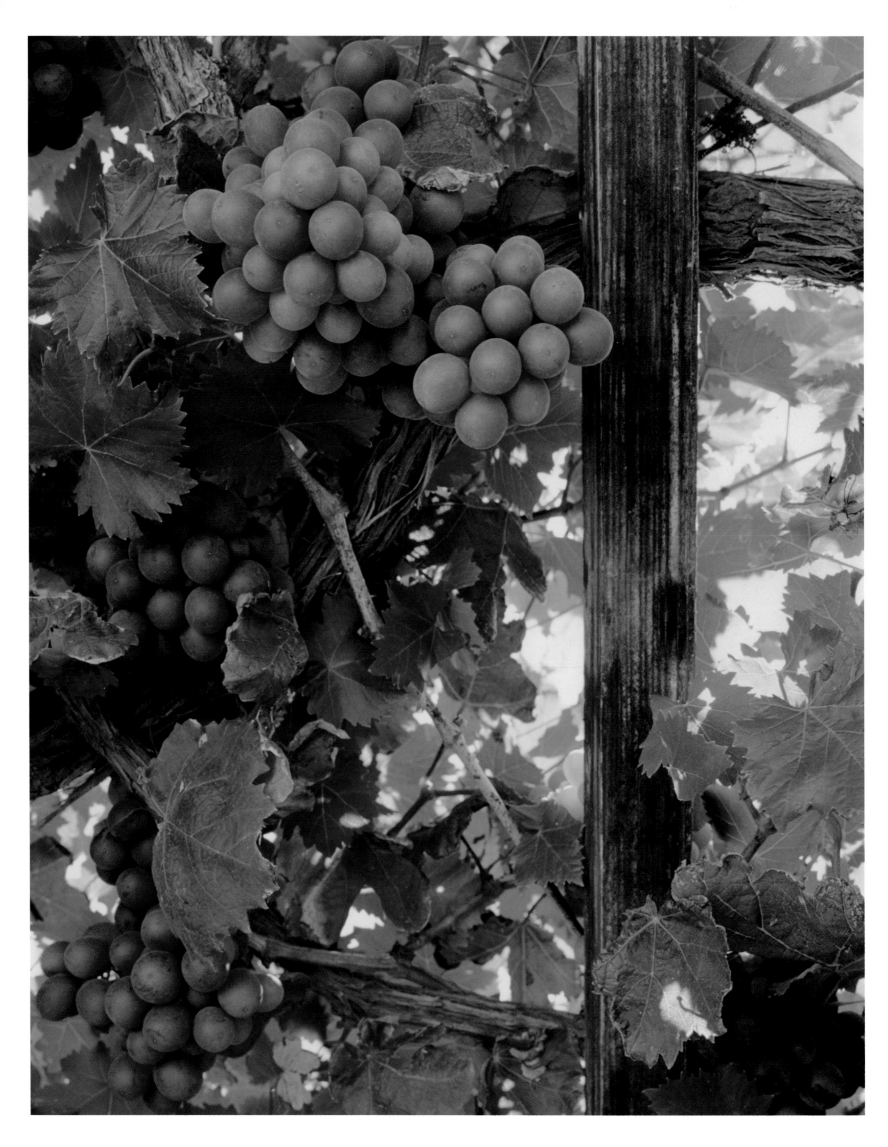

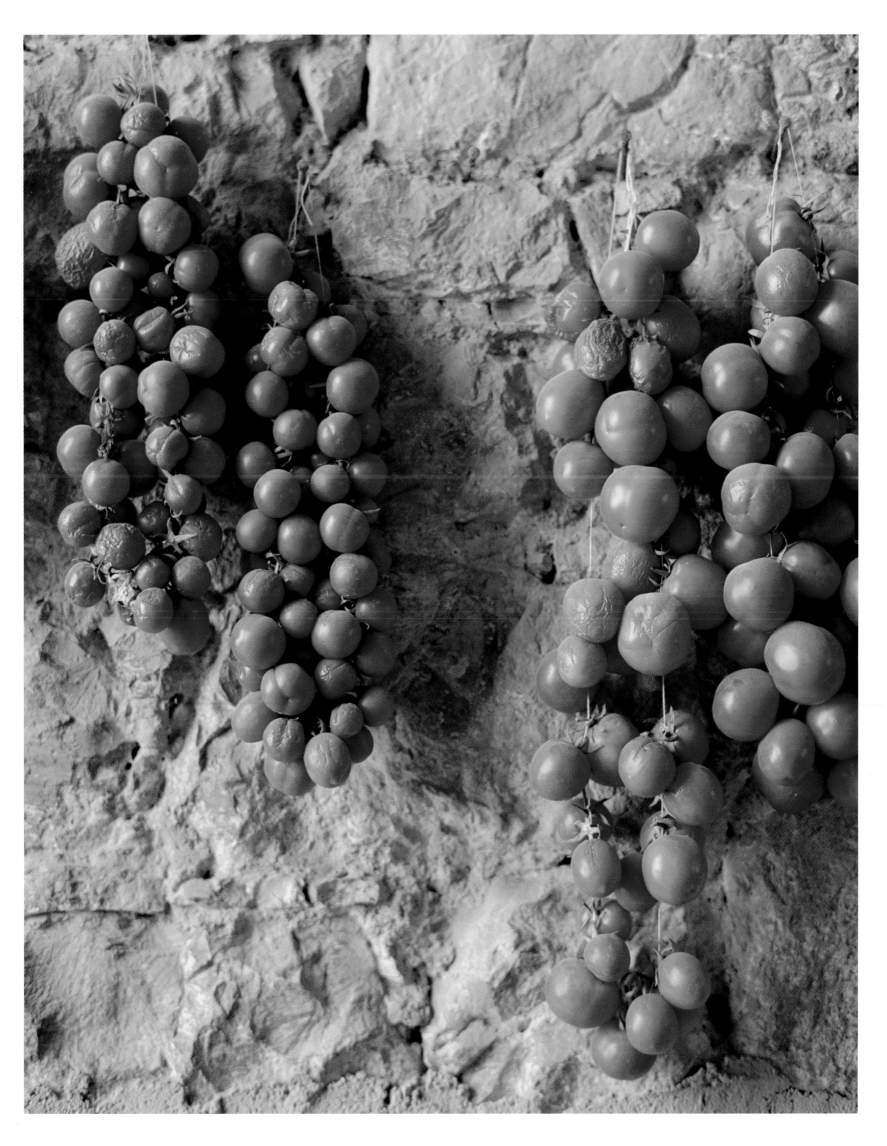

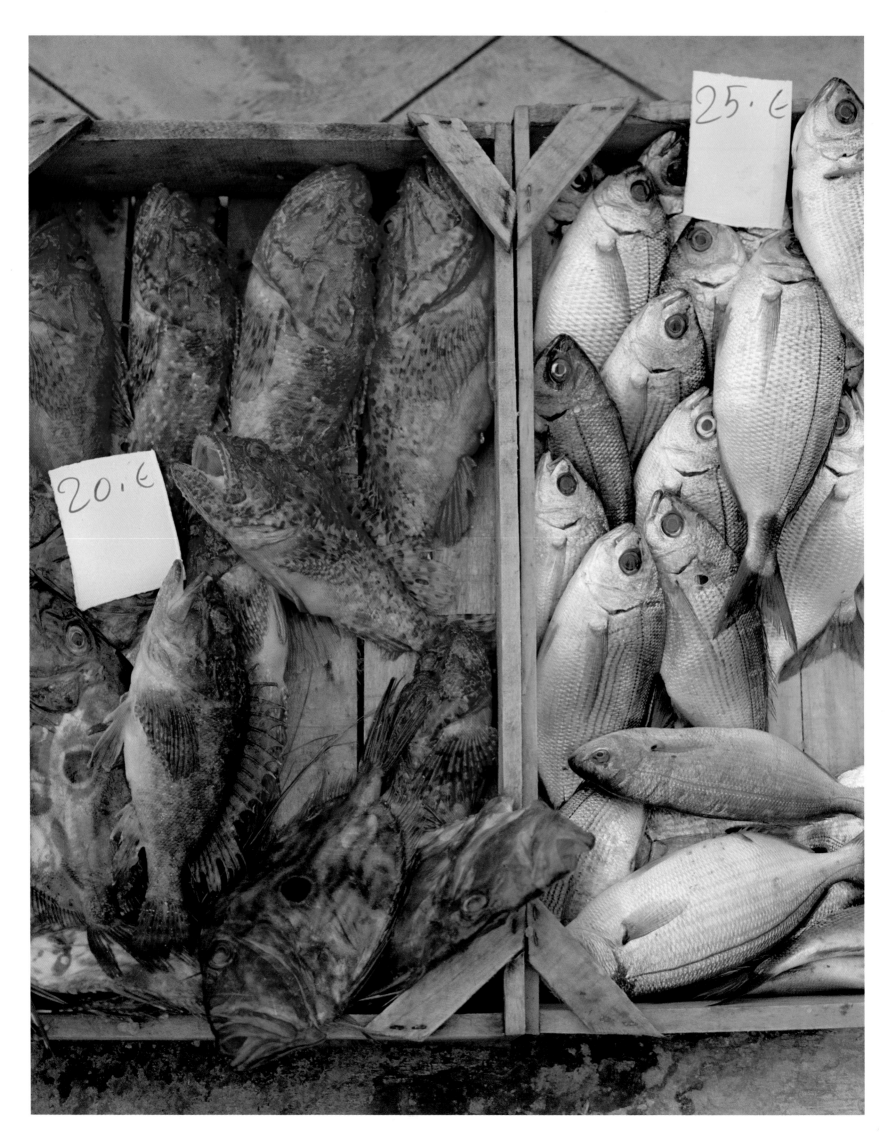

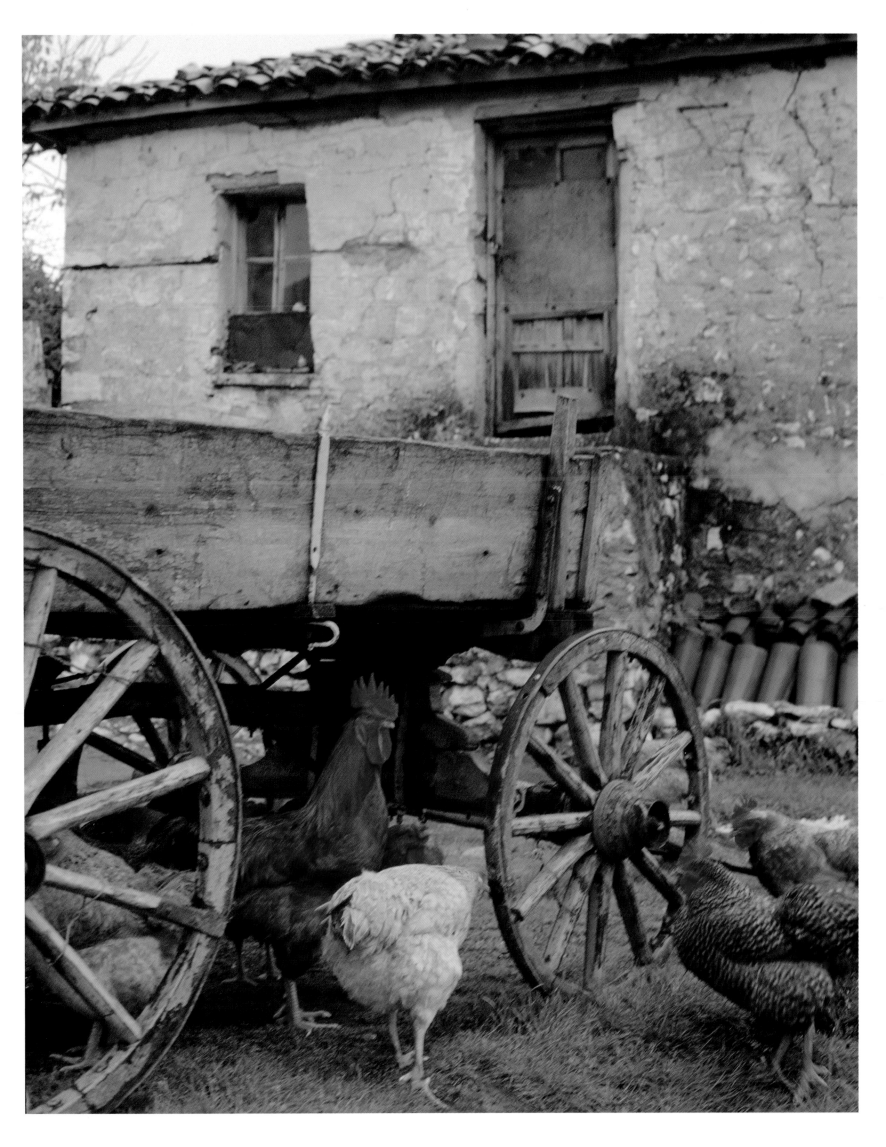

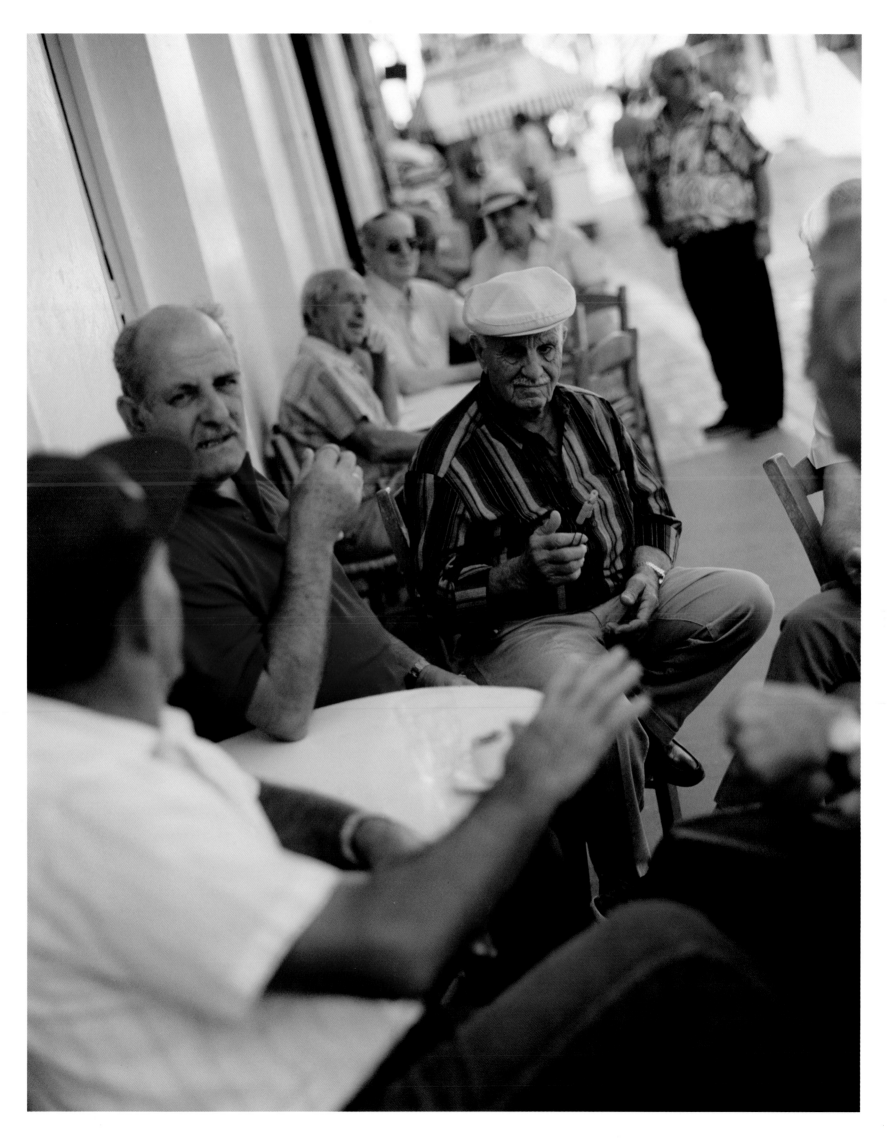

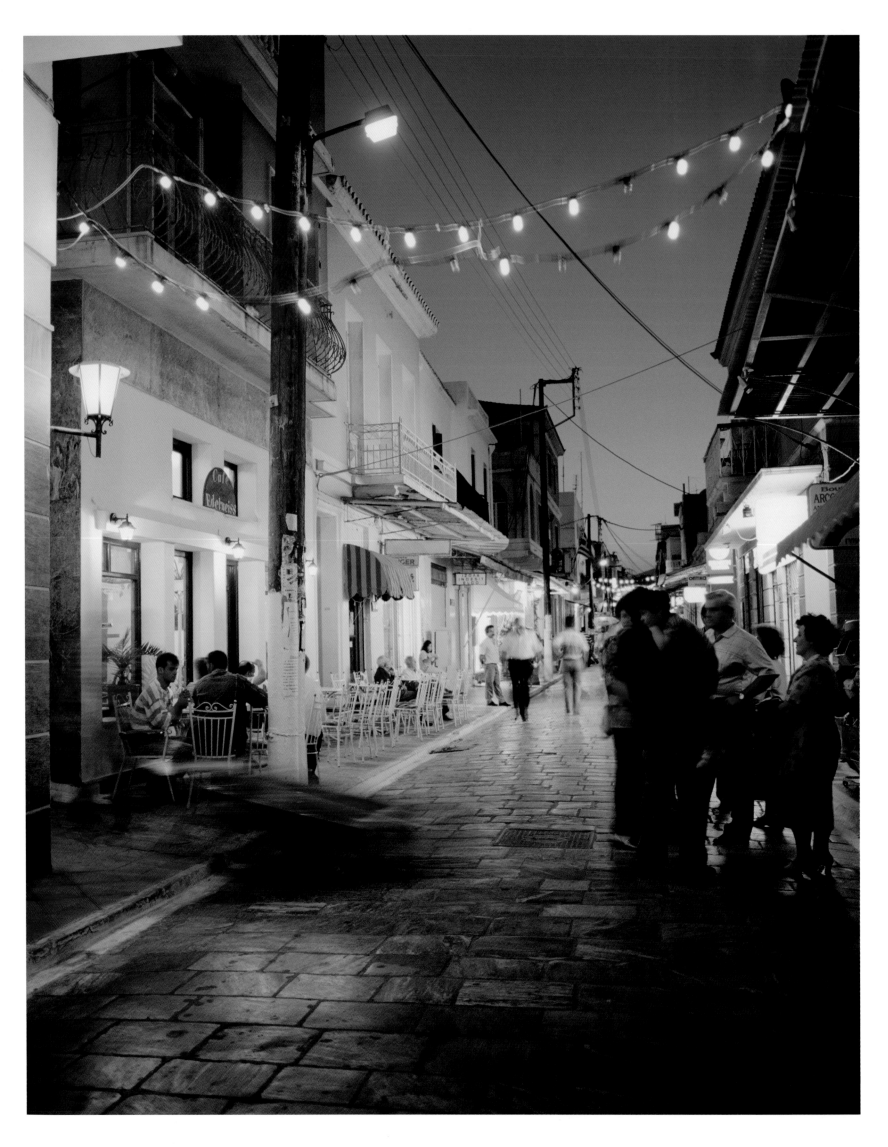

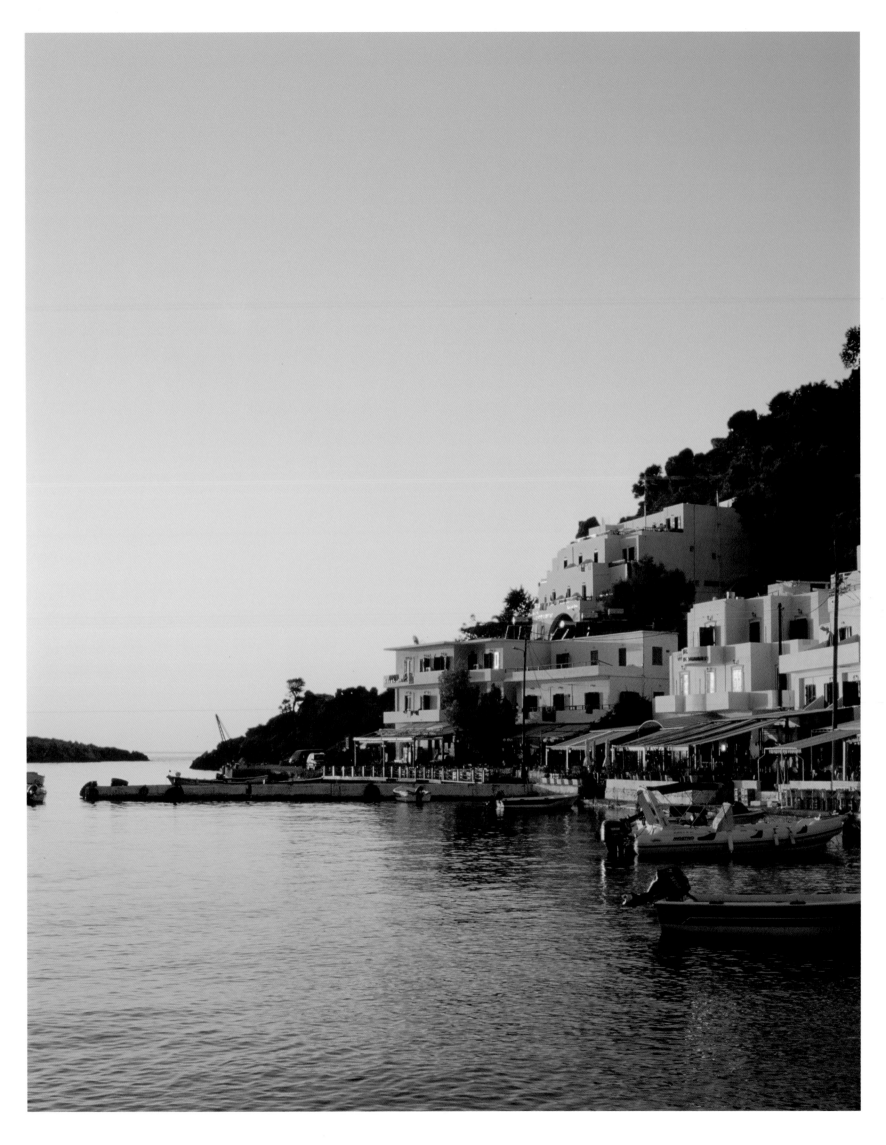

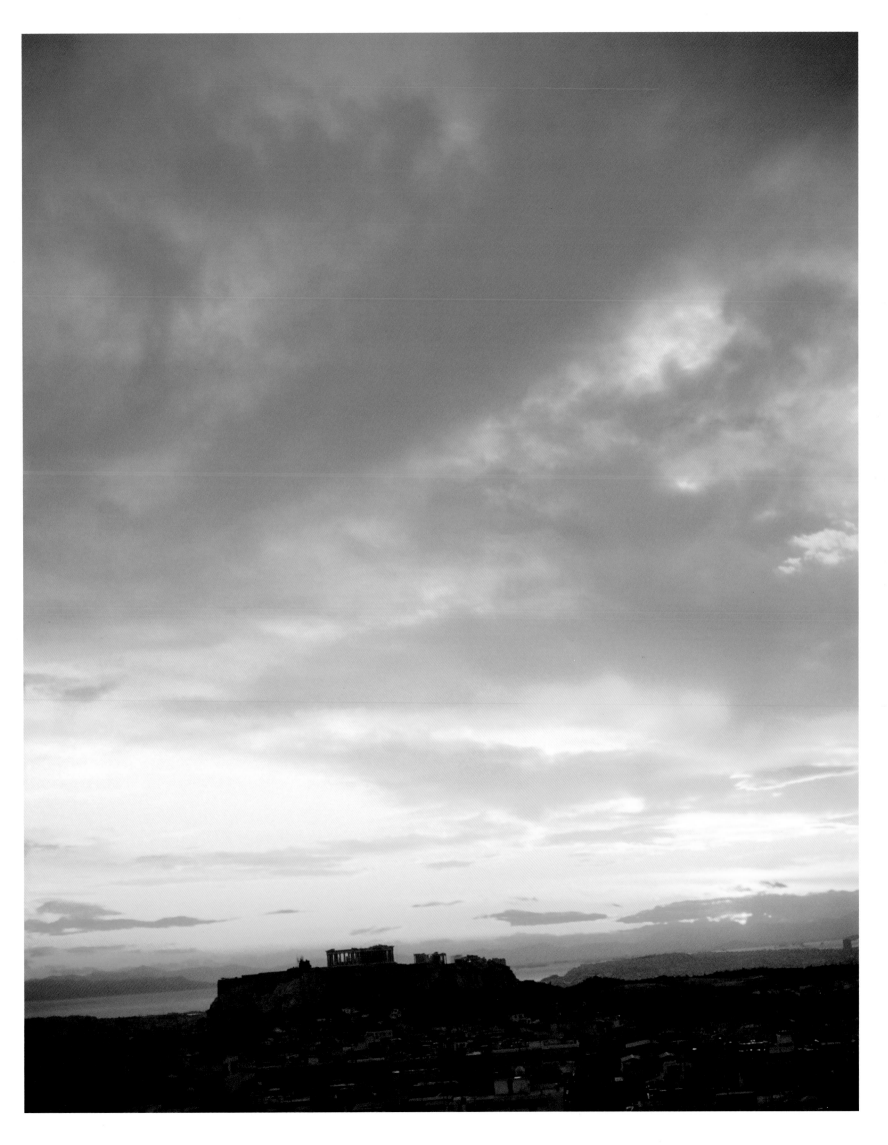

AFTERWORD

As a photographer, I make images without needing to articulate why. The thought process is spontaneous and unspoken. It is a reaction to the light, atmosphere, patina, history, or spirit of the subject, be it a place, person or object. The less time I spend trying to figure out what is in front of me and why I am taking a photograph, the more fluid the process and most often, the better the image.

My fascination with Greece has brought me—and now my family—back to Greece again and again since my first visit to Mykonos in the early 1980s. Now I have to search farther for the Greece I want to find, but it still exists—altered somewhat by the effects of globalization, but still unique and rich. What remains a constant is the light, searing and brilliant, and how it illuminates the essence of things. It has a quality that suffuses the most simple of objects—a glass of water, a cigarette, blowing curtains or a simple white bed—with monumental gravitas. In *The Magus*, his classic novel of Greece, John Fowles describes it as "a dense, golden halo . . . 'round the most trivial of moments, so that the moment, and all such moments could never be completely trivial again."

As Henry Miller wrote in *The Collossus of Maroussi*, "Everything is delineated, sculpted, etched . . . Every individual thing that exists, whether made by God or man, whether fortuitous or planned, stands out . . . even the wastelands have an eternal cast about them. You see everything in its uniqueness. . . ."

My response to Greece, expressed through my photography, has been articulated beautifully in words by a number of writers, foremost among them Edmund Keeley, a famed Philhellene who wrote the introduction to my first book of photography, *The Greek File* (Rizzoli, 2001). Keeley's work and his and Philip Sherrard's translations of the poems of Odysseus Elytis, George Seferis, and Constantine Cavafy; as well as Nicholas Gage's *Eleni*; the poetry of Seamus Heaney; and the prose of Louis de Bernières and Sir Patrick Lee Fermor, Laurence Durrell, and Henry Miller have helped me grasp the

sublime, complex simplicity that I found so compelling about this most paradoxical of countries. Antonis Capetanakis wrote in 1944:

The sun is not in love with us,
Nor the corrosive sea;
Yet both will burn our dried-up flesh
In deep intimacy

With stubborn tongues of briny death
And heavy snakes of fire,
Which writhe and hiss and crack the Greek
Myth of the singing lyre.

The ferocity and barbarism of the Greek Civil War in Keeley's *Inventing Paradise,* the sheer strength and powerful honor of Nicholas Gage's *Eleni,* the rich words of Heaney and remarkable detail of Fermor and de Bernières tempered for me Miller's and Durrell's more romantic perspectives. The Greece I have gotten to know is one rich in antiquity and myth, and famed as the birthplace of democracy—but it is also a country that from the 1930s through the present has forced rapid change and urbanization on a formerly primarily rural population. My initial experiences with Greece were during a period of relative calm, nearly seventy years after Henry Miller's first travels, fifty years after the end of the brutally violent Greek Civil War, and thirty years after the overthrow of the repressive military junta. As this book goes to press, Greece has been plunged into a period of great economic uncertainty and transition whose outcome is still uncertain.

Along with the passage of time between the taking and showing of many of the photographs here, has come the realization that the work is expressing change in myself as well as change in Greece—something I could not have foreseen as I took the images. In the end, what remains is the record of how well I felt I have gotten along with Greece as we both have evolved. In this collection I have embraced color, yet the work is subtly darker than that in *The Greek File.* I hope these photographs will, like the work of these esteemed writers of a passing generation, offer an alternative to the clichéd, postcard-perfect views of a very complex land, and reveal one more layer of past, present and future of this rich and enigmatic country: Hellas—Greece.

WILLIAM ABRANOWICZ
BEDFORD, NEW YORK, JUNE 2010

LIST OF PLATES

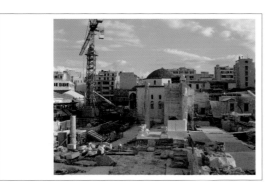

SANTORINI, 2007

ATHENS, 2002

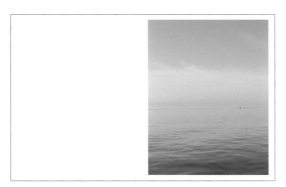

ATHENS, 2002

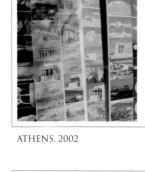

SANTORINI, 2001

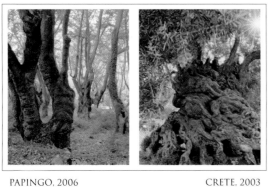

PAPINGO, 2006 CRETE, 2003

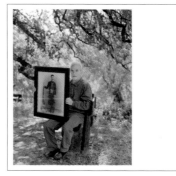

CRETE, 2003

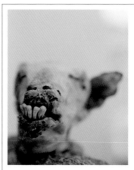

MILOS, 2007

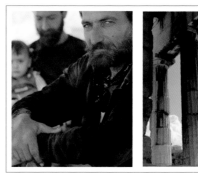

CRETE, 2003 ATHENS, 2002

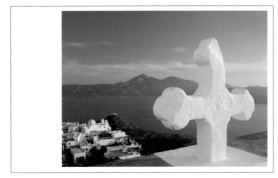

CRETE, 2006

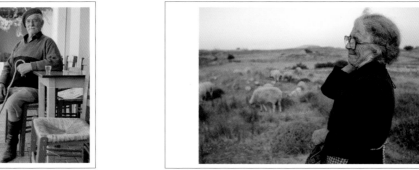

MYKONOS, 2001 MILOS, 2007

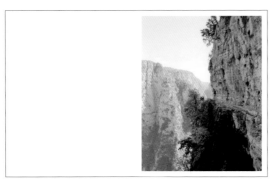

ATHENS, 2002 CRETE, 2003

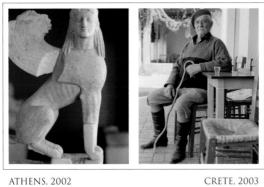

MYKONOS, 1992

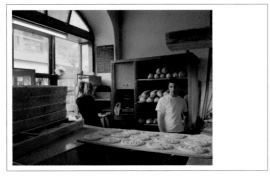

KAVALA, 2004

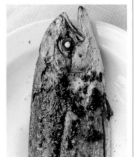

MYKONOS, 2001 KARDAMYLI, 2006

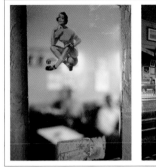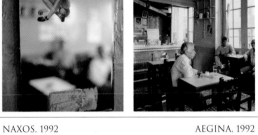

NAXOS, 1992 · AEGINA, 1992

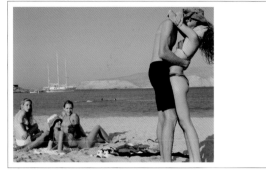

MYKONOS, 2002

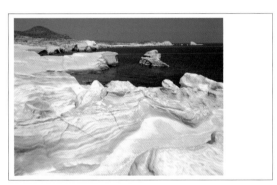

THASSOS, 1992

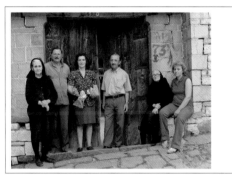

PAPINGO, 2006

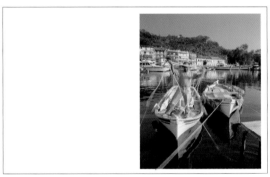

MILOS, 2007

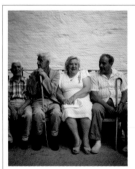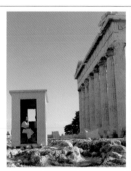

ANDROS, 1996 · ATHENS, 2002

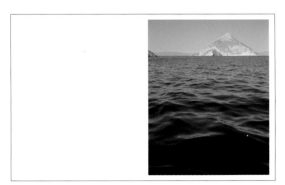

HYDRA, 1996

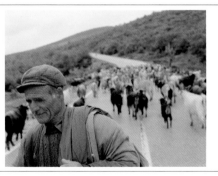

NESTO RIVER GORGE, 2004

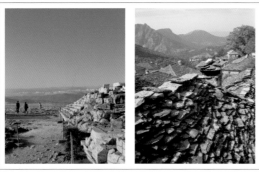 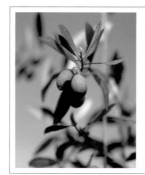

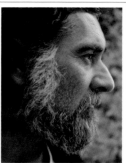

PHILIPPI, 2004 MIKRO PAPINGO, 2006 THASSOS, 1992 THASSOS, 1992

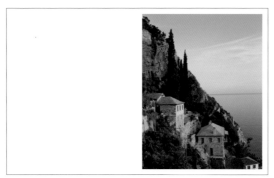 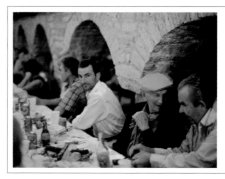

MT. ATHOS, 2004 MIKRO PAPINGO, 2006

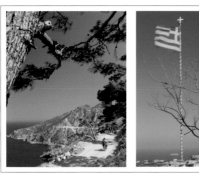 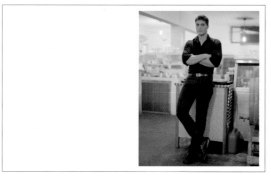

KARPATHOS, 1998 SANTORINI, 2001 CRETE, 2003

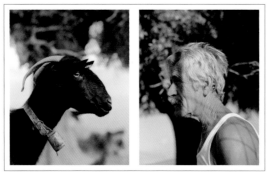 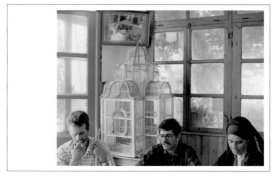

CRETE, 2003 CRETE, 2003 KARPATHOS, 1998

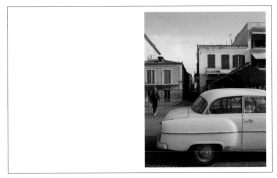

AEGINA, 1992

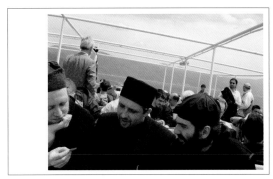

EN ROUTE TO MT. ATHOS, 2004

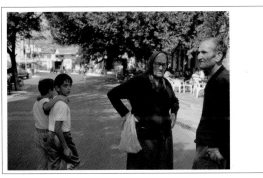

NAXOS, 1992

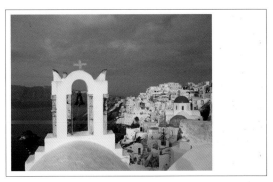

SANTORINI, 2007

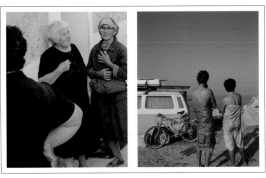
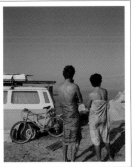

CHIOS, 2006 NAXOS, 1992

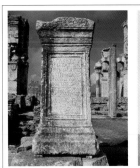
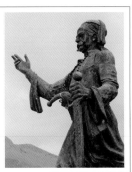

PHILIPPI, 2006 AEROPOLI, 2006

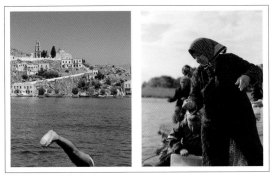

SYMI, 1998 KARDAMYLI, 2006

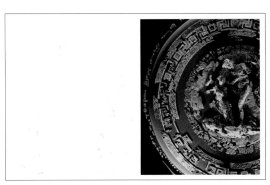

BERGINA, 2004

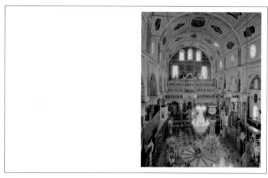

CHIOS, 2006

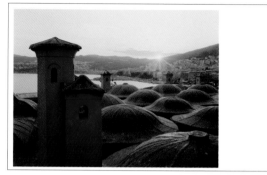

KAVALA, 2004

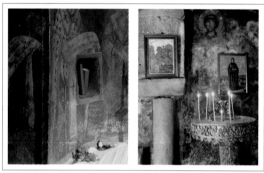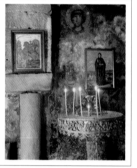

SKIATHOS, 2007

MANI, 2006

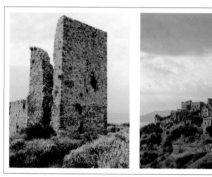

MT. ATHOS, 2004

VATHIA, 2006

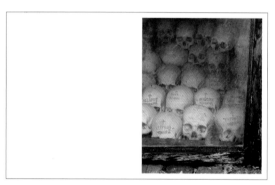

MT. ATHOS, 2004

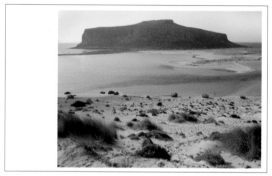

CRETE, 2003

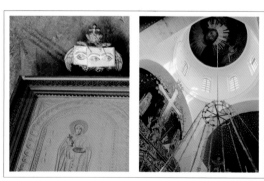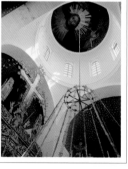

PAPINGO, 2006

CRETE, 2003

MYKONOS, 2002

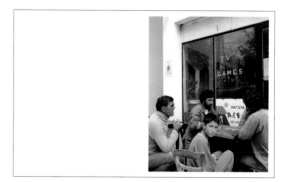

ATHENS, 2002

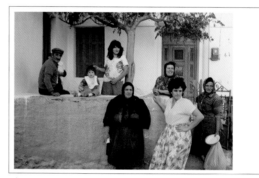

THASSOS, 1992

ATHENS, 2002 SANTORINI, 2001

NAXOS, 1992

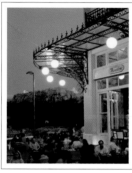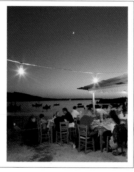

NAXOS, 1992 THASSOS, 1992

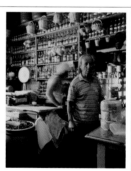

THASSOS, 1992 NAXOS, 1992

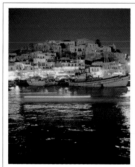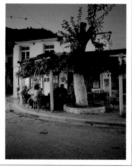

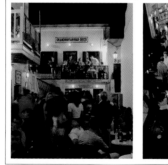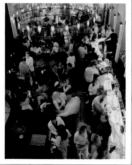

MYKONOS, 2002 KALAMAXINA, 2004

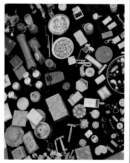

ATHENS, 2002 ATHENS, 2002

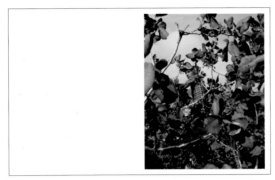

AEGINA, 1992

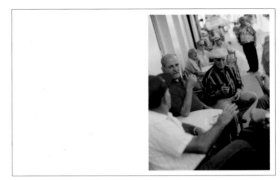

ANDROS, 1996

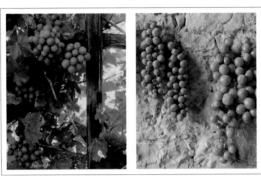

SANTORINI, 2001 CHIOS, 2006

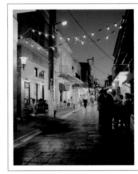
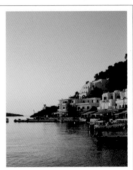

ANDROS, 1996 CRETE, 2003

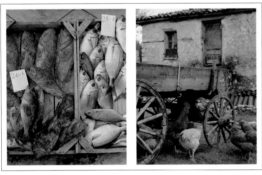

SANTORINI, 2007 LEKANI, 2004

ATHENS, 2002

ACKNOWLEDGEMENTS

THIS BOOK COULD NOT HAVE COME TO FRUITION without my family and fellow Philhellenes—my wife, Andrea, and my children, Zander, Simon, and Max Athena. Andrea pounded the pavement for me through Athens as riots and fires raged and always had faith and encouraging words on some discouraging days. They supported me over the months I was away photographing, and their love and enthusiasm is boundless, as it is with my family in Oia, Maria Erini Psychas, Timos Tsoukalas, and especially my brother in arms, Kostis Psychas. I am indebted to my assistants, Martha Emmons and Christian Harder—thoughtful, diligent workers and friends; my agency, Art + Commerce, especially my dear friends and advisors, Andrée Chalaron, Becky Lewis, Michael Van Horne and Franck Hoffman; *Conde Nast Traveler*—namely Klara Glowszewska, Kathleen Klech, Esin Ili Göknar, and Jocelyn Miller, for providing me with countless opportunities to show the world my love of Greece; the supremely talented and articulate Richard Ferretti; Jeff Braunstein, Diane D'Ambrosio, Betty Flores, and Frederic Kantor at JH Cohn for sound financial guidance; for their words, Professor Edmund Keeley, Nicholas Gage, Tom Baril, Linda Ellerbee, Sir Patrick Leigh Fermor, Matthew Goldberg, Iason and John Demos, Leonard Benowich, and Louis de Bernières for an introduction that brought me to tears when I first read it, and his agent Lavinia Trevor; designer David Skolkin for the beautiful vessel you hold in your hands; Joanna Hurley of HurleyMedia for steadfast faith (through trial and tribulation) in the project, and for ultimately delivering it to the receptive Hudson Hills Press and welcoming Leslie Van Breen; and Patricia Williams for helping me keep my head screwed on straight.

My love of the Greek people and their country has been reciprocated for over two decades. My hope for Greece burns brightly. Philakia.

ABOUT THE ARTIST & AUTHOR

WILLIAM ABRANOWICZ has been a photographer for over thirty years. He is best known for his poised and meticulous still life, landscape, and lifestyle photographs. He has been a contributing photographer to *Conde Nast Traveler* for twenty years. His photographs have been featured in nearly every major publication throughout the world including *Elle Décor, Vogue, Vanity Fair, Stern, Town and Country,* and German, French, Spanish, Italian, and Russian editions of *Architectural Digest.*

In addition, Abranowicz has an in-depth knowledge of the history of photography as well as considerable talent as a fine art printer, having assisted renowned photographers George C. Tice and Horst P. Horst, and printed negatives for Michael Disfarmer, Horst, George Hoynigen Heune, and Edward Steichen. He has taught photography at Parsons School of Design and the New School for Social Research.

His photographs are in included in public, private and corporate collections throughout the world, including those of The National Portrait Gallery in London, The Bibliothéque Nationale in Paris, The Smithsonian Institution in Washington, D.C., The International Center of Photography in New York, The Thessaloniki Museum of Photography, the Goulandris Museum in Greece, The Menil Collection Library in Houston, and the Getty Museum in Los Angeles.

His work has been exhibited at The Bonni Benrubi Gallery and The Witkin Gallery in New York, The Photographer's Gallery in Los Angeles, Afterimage in Dallas, and Camerawork in Berlin.

LOUIS DE BERNIÈRES, who lives in Norfolk, England, published his first novel in 1990, and was selected by *Granta* magazine as one of the twenty Best of Young British Novelists in 1993. *Captain Corelli's Mandolin* (1994) won the Commonwealth Writers' Prize for Best Novel and became an international bestseller. His sixth novel, *Birds Without Wings,* came out in 2004. *A Partisan's Daughter* (2008), was shortlisted for the Costa Novel Award, and *Notwithstanding: Stories from an English Village* was published in Autumn 2009.

Hellas was produced for Hudson Hills Press by HurleyMedia, LLC. and brought to publication in an edition of 2000 hardcover copies. The text was set in Minion with Trajan display, the paper is NPI, 157-gsm weight. Four-color separations were prepared by Bright Arts, Hong Kong. The book was printed and bound in Malaysia for Imago.

Published in the United States by Hudson Hills Press LLC
3556 Main Street, Manchester, Vermont 05254.

Distributed in the United States, its territories and possessions, and Canada by National Book
Network, Inc. Distributed outside North America by Antique
Collectors' Club, Ltd.

Publisher and Executive Director: Leslie Pell van Breen
Founding Publisher: Paul Anbinder

Project and Editorial Director : Joanna Hurley, HurleyMedia LLC
Design and Production: Skolkin + Chickey, Santa Fe, NM
Printed and bound in Malaysia for Imago

Library of Congress Cataloging-in-Publication Data
Abranowicz, William.
Hellas : photographs of modern Greece / William Abranowicz ; introduction
by Louis deBernieres.
p. cm.
ISBN 978-1-55595-333-1
1. Greece--Pictorial works. 2. Greece—Social life and customs—Pictorial
works. I. Title.
DF719
[.A25 2010]
949.50022'2--dc22
2010031847